VIEWPOINTS

VIEWPOINTS

Mathematical Perspective and
Fractal Geometry in Art

Marc Frantz

Annalisa Crannell

Princeton University Press

Princeton and Oxford

Copyright © 2011 by Princeton University Press

Published by Princeton University Press, 41 William Street,
Princeton, New Jersey 08540

In the United Kingdom: Princeton University Press, 6 Oxford Street,
Woodstock, Oxfordshire, OX20 1TW

press.princeton.edu

Cover photo: Winter Road along the Trees, by Wil Van Dorp

Library of Congress Cataloging-in-Publication Data

Frantz, Marc, 1951–
 Viewpoints: mathematical perspective and fractal geometry in art / Marc Frantz,
Annalisa Crannell.
 p. cm.
 Includes bibliographical references and index.
 ISBN 978-0-691-12592-3 (hardback: alk. paper)
 1. Perspective—Textbooks. 2. Fractals—Textbooks. 3. Art—Mathematics—Textbooks.
I. Crannell, Annalisa. II. Title.
 QA515 .F73 2011
 742.01′51-dc22 2010053315

British Library Cataloging-in-Publication Data is Available

This book has been composed in LATEX

The publisher would like to acknowledge the authors of this volume for providing
the camera-ready copy from which this book was printed.

Printed on acid-free paper. ∞

Printed in the United States of America

1 3 5 7 9 10 8 6 4 2

Contents

Preface

Viewpoints is an undergraduate text in mathematics and art suitable for math-for-liberal-arts courses, mathematics courses for fine art majors, and introductory art classes. Instructors in such courses at more than 25 institutions have already used an earlier online version of the text, called *Lessons in Mathematics and Art*. The material in these texts evolved from courses in mathematics and art which we developed in collaboration and taught at our respective institutions. In addition, this material has been tested at, and influenced by, a series of weeklong Viewpoints faculty development workshops.

Pedagogical Approach

The approach of *Viewpoints* is highly activity based, much like the approach of teaching in art school. As many of our workshop graduates will attest, the true value of the material can only be fully appreciated by engaging in these activities, and not by merely reading the book. We have endeavored to include problems and activities of genuine interest and value to art students—problems that go significantly beyond what students normally learn in art school. In our experience the authenticity of the problems makes them genuinely interesting, not only to art majors but to students from a broad range of disciplines. We have included a detailed appendix for instructors which includes advice on the window-taping activity of Chapter 1, a sample timetable for a first-year seminar course based on *Viewpoints*, and a list of additional writing assignments.

We have endeavored to make sure that the problems are real math problems. Happily, there is a wealth of problems at the boundary of mathematics and art having a number of excellent pedagogical properties: (1) the problems are natural and easily understood; (2) the problems have multiple solutions of varying difficulty and applicability; (3) the problems admit multiple proofs, both geometric and algebraic; (4) once arrived at, the solutions are easy to remember and rewarding to use; and (5) the search for solutions captures the essence of mathematical research and discovery. (We demonstrate in depth how this fivefold approach comes to bear on a single problem

in the solution to Exercise 8 of Chapter 4.) We have sought to make the problems in this book embody each of these characteristics, at a level that is accessible to every undergraduate student.

ARTIST VIGNETTES

A special feature of the text is a series of personal essays which we call Artist Vignettes. During the course of our project we have been fortunate to meet a number of professional artists who have generously contributed to the book. Each Vignette contains a short biography, an artist's statement, and some images of the artist's work. Color images of the artists' work will also appear in the color plate section. We feel that the input of practicing artists informed about mathematics will be an exciting and attractive addition to the text.

ORIGIN OF THE TEXT

The initial course development and the first Viewpoints workshops were supported by the Indiana University Mathematics Throughout the Curriculum project, the Indiana University Strategic Directions Initiative, Franklin & Marshall College, and the National Science Foundation (NSF-DUE 9555408). The 2001 workshop was also supported by the Professional Enhancement Program of the Mathematical Association of America. We revised and expanded the text as part of a collaboration between our two institutions, supported by an NSF Educational Materials Development grant (NSF-DUE 0439891 and 0439713).

Marc Frantz
Indiana University

Annalisa Crannell
Franklin & Marshall College

Acknowledgments

The first glimmerings of this book appeared fifteen years ago, when the two authors happened to have the good luck to be in the same place (IUPUI) at the same time (fall of 1995), just as Indiana University proposed a Mathematics Throughout the Curriculum project (MTC) to the National Science Foundation. The fearless leader of that grant was Dan Maki. Since then, he's been supportive of our small part of his larger project at every stage: as we started teaching math-and-art courses at our two home institutions, as we started writing up our materials, as we put together our Viewpoints summer workshops for college instructors, and as we hosted our follow-up reunions. We couldn't imagine a better fearless leader than Dan, and to him goes our heartfelt gratitude.

As memory serves, it was Bart Ng, Dan's coleader, who first mentioned the idea of our collaboration. We're grateful to Bart for his support and for the spark that led to such a long and rewarding adventure.

And of course, we're very grateful to the National Science Foundation for the grant to MTC (NSF-DUE 9555408), and for the grants to our own collaborative project (NSF-DUE 0439891 and NSF-DUE 0439713) to write and disseminate this book.

Tina Straley, Brian Winkel, Pippa Drew, and Dorothy Wallace invited us to Dartmouth in the summer of 1998 for a wonderful workshop on math and the humanities. Pippa and Dorothy have done a lot of nice work with symmetry groups and art, and we learned a lot from them—including the joys of running a workshop! It's no coincidence that the first Viewpoints workshop came two summers after that.

One of our first and most determined "Viewpointers" (as we called our workshop participants) was Sister Barbara Reynolds of Cardinal Stritch University. It was Sr. Barbara who brought Peter Galante and Teri Wagner to our attention; she came to our workshop two years in a row and sent even more of her colleagues in later years. In her position as Editor of the MAA Notes series, she played a pivotal role in encouraging our manuscript. The world should have more

people like Sr. Barbara; Marc and Annalisa are glad that our own world includes at least one version of her.

A second Barbara entered our life in 2001, when the emerging MAA-PREP program funded the Viewpoints workshop and assigned us an evaluator. Barbara Edwards has served (at our request) as our project evaluator since then; she's not only super at cross-country pedagogy, but also is a wonderful person!

And we must have kissed the right frog, because Vickie Kearn agreed to be our editor (and Princeton University Press our publisher). We knew we were working with the right people when Vickie told us she was working all the problems herself just for fun.

Viewpointer John Putz gave our manuscript a thorough reading before coming to the last workshop, and made many helpful suggestions. We're flattered and thankful for his careful attention. We're likewise grateful for super-detailed comments from Viewpointers Leah Berman Williams and Andrius Tamulis.

We are very grateful to each of our Viewpointers, who spent a week (or two!) in close proximity with us, poring over spreadsheets and fence posts and giving us the kind of honest and immediate feedback that made us think and rethink our material. The next round of masking tape and shish kebab skewers goes to them: Abdel-Rida Saleh, Alex I. Bostandjiev, Alexandra Robinson, Alice Petillo, Amanda K. Serenevy, Amy E. Wheeler, Amy N. Myers, Andrius Tamulis, Andrzej Gutek, Ann C. Hanson, Anna M. Gavioli, Anne E. Edlin, Azar N. Khosravani, Barbara Duval, Barbara E. Reynolds, Barbara Edwards, Barbara Pinkall, Bernard Mathon, Betty Clifford, Bill Branson, Burkett Fleming, Calvin Williamson, Carol Piersol, Carolyn H. Campbell, Cathy W. Carter, Clifford Davis, Cynthia L. McGinnis, Darwyn C. Cook, David G. Hartz, Daylene Zielinski, Dinesh G. Sarvate, Donald McElheny, Doug Norton, Douglas E. Ensley, Edwina C. Richmond, Gordon Williams, Irina Ivanova, J. Paul Balog, J. Scott Billie, Jackie Hall, Jacqueline A. Bakal, Jan G. Minton, Janette Flaws, Janice C. Sklensky, Jay M. Kappraff, Jean B. Mastrangeli, Jennifer M. Rodin, Jim R. Rose, John F. Putz, Jonathan D. Schweig, Joshua Thompson, Joy H. Hsiao, Juan Marin, Judith C. Meckley, Judy A. Kennedy, Judy A. Silver, Julian F. Fleron, Julianne M. Labbiento, Kathi Crow, Kathleen M. McGarvey, Kerry E. Fields, Kerry Mitchell, Kevin Hartshorn, Lasse Savola, Laura Eden, Leah Berman Williams, Leslie Hayes, Lily Moshe, Linda H. Tansil, Lindsay B. Hilbert, Lisa A. Mantini, Lun-Yi Tsai, Lyn Miller, M. John Kezys, M. P. Chaudhary, Marian A. VanVleet, Marianne Neufeld, Marilyn Gottlieb-Roberts, Marion D. Cohen, Mark D. Binkley, Mark D. Schlatter, Martina Z. Mincheva, Mary Anne Stewart, Mary Jane Wolfe, Mary Williams, Mary Woestman, Meltem Ceylan Alibeyoglu, Michelle Y. Penner, Mike Daven, Mindi Thalenfeld, Nancy Prudic,

Naomita Malik, Natalie Niblack, Natalie Rivera, Ozlem Cezikturk, Patricia A. Oakley, Patricia Hauss, Patricia K. Jayne, Patricia S. Hill, Penny H. Dunham, Peter Galante, Peter N. Bartram, Peter Reeves, Premalatha Junius, Rachael H. Kenney, Rachel W. Hall, Rafael Espericueta, Raymond A. Beaulieu, Robert A. Bosch, Robert Lewand, Robert Wolfe, Ruth F. Favro, Sakura S. Therrien, Sandra Camomile, Sandy Yeager, Sarah A. Berten, Shangyou S. Zhang, Sharon E. Persinger, Shehraiz Husain, Sheli Petersen, Shirley L. Yap, Sid Malik, Stanislav P. Bratovanov, Stanley Eigen, Stephen F. May, Stephen I. Gendler, Steve Cope, Susan L. Banks, Susan Shifrin, Tamara Lakins, Tanea Richardson, Teresa D. Magnus, Teri G. Wagner, Thomas George, Toby Rivkin, Tom Rizzotti, Trisha M. Moller, Valerie Hollis, Vickie Kearn, William D. Ergle, William Seeley, and Wing Mui. We think you're all 8 heads tall!

Marc is especially grateful to Neil Gussman, who has been a fantastic supporter of Viewpoints all along. Not only did you contribute your time when we needed help, Neil, you were there as a great husband and dad when the needs of our Viewpointers diverted Annalisa's time and energy (and even the family blankets) away from home. More than that, seeing the way you have bravely met your own challenges has impressed me and reminded me of the strength and optimism we all need to face what life has in store for us.

Annalisa particularly wants to thank Paula Frantz, who has become a friend over these last dozen years. Paula, you've been courageous and creative and caring. From you, I have learned to respond to change by taking a deep breath, relaxing, and resting in faith. There aren't enough thank yous to express how much I appreciate your taking such good care of the both of us during these roller-coaster times.

VIEWPOINTS

CHAPTER 1

Introduction to Perspective and Space Coordinates

OUR FIRST PERSPECTIVE ACTIVITY involves using masking or drafting tape[1] to make a perspective picture of a building on a window (Figure 1.1). It's tricky! One person (the Art Director) must stand rooted to the spot, with one eye closed. Using the one open eye, the Art Director directs one or more people (the Artists), telling them where to place masking tape in order to outline architectural features as seen from the Director's unique viewpoint. In Figure 1.1, this process resulted in a simple but fairly respectable perspective drawing of the University Library at Indiana University–Purdue University Indianapolis.

[1] Actually, half-inch drafting tape from an office supply store is better. It's less sticky and easier to find in a narrow width. Nevertheless, we'll use the more common term "masking tape."

Figure 1.1. Making a masking tape drawing on a window.

If no windows with views of architecture are available, then a portable "window" made of Plexiglas will do just as well. In Figure 1.2, workshop participants at the Indianapolis Museum of Art are making masking tape pictures of interior architectural details in a hallway.

Figure 1.2. Plexiglas will do the job indoors.

Figure 1.3. Using a display case.

Finally, if a sheet of Plexiglas is not available, the window of a display case will also work. In this case, the Art Director directs the Artists in making a picture of the interior of the case (Figure 1.3).

If the masking tape picture from Figure 1.1 is put in digital form (either by photographing and scanning, or by photographing with a digital camera) it can be drawn on in a computer program, and some interesting patterns emerge. (Figure 1.4).

Lines in the real world that are parallel to each other, but *not* parallel to the picture plane have images that are *not* parallel.
The images of these lines converge to a *vanishing point*.

Lines in the real world that are parallel to each other, and *also* parallel to the picture plane have parallel images.

Figure 1.4. Two observations of the library drawing.

Observation 1. Lines in the real world that are parallel to each other, and *also* parallel[2] to the picture plane (the window) have parallel (masking tape) images.

Observation 2. Lines in the real world that are parallel to each other, but *not* parallel to the picture plane, have images that converge to a common point called a *vanishing point*.

Two such vanishing points, V_1 and V_2, are indicated in Figure 1.4. The correct use of vanishing points and other geometric devices can greatly enhance not only one's ability to draw realistically, but also one's ability to appreciate and enjoy art. To properly understand such things, we need a geometric interpretation of our perspective experiment (Figure 1.5). As you can see from Figure 1.5, we're going to be using some mathematical objects called *points*, *planes*, and *lines*. To begin describing these objects, let's start with points.

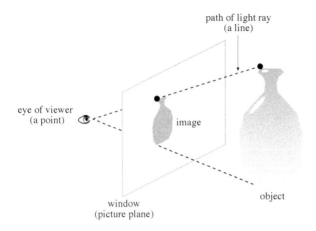

Figure 1.5. Mathematical description of the window-taping experiment.

It's assumed that you're familiar with the idea of locating points in a plane using the standard xy-coordinate system. To locate points in 3-dimensional space (3-space), we need to introduce a third co-ordinate called a z-coordinate. The standard arrangement of the xyz-coordinate axes looks like Figure 1.6; the positive x-axis points toward you.

For a point $P(x, y, z)$ in 3-space, we can think of the x, y, and z-coordinates as "out," "over," and "up," respectively. For instance, in Figure 1.6, the point $P(4, 5, 6)$ can be located by starting at the origin $(0, 0, 0)$ and going out toward you 4 units along the x-axis (you'd go *back* if the x-coordinate were negative), then over 5 units to the right (you'd go to the *left* if the y-coordinate were negative), and finally 6 units up (you'd go *down* if the z-coordinate were negative).

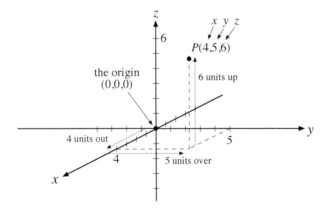

Figure 1.6. The standard xyz-coordinate system.

We took a look at the standard xyz-system in Figure 1.6 simply because it *is* the standard system, and you may see it again in another course. However, it will be convenient for our purposes to use the

Margin Exercise 1.1. What are the missing vertex coordinates of this block whose faces are parallel to the coordinate planes?

slightly different xyz-coordinate system in Figure 1.7—it's the one we'll be using from now on. In Figure 1.7 we have included sketches of three special planes called the *coordinate planes*. In this case, we have to think of the x, y, and z-coordinates as "out," "up," and "over," respectively, as indicated in the figure.

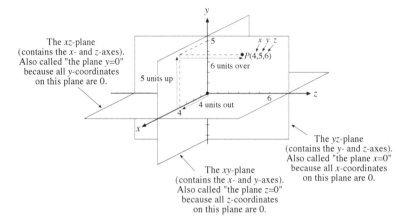

Figure 1.7. The coordinate system we will use.

A first look at how this coordinate system will be used to study perspective is presented in Figure 1.8. A light ray from a point $P(x, y, z)$ on an object travels in a straight line to the viewer's eye located at $E(0, 0, -d)$, piercing the picture plane $z = 0$ at the point $P'(x', y', 0)$ and (in our imagination) leaves behind an appropriately colored dot. The set of all such colored dots forms the perspective image of the object and hopefully fools the eye into seeing the real thing.

Margin Exercise 1.2. Suppose we are given two points $A(3, 3, 2)$ and $B(4, 2, 7)$ in the coordinate system of Figure 1.8.

Which is higher?

Which is closer to the viewer?

Which is further to the viewer's left?

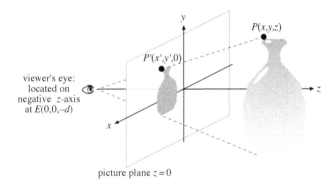

Figure 1.8. Perspective as a problem in coordinates.

In the next chapter we will see how to use this coordinate method to make pictures in perspective, much like special effects artists do

in the movies. We close this chapter by taking a look at how even the most basic mathematics can help us make better drawings.

A Brief Look at Human Proportions

Most untrained artists will draw the human figure with the head too large and the hands and feet too small (Figure 1.9). To prevent these common mistakes, artists have made measurements and observations, and come up with some approximate rules, some of which may surprise you:

- The adult human body, including the head, is approximately 7 to $7\frac{1}{2}$ heads tall.

- Your open hand is as big as your whole face.

- Your foot is as long as your forearm (from elbow to wrist).

That last one really is pretty surprising—we have big feet! To see that these principles result in good proportions, take a look at the two versions of the painting by Diego Velazquez in Figure 1.10.

Figure 1.9. Detail of a family portrait by Lauren Auster-Gussman at 8 years old. Note the height of the father in heads marked on the right, and the small hands and feet of the mother.

Figure 1.10. Diego Velazquez, *Pablo de Vallodolid*, c. 1635 oil on canvas 82.5 × 48.5 in.

In the digitally altered version on the right, we see that the figure is about 7 heads tall, the left hand (superimposed) is as big as the face, and the man's right foot, when superimposed on his right forearm, just about covers it from elbow to wrist.

Artists who understand human proportions also know how to bend the rules to achieve the effects they want. Comic artists are a good example of this (Figure 1.11).

Figure 1.11. In this sketch by popular comic artist Alex Ross, the DC Comics superhero Atom-Smasher is more than eight heads tall. Superimposed circles of the same diameter show that Starwoman's foot is roughly as long as her forearms. (From *Rough Justice: The DC Comics Sketches of Alex Ross*, Pantheon, New York, 2010. ATOM-SMASHER and STARWOMAN are ™ and © DC Comics. All Rights Reserved.)

In their book *How to Draw Comics the Marvel Way* (Simon & Schuster, New York, 1978) Marvel Comics editor Stan Lee and artist John Buscema reveal that Marvel artists generally draw superheroes eight and three-quarters heads tall, for heroic proportions. Popular comic artist Alex Ross, who has drawn for both Marvel and DC Comics, uses these proportions for the DC Comics superhero Atom-Smasher in Figure 1.11, taken from Ross's book *Rough Justice: The DC Comics Sketches of Alex Ross* (Pantheon, New York, 2010).

Having rules like this helps comic artists to visually distinguish superheroes from ordinary characters. It also helps the artists to draw the same character again and again in a consistent way. Thus we see that although artists are not bound by any one set of mathematical rules, *understanding* the rules can be very helpful. That's a theme we will see repeatedly throughout this book.

Exercises for Chapter 1

1. Divide your height in inches by the height of your head in inches (you'll have to measure). According to the artists' rule, the answer should be about 7 to 7.5.

 (a) What is your actual answer?

 (b) For a child, should the answer be greater or smaller than 7–7.5?

2. In each of Parts (a), (b), and (c), we consider a rectangular box with its faces parallel to the coordinate planes in Figure 1.7. Some of the coordinates of the eight corners (A, B, C, D, E, F, G, H) of the box are given; your job is to fill in the rest.

 (a) $A = (1, 1, 1)$,
 $B = (1, 1, 5)$,
 $C = (4, 1, 1)$,
 $D = (4, 1, 5)$,
 $E = (4, 7, 1)$,
 $F = (4, 7, 5)$,
 $G = (1, 7, 1)$,
 $H = (__, __, __)$.

 (b) $A = (1, 2, 3)$,
 $B = (2, 3, 4)$,
 $C = (__, __, __)$,
 $D = (__, __, __)$,
 $E = (__, __, __)$,
 $F = (__, __, __)$,
 $G = (__, __, __)$,
 $H = (__, __, __)$.

 (c) $A = (1, 1, 1)$,
 $B = (3, 4, 5)$,
 $C = (__, __, __)$,
 $D = (__, __, __)$,
 $E = (__, __, __)$,
 $F = (__, __, __)$,
 $G = (__, __, __)$,
 $H = (__, __, __)$.

 (d) Which of the boxes in Parts (a), (b), and (c) is a cube? How big is it?

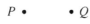

P • • Q

R • • S

T • • U

Figure 1.12.

3. This exercise involves drawing sequences of straight line segments without lifting your pencil.

(a) Without lifting your pencil, connect the dots in Figure 1.12 in the following order: $QPRSRTU$. That is, go from Q to P, from P to R, from R to S, from S back to R, etc. Notice that some vertices (dots) get visited more than once, and some edges (such as RS) get drawn more than once. What letter did you draw?

(b) Referring to Figure 1.12, write down a sequence of vertices that draws the letter H. If your straight line path takes you through a vertex, then list it. For example, don't write PT, write PRT instead.

(c) On the left of Figure 1.13 is a simple drawing of a house, and on the right are the vertices of the drawing. List the vertices in an order that duplicates the drawing. Can you do it so that only one edge is drawn twice?

(d) Refer to the box in Problem 2(a). List the vertices of the box (with occasional repetitions) in an order so that if we connect the dots in the same order, we trace every edge of the box at least once. Your path should stay on the edges and not cut diagonally from one corner to another.

Figure 1.13.

SHERRY STONE is a lecturer in Foundation Studies at Herron School of Art and Design, IUPUI, with a special interest in teaching first-year art students. Degreed in printmaking, she has become a painter and printmaker who has exhibited in the Midwest and on both coasts. She writes on the topic of the education of artists—and anything else that strikes a whim—and if she hadn't decided to study art, she says she would have become either a writer or a very bad ballet dancer.

I F YOU WERE TO ASK my freshman art students what they liked to draw when they were younger, many of them would answer Manga comics. They aren't very different from many other generations of young artists who started off by copying comics. The first comic I tried to copy was "Nancy." The drawings were simple and I was really fascinated with her hair; it looked like a helmet with spikes sticking out of it! When I was older, I liked to copy Wonder Woman, who was a much better role model—if a comic book character can be a role model—and I enjoyed her connection to mythology.

My father was a draftsman: the old-fashioned kind, one of those guys who learned to draw with rulers and mechanical instruments like compasses and protractors, not CADs and computers. My first drawing utensils were his turquoise 2H pencils. That's "h" for "hard," which means they could make the sharp, light, accurate lines that draftsmen needed for architectural drawings. I learned not to like them very well. The marks they made were too light no matter how hard you pressed and they had no erasers on the ends.

When I was growing up, he worked for a company that constructed water towers like the ones you see from the interstate that announce

"My father was a draftsman: the old-fashioned kind, one of those guys who learned to draw with rulers and mechanical instruments like compasses and protractors, not CADs and computers."

the presence of small towns like "Sellersburg" or "Speed" to everyone passing by. Sometimes his company built water towers shaped as unusual objects like ketchup bottles or Dixie cups. They acted as signposts for companies that were so big that they needed their own water tower. I thought those towers were very cool. That was before Claus Oldenberg began making his monumental Pop Art sculptures of everyday objects like baseball bats. Years later, after my dad left, the company built the giant baseball bat that leans against the front wall of the Louisville Slugger company. It's interesting to consider how an object is regarded as art in one context and not in another.

When I was in sixth grade, my dad started moonlighting as a draftsman for the developer who was building houses in our subdivision. That was the year I almost decided to become an architect rather than an artist. I learned linear perspective and I used it to design dozens of dream homes. My interest in being an architect eventually waned: my heart was set on being an artist, and my interests were too broad to be limited to houses. I have a long history of writing poetry and stories and making drawings and paintings. I love to read. Art is a great profession for someone who has a lot of interests. It's an area where the entire realm of your experiences can come together. That is why artists really need to be well educated. It's hard to make art when you have nothing to say.

"Art is a great profession for someone who has a lot of interests. It's an area where the entire realm of your experiences can come together. That is why artists really need to be well educated. It's hard to make art when you have nothing to say."

My interest in architecture was, however, a valuable detour. I learned linear perspective at a time when many kids decide they can't draw. Upper elementary school children want their drawings to look realistic. They are embarrassed by drawings that look childish because they are growing up and they want their drawings to look as mature as they feel. Linear perspective was one tool I could use to make my drawings look like reality.

Consequently, linear perspective has never been much of a mystery to me. Today, I teach linear perspective to wary students in first-year drawing courses. Some really enjoy it and take to it very quickly, while others treat it like a bad math test. That saddens me because it is so useful in understanding the three-dimensional nature of objects you are drawing, even when you are not specifically using it. Art students are an interesting lot, though. Some are little Da Vincis, very analytical and seem more like scientists and philosophers. Many, though, are intuitive souls and are content to feel their way through problems and don't take well to the structure and rules of perspective.

I find that very puzzling. I once taught a drawing workshop for 8- to 10-year-olds in which the coordinator had written perspective into the course description. I had great reservations about it. I decided to teach it by playing a game of "Follow the Leader": they were to draw what I drew, line for line, and guess what we were drawing. They were very excited and followed me perfectly as we

drew a house in two-point perspective with inclined planes, auxiliary vanishing points, and doors and windows centered on the walls. And they happily duplicated it with very little help from me! I think about that every time I am faced with an impossibly confused college art student.

My artwork now has very little to do with linear perspective, but I am always aware of it, even if I am drawing from the human form. Any form that can be simplified into a configuration of geometric shapes can be drawn in linear perspective. By considering the body as a series of boxes and cylinders situated on a plane, it is easier to draw the human form as though it is part of a space.

In my recent work, I have utilized photography and computer programs like Photoshop to do preparatory work for my paintings. I have found the distortions of planes and lines caused by viewing the subject through a lens to be very interesting and sometimes quite a departure from the invented environments one would create with linear perspective—although I have been known to purposely distort the rules of perspective for expressive reasons.

Like perspective environments, photography captures environments that appear very real, yet they both walk a line between illusion of reality and abstraction. They both are two-dimensional, striving to create an illusion of three dimensions, but if artists aren't aware of the inherent limitations of the individual processes, they can create very strange illusions. Some artists find this aspect intriguing and freely manipulate these conventions for their own purposes.

For example, the Photorealist painters of the sixties were very interested in the effect of photography on painting. Richard Estes painted many images of store windows. If you were actually standing in front of one of the stores he painted, you would be able to see the merchandise inside because of our eyes' ability to focus on various planes of space and to ignore some visual information in favor of other information. Estes, however, painted the store window as the camera saw it, with many reflections dancing across the glass and very little of the merchandise visible. Even though painters had been using photographs as resource material since the advent of photography, most artists painted from them as though they were working from life, and often would not admit they had used a photograph. Painting an image as the camera saw it—and not only admitting it but also making the work about it—was new.

One question I face is how far removed from the original subject I can progress while still maintaining the essence of the original. Through how many material, developmental, and aesthetic filters can an image pass and still be considered a documentary work? The truth is that there is no truly objective work, no matter whether it's art or journalism or law or management or anything else, because

"My artwork now has very little to do with linear perspective, but I am always aware of it, even if I am drawing from the human form."

Sherry Stone
Vampires, 2001
acrylic on canvas 11 × 17 in.

everything we do is colored by our experiences and our own points of view. Influences such as education, upbringing, societal attitudes, for example, go into effect even as a person anticipates beginning the project.

I suppose decision making is really at the core of most aspects of my work. The subjects of my work are young women and girls at a time in their lives when they are making decisions that will affect their destinies. The work, in essence, is about portraiture, but I would rather consider it to be about capturing a moment in time in these young people's lives. Art is a process-oriented activity at its best, but I am constantly questioning how far I should go in processing the image, given the immediacy of the content of my work. I do not consider myself a photographer, yet maybe the photograph is the most appropriate final form? Once I photograph, process the image in the computer, make rough sketches, and paint the image, I have to ask myself whether I am taking the image too far from its source.

In answer to that, I often leave the image as an ink-jet print, but still, unable to resist tinkering, I can be found painting on them occasionally. My answer, for now, is that my objective in photographing is to capture information, not create a finished piece of photography. The process of creating something beyond the photograph is more important for now.

"The subjects of my work are young women and girls at a time in their lives when they are making decisions that will affect their destinies."

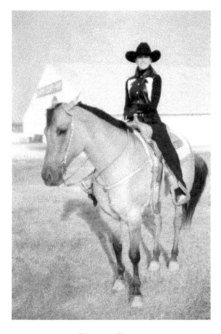

Sherry Stone
Western Rider, 2002
ink-jet print 8 × 12 in.

▣ For more of the artist's work, see the Plates section.

CHAPTER 2

Perspective by the Numbers

I N THIS CHAPTER we'll do our first perspective drawings, using nothing but mathematics! In Figure 2.1 is our basic perspective setup. A viewer's eye is located at the point $E(0, 0, -d)$. Out in the real world is an object, represented by a vase. As light rays from points on the object (such as the point $P(x, y, z)$) travel in straight lines to the viewer's eye, they pierce the picture plane, and we imagine them leaving behind appropriately colored dots, such as the point $P'(x', y', 0)$. (How do we know the z-coordinate must be 0?) The collection of the points P' comprise the perspective **image** (the perspective drawing) of the object.

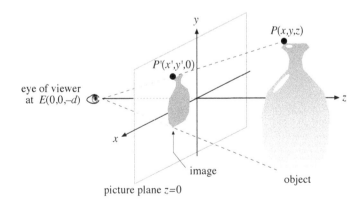

Figure 2.1. The basic perspective setup.

Our job is to figure out the coordinates of P', given a point P on a real object. Since we already know that the z-coordinate of any such point P' is 0, this boils down to finding x' and y'. To do this, we use Figure 2.2.

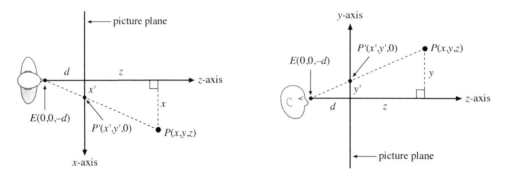

Figure 2.2. Computing x' and y'.

In Figure 2.2 the viewer is represented by a person, rather than just an eye, so that we can tell the difference between the top view and the side view. (Technically, perspective drawing is intended for viewing by just one eye, but for the purpose of symmetry, the top view shows the viewer's head centered on the z-axis.) In both views, $P(x, y, z)$ is a point on some object, and $P'(x', y', 0)$ is the perspective image of P. In the top view we see a large right triangle. Even though P and P' may not lie in the xz-plane, we think of the triangle as lying in the xz-plane. One side of the big triangle is x units long, and another side is $z + d$ units long. Inside this triangle is a smaller right triangle, similar to the larger one. In the smaller triangle, the corresponding sides are x' units long and d units long, respectively. Since the triangles are similar, the ratios of these corresponding sides must be equal:

$$\frac{x'}{d} = \frac{x}{z + d}.$$

Multiplying both sides of this equation by d gives us the formula for computing x', namely,

$$x' = \frac{dx}{z + d}.$$

In the side view we have a similar setup. We think of the large right triangle as being in the yz-plane, even though P and P' may not be. You should convince yourself that an argument analogous to the one just given leads to the following formula for computing y':

$$y' = \frac{dy}{z + d}.$$

As we noted, the z-coordinate of P' is always 0, so we only need the coordinates x' and y' to locate a point in the picture plane. Thus, from the equations for x' and y' we have the following useful theorem.

> **Theorem 2.1: The Perspective Theorem.** Given a point
> $P(x, y, z)$ on an object, with $z > 0$, the coordinates x' and y' of
> its perspective image $P'(x', y', 0)$ are given by
>
> $$x' = \frac{dx}{z + d} \quad \text{and} \quad y' = \frac{dy}{z + d},$$
>
> where d is the distance from the viewer's eye at $E(0, 0, -d)$ to the
> picture plane $z = 0$.

The formulas in Theorem 2.1 may be simple, but much can be
done with them! For instance, movies that employ computer anima-
tion or computerized special effects make use of formulas similar to
those in Theorem 2.1. One spectacular example is the movie *Jurassic
Park* (see Figure 2.4 in the exercises). In many scenes, the dinosaurs
were essentially made of mathematical points in 3-space! People who
enjoyed the movie were delighted, thrilled, and terrified by the cor-
responding computer-generated image points rampaging across the
picture plane (the movie screen)!

Exercises for Chapter 2

1. The rectangle $ABCD$ in Figure 2.3 is parallel to the yz-plane, so that all of its x-coordinates are the same positive number. Draw the top view to visualize this. Also, the y-coordinates of A and B are the same. With the viewer located as shown, what can we say about the x-, y-, and z-coordinates of the image points A', B', C', and D'?

Figure 2.3.

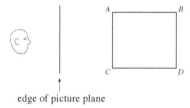

edge of picture plane

2. Think of the *Jurassic Park* image in Figure 2.4 as being painted on the picture plane, with the people and the *Velociraptor* existing in the same space. Let $P(x, y, z)$ be the lower left corner of the actual doorway, and let $Q(x, y, z)$ be the actual tip of one of the raptor's claws. The points P' and Q' are the respective images of these points. Which is bigger:

 (a) the x-coordinate of P, or the x-coordinate of Q?

 (b) the y-coordinate of P, or the y-coordinate of Q?

 (c) the z-coordinate of P, or the z-coordinate of Q?

 (d) the x'-coordinate of P', or the x'-coordinate of Q'?

 (e) the y'-coordinate of P', or the y'-coordinate of Q'?

Figure 2.4. Scene from the movie *Jurassic Park* (copyright Universal Studios). Two paleontologists, played by Laura Dern and Sam Neill, attempt to protect a child from a fierce *Velociraptor*. For the most part, the dinosaurs in the film were computer-generated mathematical perspective images. For the image to appear consistent, it must come from a virtual 3-D creature existing in the same space as the human characters.

3. This exercise deals with a point P whose x- and y-coordinates do not change (they are equal to 2 and 3, respectively), but whose z-coordinate gets bigger and bigger. That is, the point moves farther and farther away from the picture plane and the viewer. Assume that the viewing distance d is 5 units.

(a) Referring to Theorem 2.1, suppose $P = (2, 3, 5)$. What are the values of x' and y'?

(b) Now suppose $P = (2, 3, 95)$. What are x' and y'?

(c) Suppose $P = (2, 3, 995)$. What are x' and y'?

(d) Draw one TOP VIEW and one SIDE VIEW like those in Figure 2.2, and include all the points P and P' from Parts (a)–(c), along with light rays to the viewer's eye (the drawings need not be to scale). Can you see what's happening?

(e) Consider a point $P(x, y, z)$. If x and y do not change, but z gets bigger and bigger, what happens to the picture plane image P' of P?

(f) Our everyday experience tells us that objects appear smaller as they get farther away. Explain how this is consistent with your answers to Parts (a)–(e).

4. Our first perspective drawing will be of a box with its faces parallel to the coordinate planes, and a viewing distance of $d = 15$ units.

(a) If two corners of the box have coordinates $(-10, -6, 12)$ and $(-4, -2, 24)$, then: How wide is the box in the x-direction? How high is the box in the y-direction? How deep is the box in the z-direction? List the coordinates of the other 6 corners.

(b) Using Theorem 2.1, find the x' and y' coordinates of the images of all 8 corner points. Plot them in the xy-plane and connect the dots with straight lines to obtain the perspective image. Used dashed lines to indicate hidden edges. Your drawing should look something like Figure 2.5. (Note that all of the image points have *negative* coordinates.)

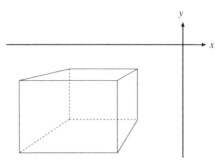

Figure 2.5. Your box should look
something like this.

5. In this more involved problem of drawing a house, we'll use a
computer to make the work easier. In Figure 2.6 is the perspec-
tive setup of a viewer, a house, and the picture plane. Since
the house is small in relation to the viewer, you can think of it
as a large dollhouse. You might also want to look at Figure 2.9
to help visualize the shape of the house.

TOP VIEW

Figure 2.6.

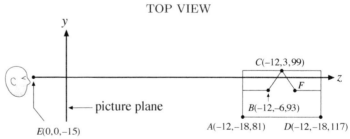

SIDE VIEW

(a) What are the coordinates of the point F? What are the
coordinates of the point G? If the measurements are in
inches, how high is the dollhouse?

(b) The rest of this problem assumes some familiarity with
Microsoft Excel, or some other spreadsheet program. In
the first 3 columns of the spreadsheets in Figure 2.7(a)
and (b) are the xyz-coordinates of all 17 vertices of the

house. In the 4th column is the viewing distance ($d = 15$ units). The 5th and 6th columns are for the x'-and y'-coordinates of the images of the points. To compute the first value of x' (Figure 2.7(a)), select cell E2. The relevant formula from Theorem 2.1 is $x' = dx/(z + d)$, but you should type =D2*A2/(C2+D2) as indicated, because d is in cell D2, x is in cell A2, etc. Then hit the return key. Similarly, to compute y' (Figure 2.7(b)) you should type =D2*B2/(C2+D2). Note in Figure 2.7(b) that the first value of x' should be -1.875. The other values of x' can be computed by selecting and copying cell E2 and pasting into the other cells in column E. Similarly, the other values of y' can be computed by selecting and copying cell F2 and pasting into the other cells in column F.

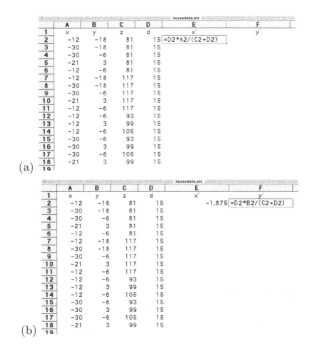

(a)

(b)

Figure 2.7. Applying Theorem 2.1 in a spreadsheet.

After this is done, the entries in columns E and F can be selected as a group, and a scatterplot can be made to display the images of the vertices. Alternatively, the points can be plotted by hand on graph paper. The result should look something like Figure 2.8. Finally, you can print out your result and use a pencil to connect the vertices correctly. This will take some thought! Then you can color and shade your drawing if you like. The result should look something like Figure 2.9.

Figure 2.8. Scatterplot (vertices of
the house).

Figure 2.9. Connect the dots and
color to your taste!

6. The house in Figure 2.9 is a bit featureless, so your job in this
problem is to add to the x, y, and z columns of your Excel
spreadsheet the correct 3-space coordinates for the vertices of
the following items:

(a) two or more windows on the near wall;

(b) a door on the right-hand wall, centered under the dormer;

(c) a small, rectangular yard for the house;

(d) a chimney somewhere on the roof, at least partially visible
to the viewer. *The bottom vertices of the chimney should
lie on the roof, not above or below it.*

To complete the exercise, compute the new x' and y' values,
and draw and "paint" the picture of the house as you did in
Problem 5, with the new details included.

Practice Quiz for Chapter 2

This quiz refers to a rectangular box in space with its faces parallel to the coordinate planes of the xyz-coordinate system we use for perspective.

1. The box has eight corner points, three of which are listed below. If the viewer is located at $E(0, 0, -6)$ (viewing distance of 6), write down the space coordinates of the other corners of the box, and the corresponding picture plane coordinates of the perspective images of those points.

Space coordinates of corners	Picture plane coordinates
$(-4, -2, 6)$	$x' = \underline{\hspace{1cm}}$, $y' = \underline{\hspace{1cm}}$, $z = 0$
$(-4, -2, 3)$	$x' = \underline{\hspace{1cm}}$, $y' = \underline{\hspace{1cm}}$, $z = 0$
$(-6, -4, 3)$	$x' = \underline{\hspace{1cm}}$, $y' = \underline{\hspace{1cm}}$, $z = 0$
$(\ ,\ ,\)$	$x' = \underline{\hspace{1cm}}$, $y' = \underline{\hspace{1cm}}$, $z = 0$
$(\ ,\ ,\)$	$x' = \underline{\hspace{1cm}}$, $y' = \underline{\hspace{1cm}}$, $z = 0$
$(\ ,\ ,\)$	$x' = \underline{\hspace{1cm}}$, $y' = \underline{\hspace{1cm}}$, $z = 0$
$(\ ,\ ,\)$	$x' = \underline{\hspace{1cm}}$, $y' = \underline{\hspace{1cm}}$, $z = 0$
$(\ ,\ ,\)$	$x' = \underline{\hspace{1cm}}$, $y' = \underline{\hspace{1cm}}$, $z = 0$

Practice Quiz for Chapter 2 (continued)

2. The box casts a shadow onto the horizontal plane $y = -5$ (all y-coordinates are -5 in this plane). Assume that the shadow is cast by parallel vertical light rays, like the sun overhead at noon. Write down the space coordinates of the 4 corners of the shadow, and then write down the picture plane coordinates of their perspective images (same viewer location as in Problem 1).

Space coordinates of shadow corners Picture plane coordinates

(, ,) $x' =$ ———— , $y' =$ ———— , $z = 0$

(, ,) $x' =$ ———— , $y' =$ ———— , $z = 0$

(, ,) $x' =$ ———— , $y' =$ ———— , $z = 0$

(, ,) $x' =$ ———— , $y' =$ ———— , $z = 0$

Practice Quiz for Chapter 2 (continued)

3. Draw the perspective image of the box and its shadow in pencil on the grid below, and shade in the shadow. The shadow should be partially hidden by the box—make sure you draw it that way! (You can also shade or color the box if you like.)

Artist Vignette: Peter Galante

PETER GALANTE is an Associate Professor of Art and University Creative Director at Cardinal Stritch University in Milwaukee, Wisconsin. Primarily responsible for the Graphic Design program, he also teaches undergraduate and graduate Digital Imaging. In his role as Creative Director, Peter supervises the Advanced Design Group, an in-house design practicum where students, as part of their academic course work, design and produce most of the university's marketing and communication materials. Balancing the responsibility of two full-time roles makes the time he spends on his current passion of filmmaking all the more precious. (Photograph by Peter Galante)

IN MY MIND I am a printmaker first and a photographer second—even though the majority of my work is photographic. This is because I approach image making, in the camera or on a zinc etching plate, with the same interest in geometry and formal composition that began in Renaissance printmaking.

My earliest memories are of television, of a large mahogany veneer set with its horizontally ovoid picture. The images I recall are not of the children's programs of the fifties, but the film noir genre movies of the forties that dominated WPIX's weekend schedule. Dark, empty streets with a hardened, solitary detective struggling to correct some injustice. The image is very clear to me, but by the time the filmed original was reproduced by our television, it was reduced to a fuzzy, high-contrast abstraction. The highlights became a green-white glow, and the shadows became murky and indiscriminate. This effect—a consequence of early television's technical limitations—heightened the sense of drama as it allowed a willful suspension of reality.

Throughout this decade when, as a child, I was forming my impression of the world, camera images began to dominate the world's access to visual media. Thereafter, the camera's inherent abstrac-

". . . I approach image making, in the camera or on a zinc etching plate, with the same interest in geometry and formal composition that began in Renaissance printmaking."

tion was understood to be faithful duplication of "reality" and was therefore perceived as "the" truth. Therein, mechanical rather than interpretive means gave us the look of things and, more important, our outlook on them.

It must be some law of nature that existentialists are to be reared in urban environments. Existentialism is a philosophical theory that emphasizes the existence of the individual person as a free and responsible agent determining his or her own development through acts of the will. It seems somewhat ironic that this approach—an approach that tends to be atheistic, disparages scientific knowledge, and denies the existence of objective values—would provide the foundation of my work, as I am a deeply spiritual person trained in both the arts and natural sciences. I suppose it is the obvious disconnection from the earth in the cities' concrete canyons that emphasizes existential alienation. In places like New York, where I grew up, distinctions of nature are blurred: it is always night in the subway, and it is always day in the streets, under the glare of unnatural light, even if the sun is shining.

Peter Galante
Waterfront Wall, Brooklyn, NY, 1986
Transmedia, 35 mm film original,
1994

"Emerson, an unlikely existentialist, said correctly, 'Every wall is a door.' Walls define our existence, and so I look for the door and the way out in my personal walls."

To reduce the city to a fundamental unit, I would say that the city is made entirely of walls. I'm sure this contradicts the majority opinion that the city is made of people, but I just don't "see" them. I only see the walls and how the city's unique light plays on them. Emerson, an unlikely existentialist, said correctly, "Every wall is a door." Walls define our existence, and so I look for the door and the way out in my personal walls.

For me, the walls reference a time before the camera's influence, and it is for these reasons that I use the camera itself to search for

fundamental meanings and human equivalents. I do this even though the camera is the very instrument that induced an altered perception of society. It is necessary for me to work with our culture's primary visual medium in order to understand its power over the traditions it consumed.

Peter Galante
Warehouse, Brooklyn, NY, 1986
Transmedia, 35 mm film original, 1994

Traditionally, art has used material means (canvas, oil, stone) to gain spiritual ends. The traditions of Renaissance printmaking provide a conceptual foundation, without which my use of the camera image would be as empty as the pervasive media images. Society nostalgically accepts the mechanical photographic likeness in the family picture album, but I do not accept the camera's view, de facto, as truth. Nor do I attempt to manipulate the image in a surrealist or Dada fashion simply to create shocking juxtapositions or anti-art sentiments. My work began simply and directly with traditional printmaking techniques to heighten visual and emotional impact, and today has become entirely digital: I am moving into the emerging genre of high-definition video. Throughout this transition I have attempted to strike a balance between the unsettling impact of technology and the stability inherent in the spiritual dimensions of tradition. For me, neither the camera nor the processes of printmaking are reproductive techniques, but, rather, are investigative tools with almost mythic significance. For all the technology in the world, there is nothing quite like the printmaker's experience—the odors and effort of mixing bone, vine, and burnt oil in handmade ink—to awaken the mythic sense of tradition.

"For me, neither the camera nor the processes of printmaking are reproductive techniques, but, rather, are investigative tools with almost mythic significance."

Peter Galante
Cabin, Belleayre, NY, 1983
Transmedia, 35 mm film original,
1994

Peter Galante
Cabin, Belleayre, NY, 1983
Transmedia, 35 mm film original,
1994

I have been rephotographing photographs as part of still lifes for as long as I can remember; some of my first published examples appeared in *Vogue* in 1979. In my current film projects, the concept of using animated stills is as much practical as aesthetic. The techniques that I have been utilizing in both my still and motion picture work frequently elicit comparison with the work of Ken Burns. He is a contemporary of mine (we were both born the same year); since I am a teacher and probably also out of professional pride, I would suggest that we likely had the same or similar influences. The "Ken Burns" effect—as it has become widely known in the United States since his 1990 Civil War documentary—may well have its conceptual roots in the work of French filmmaker Chris Marker and his legendary apocalyptic 1962–4 film *La Jetée*. I have never heard Mr. Burns speak of his influences, but for me living and working in New York in the late '70s, the Museum of Modern Art brought me into contact with László Moholy-Nagy and avant-garde filmmaking. These influences (along with others like Harry Callahan, Aaron Siskind, and Richard Avedon) have become such a part of my subconscious that I am unaware of their constant presence. This is also true of my fascination with the geometry underlying the formal composition of the picture plane. It is not possible for me to compose an image without intuitively imposing some structural framework or grid. I do not suppose that the casual viewer will become aware of my somewhat rigid organizational structure, but I cannot even imagine working without one. For me, geometry has become the glue that keeps an existential universe from flying apart.

For nearly the past ten years the focus of my creative work has been on meeting the needs of the university. The nature of a private Catholic university keeps recruiting and advancement requirements in the forefront. Hence, my work centers on telling the story of the Franciscan Intellectual Tradition. As a consequence little of my work has been exhibited in gallery settings, though all of it has been published and distributed widely. I have never felt limited or encumbered by these circumstances; conversely, I have felt quite empowered, as if I were following in the footsteps of Cimabue and Giotto, whose renowned fresco paintings document the life of St. Francis of Assisi. It has been an honor and a privilege to immerse myself in such a rich tradition and to translate my understanding of the tradition for today's postmodern, if not existential, world.

◙ For more of the artist's work, see the Plates section.

CHAPTER 3

Vanishing Points and Viewpoints

Y OU'VE PROBABLY HEARD THE TERM "vanishing point" before, and we mentioned it in Chapter 1 when we discussed the masking tape drawing of a library (see Figure 3.1).

Figure 3.1. Masking tape drawing of a library (above) and the vanishing points of the drawing (below).

In the drawing on the bottom of Figure 3.1 are two vanishing points V_1 and V_2. The three lines which converge to V_1, for example, represent lines in the real world (architectural lines of the building) that are actually parallel to one another. Clearly, however, the *images* of these lines are *not* parallel, because they intersect. The reason

we say "vanishing point" instead of "intersection point" is that a single line, all by itself, can have a vanishing point; the explanation is illustrated in Figure 3.2.

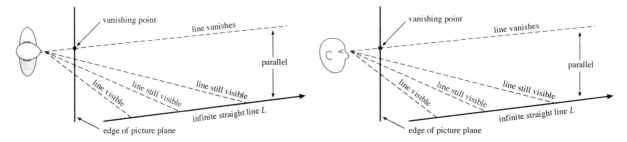

Figure 3.2. The vanishing point is where the line appears to vanish.

In Figure 3.2 a viewer looks along various lines of sight (dashed lines) at a line L in the real world. The viewer looks at farther and farther points on the line, and keeps seeing the line as long as his line of sight intersects it (imagine looking through a thin soda straw). At a certain moment, however, the line of sight becomes exactly parallel to L and no longer intersects it. That's the precise moment at which the line L seems to vanish (when looking through a soda straw), simply because the viewer isn't looking at it anymore. For this reason, the intersection of this special line of sight with the picture plane is called the **vanishing point** of the line L. A vanishing point always lies in the picture plane: its height is determined by the side view in Figure 3.2, and its right-left location is determined by the top view. Notice that the special line of sight parallel to L would also be parallel to any *other* line M that was also parallel to L; that is, if any line is parallel to L, then it has the same vanishing point as L.

To state these results in a theorem, recall that a line is parallel to a plane if it does not intersect the plane. Clearly the line L in Figure 3.2 is *not* parallel to the picture plane. Thus we have

> **Theorem 3.1: The Vanishing Point Theorem.** If two or more lines in the real world are parallel to one another, but not parallel to the picture plane, then they have the same vanishing point. The perspective *images* of these lines will *not* be parallel. If fully extended in a drawing, the image lines will intersect at the vanishing point.

Notice that the photograph in Figure 3.3 has one obvious vanishing point. It would seem reasonable to call this "one-point perspective," but there is usually one more requirement before this term is

used. We often use the term when rendering rectangular box shapes such as buildings, and we will assume one face of this box is parallel to the picture plane. (In Figure 3.3, notice that the images of the vertical beams and the horizontal crossbars on the roof are likewise vertical and horizontal.) If one face of the box is parallel to the picture plane, then the line L is orthogonal (perpendicular) to the picture plane as in Figure 3.4. Thus the special line of sight parallel to L (the sight line which goes through the vanishing point) is also orthogonal to the picture plane. This means that the correct location for the viewer's eye is directly in front of the vanishing point, and this is the situation which is usually referred to as one-point perspective.

Figure 3.3. Notice in this picture how the long beams of the ceiling, which are parallel in the real world, have images that almost touch at the vanishing point. This is a World War II photograph of Henry Ford's Willow Run bomber plant near Ypsilanti, Michigan. Over half a mile long, the plant was the largest factory in the world under a single roof when it was completed in 1941.

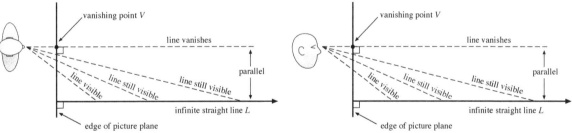

Figure 3.4. In one-point perspective, the only lines with vanishing points are those orthogonal to the picture plane.

We will say that a perspective drawing is in **one-point perspective** if (a) there is only one vanishing point V to which lines that are part of the drawing converge, and (b) those image lines that converge to V represent lines in the real world that are orthogonal to the picture plane.

It's often possible to tell by looking that a drawing is in true one-point perspective. In this case it may be easy to find the exact viewing

position for the viewer's eye. One such example is the drawing of a rectangular box in Figure 3.5.

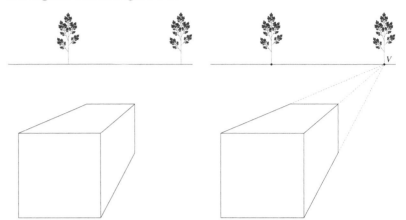

Figure 3.5. A box in one-point perspective.

First, let's see how we can tell that Figure 3.5 exhibits true one-point perspective. Clearly there is one vanishing point V (conveniently located at the base of a tree), but we must also verify that the image lines (dashed) which converge to V represent lines in the real world (the edges of the real box) which are orthogonal to the picture plane (the plane of the page). This will be true if the front face of the box is *parallel* to the picture plane. But this must be the case, because the image lines of the edges of the front face *appear* to be parallel; if the front face of the actual box were not parallel to the picture plane, then at least one opposing pair of its edges would not be parallel to the picture plane, and by Theorem 3.1, their images in the drawing would converge to a vanishing point. In other words, since the front face of the box appears undistorted, the drawing is in true one-point perspective.

It therefore follows that the correct viewing position is somewhere directly opposite the vanishing point V—but how far from the page? To determine that, we need the top view of the perspective setup for the box (see Figure 3.6).

In Figure 3.6 we see the vanishing point V for the edges of the box that are orthogonal to the picture plane, and we also see the vanishing point V' for the diagonal of the top face of the box. Since the indicated pairs of lines are parallel, the two shaded triangles are similar. Thus the ratios of corresponding sides are equal:

$$\frac{d}{a} = \frac{D}{A}.$$

We can easily solve for the viewing distance d to get

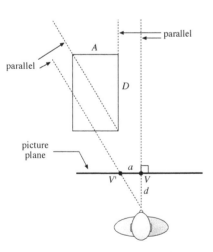

Figure 3.6. The shaded triangles are similar.

$$d = a\left(\frac{D}{A}\right). \tag{3.1}$$

Obviously we need more information to find d, but often this can be gleaned from the context of the artwork. Suppose, for instance, we know that the box in Figure 3.5 is a *cube*. This may seem strange, because the box doesn't look like a cube—it looks too elongated (more like a dumpster), but the picture will look better when we determine d. If the box is a cube, then the top is a square (even though it wasn't drawn as a square in Figure 3.6), and A and D in Figure 3.6 must be equal. In this case, $(D/A) = 1$, so by Equation (3.1) we have $d = a$.

But a is the distance between V and V', so the viewing distance for a cube is the same as the distance between the main vanishing point V and the vanishing point V' of the diagonal of the top face (see Figure 3.7). This distance can be measured directly on the drawing!

In the drawing (Figure 3.7) we locate V' (base of the other tree) by drawing the dashed diagonal line of the top face of the box. How do we know that V' is on the same horizontal line as V? Because the dashed lines are images of real lines which are level with the ground, so the sight lines of the viewer to their vanishing points must be level also.

To test out our determination of d, use the large drawing in Figure 3.8 as follows:

- Close your right eye.

- Hold the page vertically and place your left eye directly in front of the point V (*not* in the center of the page!).

- Move the page until your left eye is d units away from V. (You may want to use a thumb and forefinger to measure the distance between the trees.)

- Without changing your position, let your eye roll down and to the left to look at the box. Although it may be a bit close for comfortable viewing, it should look much more like a cube!

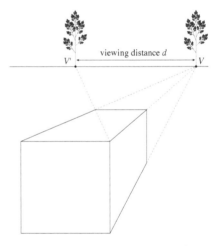

Figure 3.7. The viewing distance for a cube.

viewing distance d

V

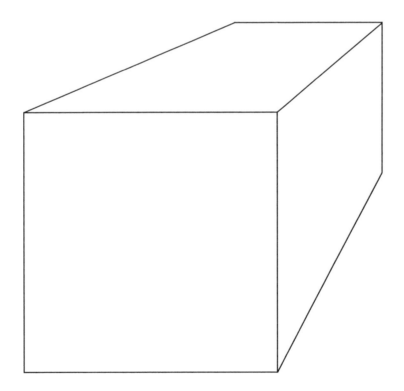

Figure 3.8. To see a cube, look with one eye, directly opposite V, at the indicated distance d.

We have only used a little mathematics, but we have accomplished a lot. For one thing, we see the importance of the unique, correct perspective viewpoint (sometimes called the "station point"). If we view art from the wrong viewpoint, it can appear distorted—a cube can look like a dumpster. For another thing, the majority of perspective works in museums are done in one-point perspective, with clues that can help determine the viewing distance. Thus our simple trick can actually be used in viewing and enjoying many paintings in museums and galleries. In Figure 3.9 we see the trick applied to finding the viewpoint for the painting, *Interior of Antwerp Cathedral*. Since the floor tiles are squares, they serve the same purpose as the square top of the cube in the previous discussion. The viewing distance is as indicated, with the correct viewpoint directly in front of the main vanishing point V.

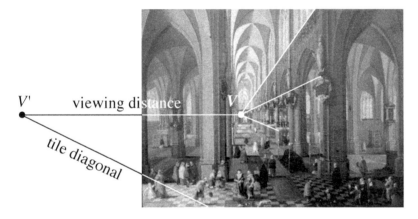

Figure 3.9. Peter Neeffs the Elder, *Interior of Antwerp Cathedral*, 1651. (Courtesy of the Indianapolis Museum of Art.)

Although it's not possible to tell by viewing this small reproduction of *Antwerp Cathedral*, the effect of viewing the actual painting in the Indianapolis Museum of Art gives a surprising sensation of depth, of being "in" the cathedral. The viewing distance is only about 24 inches, so most viewers never view the painting from the best spot for the sensation of depth!

Of course you can't draw lines on the paintings and walls of an art museum, so some other method is needed to find the main vanishing point and the viewing distance. A good solution is to hold up a pair of wooden shish kebab skewers, aligning them with lines in the painting to find the location of their intersection points. First, the main vanishing point V is located. Then one skewer is held horizontally so that it appears to go through V, and the other is held aligned with one of the diagonals of the square tiles; the intersection point of the skewers is then V'. Figure 3.10 shows workshop participants at the Indianapolis Museum of Art using their skewers to determine the viewpoint of a perspective painting. Then, one by one, the viewers

assume the correct viewpoint, looking with one eye to enjoy the full perspective effect. If shish kebab skewers aren't practical, any pair of straight edges, such as the edges of credit cards, will work almost as well for discovering viewpoints of perspective works.

Figure 3.10. Viewing art with shish kebab skewers at the Indianapolis Museum of Art.

Certainly there are other important ways to view a painting. It's good to get very close to examine brushwork, glazes, and fine details. It's also good to get far away to see how the artist arranged colors, balanced lights and darks, etc. Our viewpoint-finding techniques add one more way to appreciate, understand, and enjoy many wonderful works of art.

Exercises for Chapter 3

1. (Drawing your own cube.) In Figure 3.11 a start has been made on the drawing of a cube in one-point perspective. The front face is a square, V is the vanishing point, and the dashed lines are guide lines for drawing receding edges of the cube. Suppose you want to choose the viewing distance *first*. Let's say the viewing distance should be 7 inches. Finish the drawing of the cube. (HINT: For help in thinking about it, look at Figure 3.7. The idea is to draw the same lines, but in a different order!)

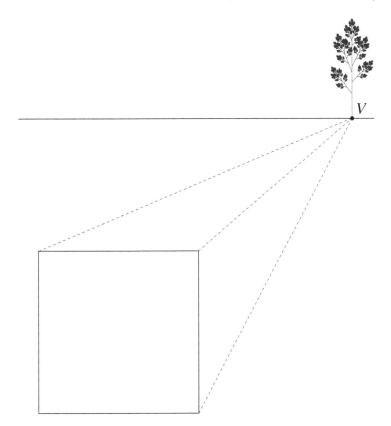

V

Figure 3.11. How do you finish the cube if the viewing distance is 7 inches?

2. Suppose the box in Figure 3.12 is *not* a cube. Let's say its front face is a square, but its top face is in reality twice as long as it is wide from left to right. In this case, the viewing distance is *not* equal to the distance between the two trees. What is the viewing distance? (Figure 3.6 can help you think about this problem.) What if the top is *three* times as long as it is wide from left to right?

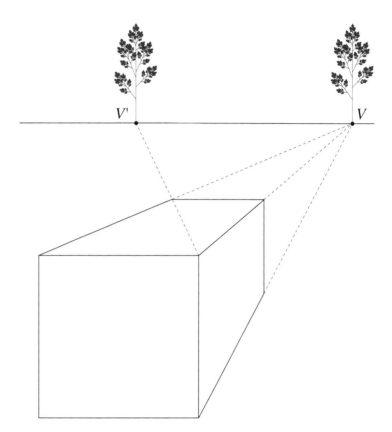

Figure 3.12. What if the box is *not* a cube?

3. Now do the real thing: go to a gallery or museum and practice your viewing techniques!

4. Top views, side views, and similar triangles are very useful for finding viewpoints, setting up drawings, and generally understanding what we see in pictures. For example, we often see photographs of the moon shot with telephoto lenses to make the moon seem dramatically large. However, when we see the moon in ordinary photographs, it appears quite small. To see why, suppose you want to make a drawing of the full moon rising over the ocean, with a viewing distance of two feet. What should the diameter of your moon image be? (You'll need to do a little astronomical research.)

5. Take a drawing pad and go outside to sketch a street, alleyway, or walkway, using one or more vanishing points to help make your drawing look realistic.

JIM ROSE is a professional illustrator, graphic designer, and videographer using both digital and hands-on techniques; he also teaches at Clarion University of Pennsylvania and is a student of the creative process.

He holds a Master of Fine Arts in Illustration from Syracuse University. In Philadelphia he graduated from the Pennsylvania Academy of the Fine Arts and studied with Evangelos Frudakis for anatomy. At the Cape Art School in Provincetown, Massachusetts, he studied color with Henry Hensche. His biggest influence was his mentor, Porter Groff. (Photograph by Jim Rose)

I GREW UP in inner-city Philadelphia, you know the place; it's where they filmed *Rocky*. As a matter of fact, my grandmother lived three blocks from the pet store that Adrian worked in.

My father was a welder, paratrooper, and a kind and gentle man. My mother was a homemaker and gave me a wonderful childhood. Mom always told me that I could do anything I set my mind to do; I actually believed her. We didn't know any artists and there wasn't much talk about fine arts in our home, which was on a small street nestled among giant, red-brick factories. There were a number of trees in the library park, which most people used while walking their dogs. It was years before I realized that air didn't smell like mints (there was a mint factory on the next block).

I loved to draw pictures, so Mom suggested that I go to Sears and Roebuck, which was a bus ride away, to apply for an artist's job. I did this with great expectations.

The advertising director said, "We have one artist that does all the illustration for Sears on the East Coast. Go to the second floor and ask for Porter Groff."

"We didn't know any artists and there wasn't much talk about fine arts in our home, which was on a small street nestled among giant, red-brick factories."

"[Porter Groff] was my Mentor in Art and many other things. He was quiet, elegant, kind, artistic, and humble. He taught me some of these traits, but not all."

Jim Rose
Agent Orange, 2005
Digital

I entered a small cubicle where a quiet man, dressed formally with a starched white shirt and tie, sat working on ink wash drawings of washing machines, fashions, and toys. He did fine renderings of just about everything that Sears sold except guns. He refused to draw anything to do with the military.

I introduced myself, telling him why I was there. He looked over his glasses and welcomed me in with a smile. He looked at each sample of my work intently. I was sure I had the job. He looked at me and said, "This is what I do," handing me a beautiful rendering of a living room suite done in pen and ink. I stood there disappointed and feeling a bit foolish, knowing that my work was not up to par. I said, "I'll be back." He sensed my embarrassment and offered to give me lessons. He was the first artist I ever met. He was also the first conscientious objector, farmer, woodworker, Quaker, and intellectual I ever met.

After many years of visiting Porter once a week in his studio in Cheltenham, Pennsylvania, where there were many trees, I became a layout man for the *Philadelphia Bulletin* and Sears. He was my Mentor in Art and many other things. He was quiet, elegant, kind, artistic, and humble. He taught me some of these traits, but not all. One evening I asked Porter, "How do I know if I'm a conscientious objector?"

He said, "You're a conscientious objector if you have a gun and the man across from you has a gun and you let him shoot you."

From the time that I met Porter Groff, drawing, painting, and design have always been part of my life. As a matter of fact, drawing has saved my life more than once. One instance was when I was in Vietnam as an illustrator for the army, trying to find out if I was a conscientious objector. I found that I was not, but that's another story.

I entered one of the many cul-de-sacs found in Saigon, Vietnam, where I lived. The afternoon was warm and humid, and the dust powdered around my boots. At the community fountain/bathtub that sat in the middle of the fortlike houses glazed with barbed wire, I turned right toward my door.

I drew pictures for the residents, whose families lacked men of military service age. I drew the young children's dreams: horses, cowboys, circus animals, anything that they wished. On occasion I was invited to dinner and enjoyed watching *The Wild Wild West* with the children, who thought all Americans knew karate from watching the show dubbed in Vietnamese. It was easy to convince them that I knew karate because they weighed about 25 pounds and I weighed 180. We played, we ate fish and rice, and drawing was my link to them.

One evening I retired to my enclave, listening to the soup man

banging his sticks and firefights off in the distance—far enough to make them a fantasy to me. I dozed off slowly, counting the small lizards scampering on the ceiling eating the bugs. I woke up abruptly.

Barrrrrrrrrrup! Someone had climbed the barbed wire enclosure, riddling the entire room next to mine with bullets. An American soldier and his girlfriend died instantly. He did not draw pictures and he was not kind and gentle. I moved the next day.

My job in the army was illustrating numbers. I worked directly under General Creighton Abrams, commander in chief of all U.S. forces in Vietnam. Officers would supply me with numbers of MIA and DOA and I would do the charts and graphs to be presented to various allies. These numbers rose constantly, so unfortunately I had job security. Each number represented a human.

When I was discharged I returned to Philadelphia with no job. I freelanced and decided to move out to the country. It was time for me to live with the trees and not breathe air that smelled like mints. I stayed in the suburbs for a few years doing photography and freelancing in graphic design. While I enjoyed doing advertising layout, I needed more. I wanted to learn what the "Fine" meant in Fine Arts, so I returned to school.

The Pennsylvania Academy of the Fine Arts is where I learned how to paint, draw, and think like an artist. I was still doing advertising design and illustration. Porter warned me of my presumption that I was an artist. He said, "You should not call yourself an artist; other people should." I spent three summers studying color at the Cape Art School under Henry Hensche because my mentor studied there.

After graduating from the academy I moved north, settling in Starrucca, Pennsylvania, where I freelanced in illustration and graphic design. I also made many new friends from all over the country. I did community theatre, got divorced, played Santa Claus for the Baptist church, earned a Master of Fine Arts degree from Syracuse University, walked through the woods, got remarried, had a son, and became the mayor. I loved Starrucca, where I lived among the trees as a trout stream lullabied me to sleep every night. It was a magical place.

It was there that I met my wife Linda. We were married behind our house at the base of a small mountain with all of our favorite people. A year later our son James was born. Needing more security, I found a job at Western Illinois University (where I taught graphic design and illustration, and helped create their new computer lab), requiring me to move to Macomb, Illinois. While in the Midwest I was very productive and we had our second son, John. I also created a series of paintings called *Genetic Signatures* having to do with meditation, family, and calligraphy. I had two one-man shows and

Jim Rose
Is It Really Over, 2000
Digital
(Photographs of Rose's children, father, and son)

"I did community theatre, got divorced, played Santa Claus for the Baptist church, earned a Master of Fine Arts degree from Syracuse University, walked through the woods, got remarried, had a son, and became the mayor."

then moved on to more digital projects.

After six years I left Illinois kicking and screaming because of disagreements with the dean and the faculty. A creative person must be a politician in the academic environment. I had not yet developed that skill. The following year I started at Clarion University of Pennsylvania, closer to our families and making more money, so I thank my colleagues at Western Illinois for pushing me forward.

At Clarion I met a man who lives on my avenue and grew up fifteen minutes away from where I was raised in Philadelphia. Dr. Steve Gendler is a mathematician, professor, day trader, and somewhat eccentric Jewish philosopher. Steve introduced me to the connection between art and mathematics. He coerced me to attend the workshops given by Annalisa Crannell and Marc Frantz, where I realized that I was doing math all along.

Dr. Gendler and I taught a cluster course called Art in Perspective, combining the mysteries of art and mathematics to create a clear understanding of how things work in the world. Steve and I presented reports on the course we taught at the Viewpoints conference at Franklin & Marshall College and the 2002 International Bridges Conference at Towson University. I recently presented and exhibited my work called *NAMAN Dream Altars, Vietnam: A Search for use of the Golden Mean and its Effect on Design and Content* at the 2005 International Bridges Conference in Banff, Alberta, Canada.

Recently, I have had a one-man show of watercolors at Michelle's Café in Clarion and exhibited my Vietnam Memory work in Clarion's faculty show and at the Bridges Conference in Banff, Canada. I have just received a grant to work on the design and production of an illustrated book of poems regarding my NAMAN Vietnam Memory Project. I am designing Web pages and working on a series of watercolors that hopefully will come from my inner self, inspired by my readings of Zen Buddhist philosophies.

I work in many different media: paint, Photoshop, pen and ink, mathematics. Oops—I would have never thought I would ever consider mathematics as a medium, but I do. The use of the golden section, fractals, perspective, and tessellations has expanded my vision. I feel closer to the great artists such as da Vinci, M.C. Escher, Raphael, and many more. In today's art world many artists have combined digital and hands-on media to create their art.

The realization that my paradigm was changing happened when I was in the woods painting a landscape—a break from the computer screen. I found myself thinking, "That color is 53% cyan, 10% magenta, 25% yellow and 12% black." A new day has begun and I'm going to give it 110%.

▣ For more of the artist's work, see the Plates section.

"I work in many different media: paint, Photoshop, pen and ink, mathematics. Oops—I would have never thought I would ever consider mathematics as a medium, but I do."

CHAPTER 4

Rectangles in One-Point Perspective

I N OUR PERSPECTIVE WORK with the house in Chapter 2, we saw
how the perspective transformation equations of Theorem 2.1
could be used to create a perspective drawing, by mathemati-
cally imitating what we did physically when we used masking tape
to draw buildings on the windows in Chapter 1. However, neither
of these techniques is useful to artists using traditional painting or
drawing media, so we need to come up with some more practical
techniques for perspective drawing. In this chapter we'll concentrate
on techniques for correctly subdividing and duplicating rectangles
in one-point perspective. This will enable you to draw a variety of
things in one-point perspective, and many of the techniques also work
for perspective with more than one vanishing point.

Although the techniques are based on mathematics, most people
find them easy and fun to use in practice, and sensible from a "com-
mon sense" point of view. (Nevertheless, even a small alteration can
change an easy problem into a more challenging one.)

Before presenting the techniques, we list the rules they are based
on.

Rule 1. The perspective image $P'Q'$ of a line segment PQ is also
a line segment (unless PQ is seen end-on by the viewer,
in which case the image is a point).

Rule 2. A line segment PQ that is parallel to the picture plane
(i.e., lies in a plane parallel to the picture plane) has a
perspective image $P'Q'$ that is parallel to PQ.

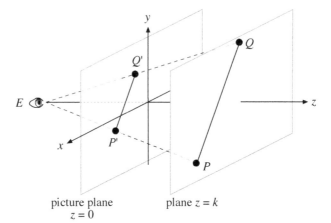

Figure 4.1. A line segment PQ and its image $P'Q'$.

The reasons for Rules 1 and 2 can be seen in Figure 4.1. First, observe that the triangle $\triangle EPQ$ lies in a plane, and the intersection of that plane with the picture plane is the line containing the segment $P'Q'$. Second, if PQ lies in a plane $z = k$ parallel to the picture plane, then the lines containing PQ and $P'Q'$ cannot intersect, and furthermore, these two lines are coplanar, since they lie in the plane containing $\triangle EPQ$. Since nonintersecting coplanar lines are parallel, this shows that PQ and $P'Q'$ are parallel.

Rule 3. If two line segments PQ and RS in the real world are parallel to each other and *also* parallel to the picture plane, then their perspective images $P'Q'$ and $R'S'$ are parallel to each other.

By Rule 2, PQ is parallel to its image $P'Q'$. Since PQ is also parallel to RS, it follows that $P'Q'$ is parallel to RS. But Rule 2 also says that RS is parallel to its image $R'S'$, so it follows that the two images $P'Q'$ and $R'S'$ are parallel to each other.

An illustration of Rule 3 can be seen in Figure 3.1 of Chapter 3. The vertical edges of the library building are parallel to one another, and *also* parallel to the picture plane (the window). Thus their images (the masking tape lines on the window) are all vertical, and parallel to one another.

Rule 4. If two or more lines in the real world are parallel to each other, but *not* parallel to the picture plane, then they have the same vanishing point. The perspective *images* of these lines will *not* be parallel. If fully extended in a drawing, the image lines will intersect at the vanishing point.

Rule 4 is just a restatement of Theorem 3.1 in Chapter 3. Rule 4 is also illustrated by Figure 3.1 of Chapter 3. Edges of the library

building that are parallel to one another in the real world, but *not* parallel to the picture plane, have images that converge to a common vanishing point.

Rule 5. A shape that lies entirely in a plane parallel to the picture plane has a perspective image that is an undistorted miniature of the original.

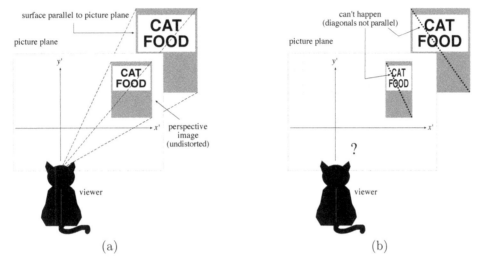

Figure 4.2. An illustration of Rule 5.

Rule 5 is illustrated in Figure 4.2(a). The image is a "miniature" in the sense that the distance between any two points on the cat food box is always greater than the distance between their images. This is apparent from the "squeezing" process of projecting everything to a point, and you can prove it using the transformation equations and the distance formula. The fact that the image must be "undistorted" is illustrated in Figure 4.2(b). At first, everything seems OK, because the top and sides of the box are parallel to their images, which is consistent with Rule 2. However, the too-skinny image of the cat food box results in a situation in which the *diagonal* of the box is not parallel to its image! Since this contradicts Rule 2, the distortion cannot take place.

Tricks with Rectangles

Knowing how to subdivide or duplicate rectangles in perspective is very useful, not only because rectangular shapes occur frequently in architecture, but also because other shapes can be drawn with the help of (properly drawn) rectangles. For instance, a circle inscribed in a square will be tangent to the square at the midpoints of the sides.

Thus if you can draw the square and the midpoints in perspective, you have a guide for sketching the circle in perspective.

Center of a rectangle. The perspective image of the center of a rectangle is the intersection of the images of the diagonals (because the actual center is the intersection of the actual diagonals).

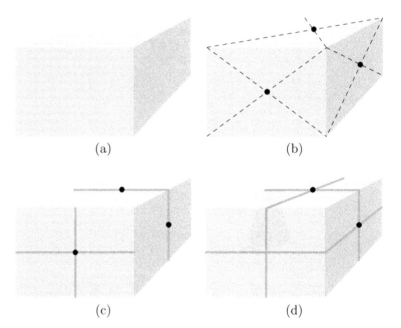

(a) (b)

Figure 4.3. Putting string around a package by finding centers of rectangles.

(c) (d)

In Figure 4.3 we use this fact to draw string around a box-shaped package that has been drawn in one-point perspective in Figure 4.3(a). In Figure 4.3(b) we locate the perspective centers of the three visible faces as the intersections of the corresponding diagonals. In Figure 4.3(c) we use Rule 3 to draw the images of the sections of string that are parallel to the picture plane. By Rule 3, we simply draw the horizontal sections as horizontal lines, and the vertical sections as vertical lines. However, there are two horizontal sections of string that are *not* parallel to the picture plane, so we have to draw them by another method. This is done in Figure 4.3(d), where we use the fact that these two sections of string must go through the centers of the corresponding faces of the box.

You'll soon discover that there is more than one way to solve most perspective drawing problems. For instance, by Rule 5, the near face of the box, which is parallel to the picture plane, has an undistorted image. Thus the center of that face could have been located by measuring, rather than drawing the diagonals. (However, measuring doesn't work for the other two visible faces.) As another example,

the last two sections of string we drew could have been drawn by locating and using the vanishing point of the box. Both methods lead to the same solution, as illustated by Figure 4.4, where we have extended the lines of the two strings to show that they converge to the vanishing point.

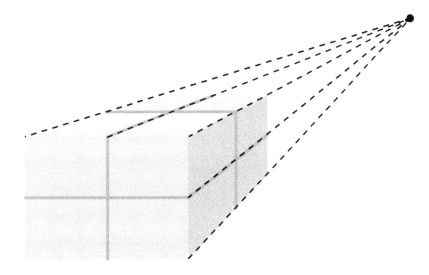

If we know that the actual top face of the package in Figure 4.4 is twice as long (into the distance) as it is wide, can you locate the correct viewpoint?

Figure 4.4. The strings are automatically consistent with the vanishing point.

Duplicating a rectangle. The next technique involves duplicating a rectangle in perspective, a trick that's often used to draw fences, bricks, sidewalks, tiles, etc. To see how to do it, let's first imagine the steps while looking at the rectangle straight on, as in Figure 4.5(a), where we have sketched a duplicate of the original rectangle in black dashed lines. In Figure 4.5(b) we locate the center of the first rectangle. In Figure 4.5(c) we draw the horizontal center line. Since the midpoint (black dot in Figures 4.5(c) and (d)) of the right side of the original rectangle is the center of the larger rectangle formed by the pair, we can locate the upper right corner of the duplicate rectangle by drawing a line from the lower left corner of the original rectangle, through the midpoint, and continuing it until it intersects the top line of the two rectangles, as in Figure 4.5(d). Now we can draw the right side of the duplicate rectangle as a solid line in Figure 4.5(d).

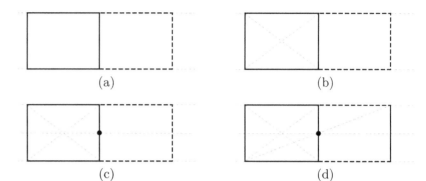

Figure 4.5. Duplicating a rectangle.

(a) (b)

(c) (d)

The analogous steps in perspective are carried out in Figure 4.6. Can you explain how they work?

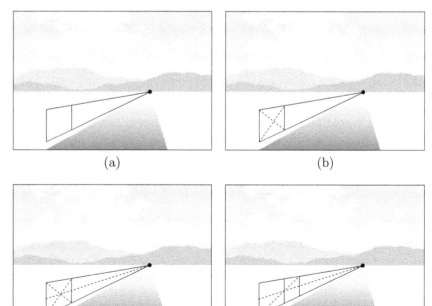

Figure 4.6. Drawing fenceposts by duplicating rectangles.

(a) (b)

(c) (d)

It's fun to keep going and make a really long fence, as in Figure 4.7. Making the fenceposts thinner and paler as they go into the distance helps, too; this is called *atmospheric perspective*.

Figure 4.7. Extending the fence.

We see examples of the principles of perspective every day. For example, Figure 4.8 shows the walkway in front of the Franklin Dining Hall at Franklin & Marshall College.

Notice in Figure 4.8 how certain lines converge to a vanishing point, and how the vertical column edges conform nicely to the construction in Figure 4.6. In a sense, a photograph is a very accurate perspective drawing made by a machine (a camera). That's why, using the rules of perspective, an artist or architect can start with a blank piece of paper and make a convincing drawing of a building before it even exists!

Figure 4.8. Photographs automatically conform to the rules of perspective.

Exercises for Chapter 4

1. Draw an 8×8 chessboard in perspective.

2. Draw the string around the package in Figure 4.9. Observe that the package has two vanishing points, like the library building in Figure 1.4.

Figure 4.9.

3. Draw the rest of the sidewalk tiles in Figure 4.10.

Figure 4.10.

4. Make a copy of Figure 4.11 and finish drawing the perspective letters "TJC." Assume that the actual letters all have the same depth. (Compare this exercise to Exercise 5 in Chapter 5.)

Make copies of the picture of a fence panel in Figure 4.12, and use them to solve the following drawing problems.

5. Draw 7 more fenceposts inside the fence panel to divide the panel (solid outline) into 8 equal sections.

6. Draw a duplicate of the fence panel (in the same plane as the original) with the top of its near fencepost at point P.

7. Draw a duplicate of the fence panel (in the same plane as the original) with the top of its *far* fencepost at point P.

8. Draw 2 more fenceposts inside the fence panel to divide the panel into 3 equal sections. (This is harder, but you would do the same thing to draw, say, the Italian flag in perspective, or the flags of many other nations.)

9. Draw 4 more fenceposts inside the fence panel to divide the panel into 5 equal sections, *without any measuring*. (Really hard!)

Figure 4.11.

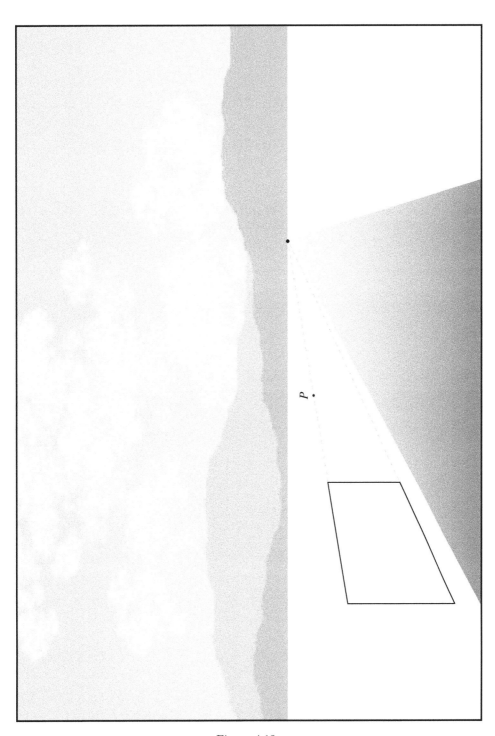

Figure 4.12.

What's My Line?
A Perspective Game[*]

T HE PURPOSE OF THIS GAME is to draw, in excellent 1-point perspective, the house that we first constructed in Excel in Chapter 2. The idea is to do it one line at a time, without coordinates, the way artists do! The class takes turns at the blackboard (or whiteboard), working on the same drawing. The only tools needed are a piece of chalk and a couple of yardsticks (two are occasionally needed to draw long construction lines).

Rules of the game:

- The drawing must be of a house with the *same proportions* as the house in Chapter 2. Students will therefore need their books open to the appropriate page to recall these proportions.

- Students may work individually or in teams.

- When it is their turn, students may make one measurement, one line, or occasionally two construction lines (e.g., an "X" to find a midpoint), subject to the approval of the instructor.

- When direct measuring is valid (and only when it is valid), students may use the yardstick to make a measurement.

- When students come to the board, they must first tell their instructor what they intend to draw and get permission. If the instructor denies them permission, students lose their turn and must wait one full round to have another chance.

- Instructors may disallow students from drawing a line if the construction is not valid, or if a different construction for the same part of the house has already been started, or if the instructor judges the construction to be insufficient or inelegant in any way.

[*]The authors invented the game, but not the title. *What's My Line?* was a popular game show on CBS television in the 1950s and '60s. The show would bring on a guest contestant, and celebrity panelists would attempt to guess the contestant's line of work. In our game you have to guess your own line—literally!

- The instructor will help to hold the yardsticks; students should draw lightly unless told otherwise.

- The instructor is allowed to darken up important or visible lines and to erase lines that have become extraneous.

While playing the game, a student (or a team) may wish to tackle a particularly difficult part of the drawing to show off their skills. This is of course good. On the other hand, they often have the option of choosing an easy line, thereby passing the hard problems along to someone else (the sneaky approach). In any case, students should continue to think about the hard problems, because the game can reach a point where no easy options are available until someone "breaks through" one of the hard parts.

Suggestions for instructors. Since the drawing is fairly large, a few guidelines must be drawn using two yardsticks placed end-to-end, so it's important to have a couple handy. The instructor starts by drawing the front, right vertical edge of the house—the first line of the game—along with a (lightly drawn) horizon line and a vanishing point (see Figures A and B). Putting these in good locations will help the construction greatly.

Figure A. Setup of the game.

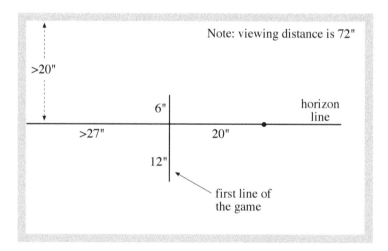

Here are some suggested measurements:

- Draw the horizon line more than 20″ below the top edge of the board.

- Draw the vertical line more than 27″ from the left edge of the board.

- Make the vertical line 18″ tall, with 6″ of it above the horizon and 12″ below.

- Draw the vanishing point on the horizon, 20″ to the right of the vertical line.

Instructors may find it necessary to remind students that the house they are drawing must have the same proportions as the house in Chapter 2. It's of course much easier to draw a house with, say, a cubical lower section. But the whole point is to show students that they can accurately draw the house in Chapter 2 without a computer, using only a yardstick and a piece of chalk.

It helps to see the house better if you think of it as "open" in the front: that is, the front pentagon is glass, and the rest is translucent. As students add lines to the house, darken the visible lines and leave the hidden lines fainter. If you no longer need construction lines, erase them so they don't make the picture even more confusing.

In a class period of less than eighty or ninety minutes, students may not completely finish the drawing. It's different every time. However, students should get enough done so that the structure of the house becomes apparent. When the house is done, each of the students should get a chance to view the picture (with one eye only, of course!) from the proper viewing location.

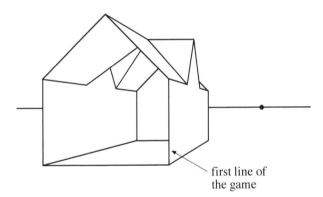

first line of
the game

Figure B. The finished house with a "glass wall" on the near end, and the hidden lines completely erased.

As an alternative, this could be a "turn it in" project in The Geometer's Sketchpad or GeoGebra. Students could be given a worksheet with the diagram of Figure A and an indicated viewing distance, with the assignment to draw construction lines in light gray and house lines in black.

CHAPTER 5

Two-Point Perspective

I N ADDITION to one-point perspective, another common perspective drawing technique is two-point perspective, illustrated in Figure 5.1. Unless otherwise stated, we will use the term "two-point perspective" to refer to a picture that is set up in such a way that the picture plane is perpendicular to the plane of the ground (outdoors) or the floor (indoors), and as a consequence of this, only two vanishing points on the horizon line are needed to render buildings or other objects whose adjacent vertical walls or sides are perpendicular to each other. This is a typical situation when dealing with architectural subjects, both indoors and outdoors.

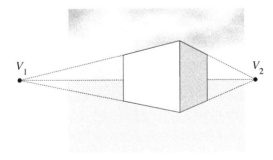

Figure 5.1. A simple example of two-point perspective.

Suppose the rectangular box in Figure 5.1 represents some kind of building, but we don't know anything about its size or proportions. Can we say anything about the correct location of the viewer? It turns out that we can.

First, we can tell by looking that the picture plane must be perpendicular to the plane of the ground—that is, vertical—because the images of the vertical lines of the building are parallel to one another

in the picture, and hence do not converge to a vanishing point. This can only happen if the picture plane is parallel to the vertical lines of the building, and hence perpendicular to the plane of the ground.

Since our line of sight to any point on the horizon must be level, the viewer's eye is the same height as the horizon line in the picture. Thus the viewer's eye lies in a horizontal plane (the eye-level plane) H containing the horizon line (see Figure 5.2). Since the picture plane is vertical, H is perpendicular to it. It is convenient to think of H as a half-plane existing in the room where the viewer is to view the painting, as in Figure 5.2. The question is, exactly where in the plane H should the viewer's eye be located?

Figure 5.2. The eye-level plane H. The correct viewpoint for the painting is somewhere in this plane, but where?

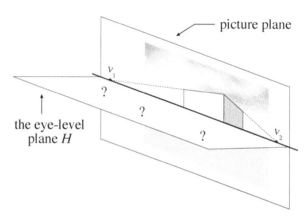

If the picture were the result of a window-taping experiment, then the building would still be located beyond the window, and we could find out all sorts of things about it. Even though it's not a window, we can think of the painting as the projection of a building that was once behind the canvas. At this stage we don't yet know how the building would be situated to make such a projection. Figure 5.3 shows two possible cases.

We can narrow down our choices for the viewpoint E by recalling an important fact about perspective on windows. When the viewer's eye is at the correct viewpoint E, the line (of sight) from E to any vanishing point V on the window must be parallel to the actual line in the real world whose image has V as its vanishing point. Thus, regardless of how the building was oriented, the lines $\overline{EV_1}$ and $\overline{EV_2}$ in Figure 5.3 must be parallel to the corresponding building edges; since adjoining building edges are perpendicular, $\overline{EV_1}$ and $\overline{EV_2}$ are also perpendicular to each other. Figure 5.3 shows two examples of all possible cases.

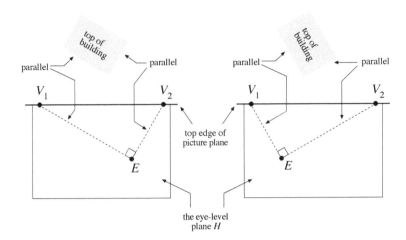

Figure 5.3. Two of many possible locations for the viewpoint E. Because the edges of the building form a right angle, the lines of sight to the vanishing points must form a right angle at the point E.

This brings up a question:

What is the set of all points E in the eye-level half-plane H such that $\overline{EV_1}$ and $\overline{EV_2}$ are perpendicular?

It turns out that this set is a semicircle whose endpoints are V_1 and V_2 (see Figure 5.4).

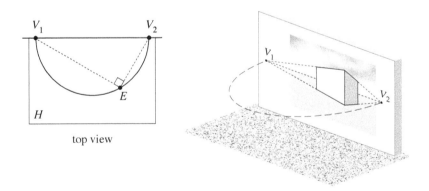

Figure 5.4. The viewpoint E must lie on a horizontal semicircle in the half-plane H.

Theorem 5.1. The viewpoint E for a standard two-point perspective painting (drawing, photograph) with vanishing points V_1 and V_2 lies on a semicircle with endpoints V_1 and V_2. The plane of the semicircle is perpendicular to the picture plane.

Proof. Consider a possible viewpoint E in the half-plane H, as on the left of Figure 5.5. Since E is a possible viewpoint, the lines $\overline{EV_1}$ and $\overline{EV_2}$ are perpendicular. Let M be the midpoint of V_1 and V_2, so that the two segments MV_1 and MV_2 have the same length r. Let

s denote the length of EM. We are done if we show that $s = r$, for that will mean that all possible viewpoints E are r units away from M, and therefore lie on a semicircle.

Now $\overline{EV_1}$ and $\overline{EV_2}$ are adjacent sides of a rectangle, so draw the entire rectangle EV_1FV_2, as indicated on the right of Figure 5.5. It's a well-known fact from geometry that the diagonals of a rectangle have equal lengths and meet at their common midpoint. Referring to the figure, this implies that $s = t = r$. ∎

Figure 5.5. Looking down on the plane H and the top edge of the picture plane.

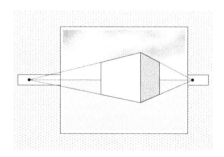

Figure 5.6. When working in two-point perspective, art students often tape strips of paper to their drawings so they can spread the vanishing points far apart. This makes for a larger viewing circle, one that is more likely to be occupied by the casual viewer's eye.

Theorem 5.1 explains a common trick used in art classes. Notice in Figure 5.4 that the farther apart the vanishing points V_1 and V_2 are, the bigger the "viewing circle"; that is, the farther away the potential viewpoints will be from the picture. We know from Chapter 3 that when viewpoints are unusually close to pictures, viewers perceive distortions, because they won't suspect that the correct viewpoint is so close. To prevent this from happening in two-point perspective drawings, art teachers often have their students tape strips of paper to their drawing paper (as in Figure 5.6) so that one or both of the vanishing points can be located beyond the edges of the paper. An art teacher would say, "We spread the vanishing points to avoid distortion." In view of Theorem 5.1, we could also say that "We spread the vanishing points to enlarge the viewing circle."

Is a small viewing circle really so bad? To convince yourself that it is, look at Figure 5.7. It's a drawing of some boxes in two-point perspective, with both vanishing points V_1 and V_2 in the drawing, making them very close together. The drawing has been set up so that the viewpoint is directly in front of the midpoint C of V_1 and V_2. Imagine a semicircle coming out of the page with V_1 and V_2 as its endpoints. It should be clear that the viewing distance in this case is just the radius of the semicircle, which is the distance between C and V_1 (or V_2). Close one eye and hold the page so that your open eye is very close to C and directly in front of it. Gaze at C for a second, then let your eye roll down and look at the boxes. You'll see

that they are just ordinary boxes with square tops! Now move the page away from your eye and see how distorted they get.

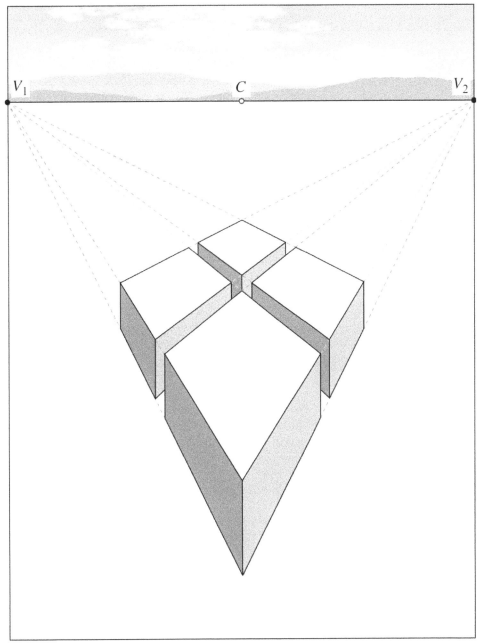

Figure 5.7. Vanishing points close together. Close one eye, put the other one very close to C (at a distance CV_2), and gaze down at the boxes. From there you will see they are perfectly normal boxes with square tops!

Example 1 (uncropped photograph). At this stage we know that the viewpoint E must be on a semicircle, but where on the semicircle? The answer requires more information about the picture. A simple case is when we know that a picture such as Figure 5.1 is a standard, uncropped photograph. When a standard photograph is not cropped, the viewpoint must lie on a line orthogonal to, and through the center of, the photograph.

Let's assume this is the case in Figure 5.8. Explain why the construction in Figure 5.8 correctly determines the viewing distance TU and the "viewing target" T (the point in the photo that should be directly in front of the viewer's eye).

Figure 5.8. Solution for an uncropped photograph. The viewing target is T and the viewing distance is TU. Why does the construction work?

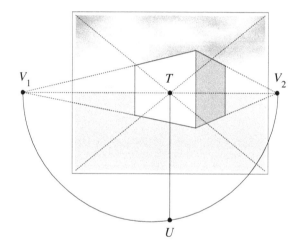

Notice that in order to solve the problem, we don't need to know the proportions of the building; that is, whether it's a cube or an elongated box of some kind. In fact, it's possible to *use* the solution to *figure out* the proportions—look for this same "photograph" in the exercises!

WARNING: This example and the ones that follow are actually *partially worked exercises*. It is essential that you answer the questions, fill in the gaps, and complete the explanations. You may find that doing so constitutes the hardest set of problems that you have worked so far! Your work will of course require you to draw lots of top and side views of each situation, so have a ruler, compass, and lots of paper handy.

Example 2 (horizontal square). When we're not sure that a two-point perspective picture is an uncropped photograph, other information about the picture or the subject can be helpful. In Figure 5.9 someone has started a perspective drawing of train tracks. Assume that the rectangles between railroad ties are actually squares. Find the viewing target and the viewing distance. (Or if you like, look at Figure 5.10 and explain why the construction works.)

When you've finished this example, try looking at Figure 5.9 (with one eye) from the correct viewpoint. You may find that you need to use your *right* eye, so that your nose doesn't block the view!

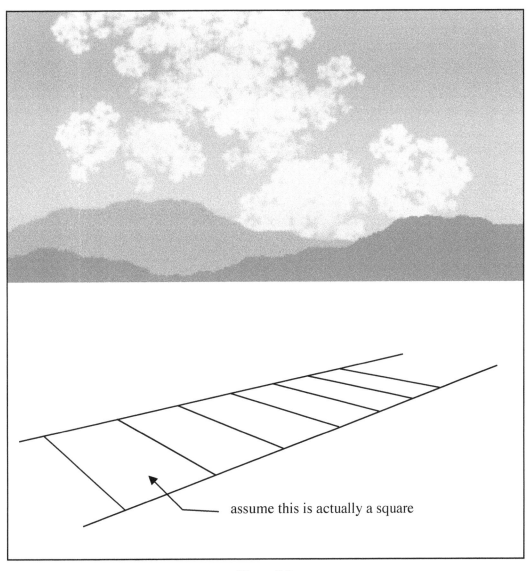

assume this is actually a square

Figure 5.9.

Figure 5.10. Solution of Example 2.

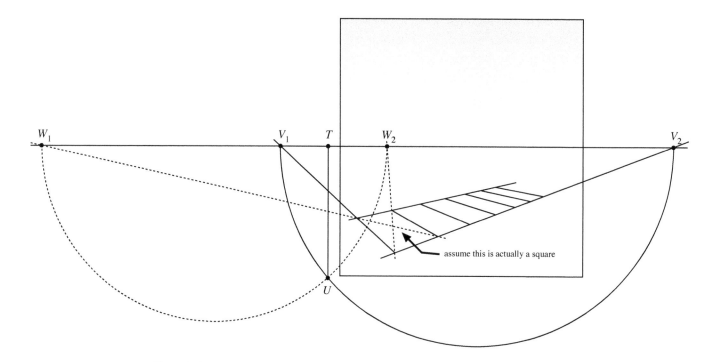

assume this is actually a square

The solution. The viewing target is T and the viewing distance is TU. Why?

Example 3 (horizontal rectangle). What if the rectangles between railroad ties are not square? We just used the fact that if two vanishing points are for horizontal lines that are at right angles to each other in the real world, then the "viewing circle" is a horizontal semicircle whose endpoints are the vanishing points. This is a special case of a theorem from plane geometry, illustrated in Figure 5.11 and stated as follows:

Let circle W_1EW_2 have center C. If $\angle W_1EW_2$ has measure θ, then $\angle W_1CW_2$ has measure 2θ.

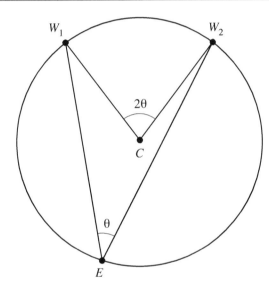

Figure 5.11. A theorem from plane geometry.

The theorem implies that if W_1 and W_2 are fixed on the circle (so that $\angle W_1CW_2$ is fixed), then a viewer's eye at any point E on the circle below W_1 and W_2 will see W_1 and W_2 as subtending an angle that is half of $\angle W_1CW_2$.[1] In the case when W_1 and W_2 are endpoints of a diameter ($2\theta = 180°$), we have $\angle W_1EW_2 = 90°$. Thus Theorem 5.1 is just the special case when $\theta = 90°$.

If the angle θ between the dashed diagonals in Figure 5.10 is not 90°, we need the full generality of the above theorem, as indicated in Figure 5.12. Can you explain why Figure 5.12 solves the problem?

[1] "Alright," someone says, "But how do we know that there is not some *other* point E' that is *not* on the circle, but still below W_1 and W_2, such that $\angle W_1E'W_2 = \theta$?" Can you answer the question?

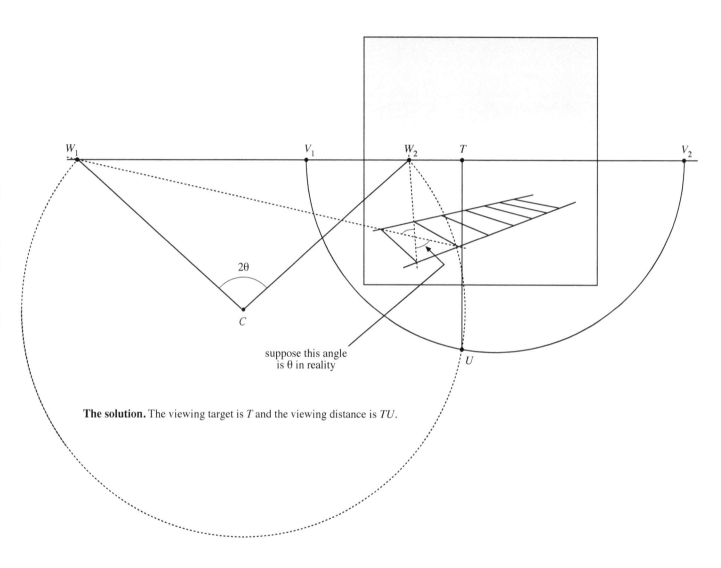

Figure 5.12. Solution of Example 3.

2θ

C

suppose this angle
is θ in reality

The solution. The viewing target is T and the viewing distance is TU.

W_1 V_1 W_2 T V_2

U

Example 4 (vertical rectangle). Suppose our building picture is not necessarily an uncropped photograph, but we do know the true shape of one end of the building, so that we can measure the angle α in Figure 5.13.

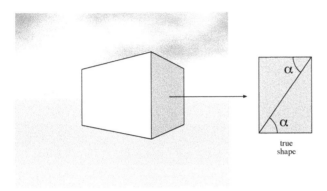

Figure 5.13. True shape of a vertical face of the building.

Explain why the following construction works. (Hint: V_3 is a vanishing point, and also the apex of a very important cone.)

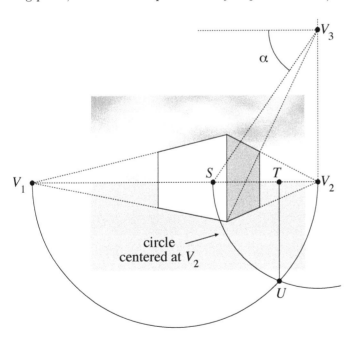

Figure 5.14. Solution of Example 4. The viewing target is T and the viewing distance is TU.

Example 5 (drawing a cube). Drawing a box in two-point perspective is a cinch, if there is no requirement on its proportions. But how about a cube? For the base, we can draw an arbitrary rectangle in two-point perspective, as in Figure 5.15 (only one vanishing point is shown). Now assume that the base is a square; this determines the viewing target T and the viewing distance, indicated by TU in the figure. (We assume you know how to determine T and TU by now, so we left out the messy construction.) Can you draw the left front face of the cube? The vertical line through V_1 is a hint. Can you finish the picture by drawing the entire cube?

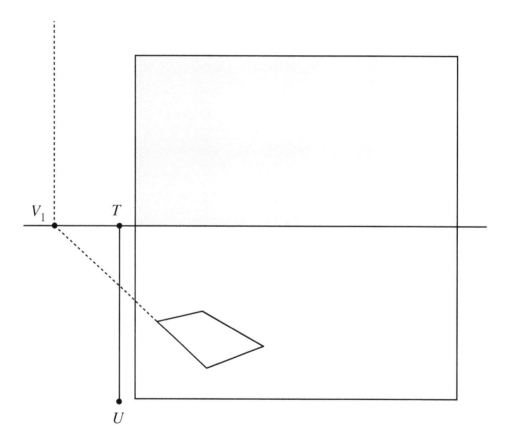

Figure 5.15. Base of a cube. The viewing target is T and the viewing distance is TU.

Exercises for Chapter 5

1. If Figure 5.10 is drawn perfectly, what should be the exact measurements of the following angles?

(a) $\angle V_1 U V_2$ _____ (b) $\angle V_1 U W_2$ _____

(c) $\angle W_2 U V_2$ _____ (d) $\angle W_1 U W_2$ _____

(e) $\angle W_1 U V_1$ _____ (f) $\angle W_1 U V_2$ _____

2. Figure 5.16 is the start of a drawing of a square tile S lying on the ground. If the viewing target is T and the viewing distance is TU, finish drawing the tile. If you like, you may use a protractor to construct angles.

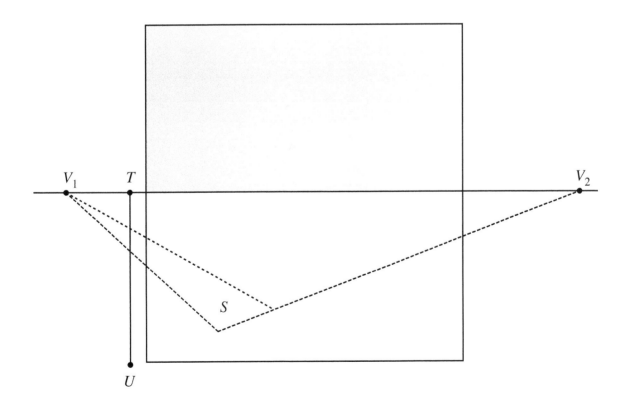

Figure 5.16.

When you finish this exercise, it should be clear that we really don't need to know the height of the building to figure out its proportions—that is, the ratio of the width of the white face to the height of the white face, etc. Uncropped photographs can reveal the true shape of every face of a building even when we don't know the size!

3. Figure 5.17 shows an uncropped photograph of a building. The viewing target T and the viewing distance TU have been located by the method of Example 1. Suppose we know that the actual building is 50 feet high. Answer the following questions. You will find it helpful to use a compass and a ruler with millimeters on it. There will of course be some errors in measuring, so show all your work.

(a) How wide is the white face of the actual building?

(b) How wide is the gray face of the actual building?

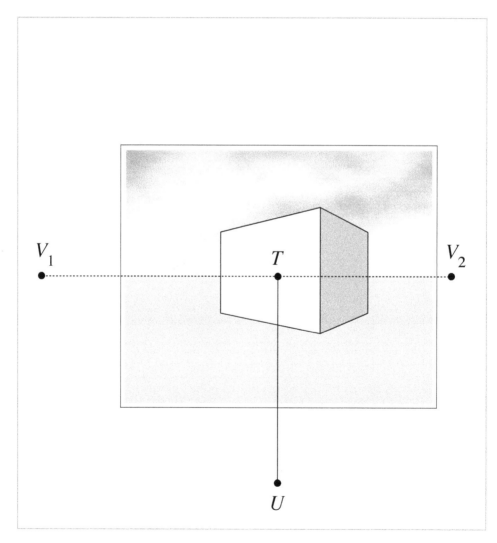

Figure 5.17.

4. Figure 5.18 shows the start of a drawing of a child's backyard playhouse. Add another window to the right-hand wall. The new window should represent one in the real world that is (a) the same size and shape as the existing window, (b) located at the same height as the existing window, and (c) separated from the back wall by the same distance that the existing window is separated from the front wall.

Figure 5.18.

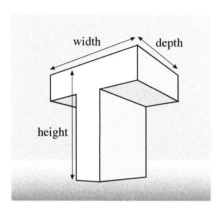

Figure 5.19. The (apparently distorted) width, depth, and height of a letter in two-point perspective. Although the widths, depths, and heights of letters will appear to vary in your drawing, your drawing should correctly represent letters with a common width, a common depth, and a common height.

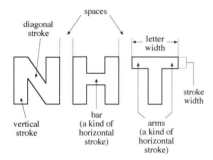

Figure 5.20. Some typography terms.

5. Using two-point perspective, draw a word in all capitals that is at least 4 letters long, with the letters in the word receding toward one of the vanishing points. (Compare this exercise to Exercise 4 in Chapter 4.) Referring to Figures 5.19 and 5.20, make sure that

- your drawing represents letters whose actual widths are equal (except for the letter "I"), whose actual heights are equal, and whose actual depths are equal;

- your drawing represents letters with constant spacing between them, the space being narrower than the letters;

- lines that should be parallel in the picture are indeed parallel;

- lines that should go to a vanishing point do indeed go to that vanishing point.

Here are some things that will help to make your picture beautiful:

- planning out the *stroke widths* of the letters (making sure that the bar of an "H" has the same stroke width as the arms of a "T"—see Figure 5.20);

- giving the word a surrounding context (is it disappearing into a starry sky? Sitting on a table? In a vast plane with trees on the horizon?);

- making sure that your lines are drawn neatly with a straight-edge;

- using lots of lines in the picture (e.g., your letters could be made of boards, bricks, quilts, etc.);

- making sure that the depth of the letters is constant.

6. Imagine that your word drawing in the previous exercise uses the shapes of an actual font that you have on your computer (or a font you see in a magazine or newspaper). Print out a letter from that font—a letter that appears in your drawing—at a fairly large size. Use the proportions of the letter to estimate the viewing target and viewing distance for your drawing.

7. Finish the cube in Example 5, and then make it a Rubik's cube. (Each face of a Rubik's cube is a checkerboard with 9 squares.)

8. Are the boxes in Figure 5.7 cubes? Explain how you know.

9. This problem describes a drawing project that can be done over a few class periods, or during several hours at home. At this point you have enough skills and techniques to make a complex, attractive drawing! Try using several of the constructions you've learned in this chapter and the previous one. Take your time, making sure every line is neat, straight, and conforms to the rules of perspective.

Make a pencil drawing in two-point perspective, following these guidelines:

(a) Keep the vanishing points far apart, even off the paper if feasible. More than two vanishing points is of course OK.

(b) Objects with equal-size parts (fences, brick walls, etc.) must be divided correctly into parts (halves, thirds, fourths, etc.).

(c) Separate objects that are duplicates of each other, such as windows in a building (and the gaps between them), must be duplicated correctly.

(d) All straight lines must be drawn neatly with a straight-edge. Any straight line not drawn with a straightedge will make the drawing unacceptable.

(e) A grading scheme should depend partly on counting the number of line segments in your drawing. For example,

 (i) Less than 600 line segments will result in a grade lower than an A.

 (ii) Less than 450 line segments will result in a grade lower than a B.

 (iii) Less than 350 line segments will result in a grade lower than a C.

An unbroken line segment will be counted as one line segment, even if several lines cross it. (Figure 5.22 shows that you get more line segments with bricks than you do with tiles.)

Figure 5.21. Two impressive drawings by a pair of biology (not art!) majors: Tia Milanese (top) and Julie Torkelson (bottom). Patience and following the rules can lead to satisfying results.

Figure 5.22. Going by the rules, the brick wall on the left counts as 21 line segments, while the tiled wall on the right counts as only 13 line segments.

Figure 5.23. Two views of a flag.

²Some examples are Belgium, Chad, Guinea, Ireland, France, Italy, Mali, Peru, and Romania. Many other nations, such as Canada and Mexico, use this pattern with the addition of an emblem in the center.

10. Figure 5.23 shows two views of a flag, one straight on and the other in two-point perspective. The straight-on view shows that the flag is a rectangle divided into three smaller, equal-sized rectangles. Many national flags use this pattern.²

In this exercise your job is to draw on the two-point perspective flag shown in Figure 5.24 (or rather a photocopy of it) and correctly divide it into thirds to make a flag that looks like the one on the right of Figure 5.23. To get you started, we have also included an undistorted flag (the rectangle R) in Figure 5.24. Begin by correctly dividing the rectangle R into thirds to establish a method that can be used in two-point perspective. Then use your method on the two-point perspective flag. Ignore the wavy left edge of the flag and treat the flag as a rectangle whose corners are the four black dots.

Figure 5.24.

ROBERT BOSCH is Professor of Mathematics and the Robert and Eleanor Biggs Professor of Natural Science at Oberlin College. He specializes in optimization, the branch of mathematics concerned with optimal performance. Since 2001, Bosch has devoted increasing amounts of his time and effort into devising and refining methods for using optimization to create pictures, portraits, and sculpture. He has had pieces commissioned by Colorado College, Western Washington University, Occidental College, Spelman College, and the organizing committees of several academic conferences. He operates a website, www.dominoartwork.com, from which it is possible to download free plans for several of his domino mosaics.

EVERYONE is an optimizer. Everyone, from time to time, attempts to perform a task at the highest level possible. Everyone benefits from being an optimizer and from keeping the company of optimizers.

When you take a new job and seek out the shortest route for your daily commute, you are being an optimizer, and you benefit by spending less time in the car and less money on fuel. When you create an itinerary prior to running errands (determining that it would be best to go to the bank first, and then the post office, the grocery store, and finally the library), you are again being an optimizer, reaping the same benefits.

Whenever you fly on an airplane, make a telephone call, or shop on the internet, you are keeping the company of optimizers. Airlines use optimization to construct their schedules. Telecommunications companies use it to design their networks. E-commerce giants like Amazon use it to set up their supply chains. You benefit by being able to travel, communicate, and shop from the comfort of your home. Without optimization, some companies wouldn't be able to stay in

business, and others wouldn't be able to provide their services at the level of quality we expect.

I am a mathematician who specializes in optimization. Each fall, I tell my students that optimization is the most useful branch of mathematics, as it can be applied to every field imaginable. These conjoined claims are bold ones, and I try to construct a supporting argument built on a variety of examples from diverse disciplines. Many of the examples come from my own research.

I have used optimization to compare fast-food restaurants. I have used it to investigate how the optimal length of a Phase III clinical trial for a new AIDS drug depends on the Phase II estimate of its efficacy. I have used it to find fingerings for piano pieces, to tackle disputed authorship problems, and to solve Sudoko-like puzzles (I wrote a puzzle column for six years). And since 2001, I have used optimization to create pictures, portraits, and sculpture.

My efforts to use optimization to produce art can be traced back to a 2001 installment of my puzzle column, in which I asked my readers to use integer programming (one of the most widely used tools in mathematical optimization) to arrange three complete sets of double-nine dominoes so that they'd form the best possible likeness of Leonardo da Vinci's *Mona Lisa*. By doing this, I was challenging my readers (and myself) to see if integer programming could be used to do what the artist Ken Knowlton had done (using other techniques) in the early 1980s. Knowlton is a former Bell Labs computer scientist who has made wonderful "computer assisted" mosaics, including lovely 4-set domino portraits of Marilyn Monroe and Albert Einstein.

My 3-set *Mona Lisa* was just barely recognizable. Still, I decided to carry on. I performed extensive surgery on the heart of my integer programming model and then embarked upon a phase of rigorous testing, varying the parameters of the model (to determine the role each one played) and creating more and more domino portraits, some from a small number of sets (like Knowlton's) and some from as many as 100!

The computer I owned at the time was able to solve a 2-set problem in seconds, but usually required more than eight hours to tackle a 100-set one. (The integer programming model for a 100-set portrait has just over $10,000$ equations and well over $1,000,000$ variables! The size of this model is of the same order of magnitude as those used in the airlines and telecommunications industries.)

So I ended up adopting a rather strange routine: Every night before I went to bed I'd instruct my computer to make another domino portrait. The next morning I'd print it out and show it to my wife Kathy (an antiques dealer) and son Dima (who was seven at the time).

"Each fall, I tell my students that optimization is the most useful branch of mathematics, as it can be applied to every field imaginable."

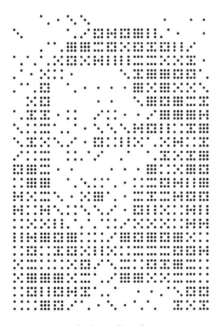

Robert Bosch
Domino Mona Lisa (First Attempt),
2001
3 complete sets of
(virtual) dominoes

Robert Bosch, *Domino da Vinci*, 2003,
96 complete sets of (virtual) dominoes

I did this for several months. Over time, I became better and better at determining which digital images would have a good chance of being turned into high quality domino mosaics. I became better and better at giving the computer detailed instructions on how to process these digital images (thereby increasing the chance that the domino mosaics would be of high quality). I gradually gained confidence that the best of my pieces would be appreciated by a general audience. Over time, I transformed myself from a mathematician who made pictures into an artist who uses mathematics.

Years ago, just after I began my teaching career at Oberlin, I saw Georges-Pierre Seurat's *A Sunday on La Grande Jatte—1884* while taking a break from a conference in Chicago. If you ever have the good fortune to view this masterpiece from up close, you'll see a mass of colorful dots. And if you can manage to keep looking at the painting while backing away from it, your eyes will do an amazing thing: they'll somehow merge all of the dots into a group of Parisians relaxing on an island on the Seine.

Seurat's masterpiece is the most widely reproduced example of what critics call pointillism. Seurat set himself the task of producing the best possible depiction of what he saw on the riverbank, subject to a set of interesting, self-imposed constraints—he had to keep his colors separate, and he could only apply paint to the canvas with tiny, precise, dotlike brush strokes. Seurat was an optimizer. He was trying to perform a task (a very difficult one, due to the constraints!) at the highest level possible. All artists are optimizers in this sense. Seurat is just a particularly clear example.

The main difference between me and other artists is that I use optimization explicitly. I don't use a pencil, paintbrush, or any other traditional tool. I do use a computer, but not in the same way that other digital artists do. Instead, I use mathematical optimization. Here's how I work: After I get an idea for a piece, I translate the idea into a mathematical optimization problem. I then solve the problem, render the solution, and see if I'm pleased with the result. If I am, I stop. If not, I revise the mathematical optimization problem, solve the revised problem, render its solution, and examine it. Often, I need many iterations to end up with a piece that pleases me.

Usually, I emulate Seurat. Like Seurat, I want the piece to appear abstract when looked at closely, but recognizable when viewed from a distance. Like Seurat, I want to challenge myself, and again, like Seurat, I do this by imposing constraints. (When making domino portraits, for example, I force myself to use *complete* sets of dominoes.) Often, this means that I end up having to solve a very difficult mathematical optimization problem. But that's part of the fun!

Of all the difficult problems in mathematical optimization, the most well-known (and well-studied) is the Traveling Salesman Prob-

"Over time, I transformed myself from a mathematician who made pictures into an artist who uses mathematics."

Above: Georges-Pierre Seurat
A Sunday on La Grande Jatte—1884,
1884–86
oil on canvas 81.75 × 121.25 in.
The Art Institute of Chicago
Helen Birch Bartlett
Memorial Collection
Below: detail from the painting

lem (TSP). The TSP concerns a salesman, based in one city, who must visit all of the cities in his territory and then return home. The goal is to visit the cities in an order that minimizes the total distance traveled.

In 2003 I realized that the TSP could be used to produce continuous line drawings of target images. The basic idea is quite simple: You convert the target image into a collection of dots (cities), solve the resulting instance of the TSP, and connect the dots in the order specified by the optimal tour! The end result is a continuous line drawing that does not cross itself and ends where it starts. In other words, the drawing is what mathematicians refer to as a simple closed curve.

Mathematicians have constructed rigorous proofs that every simple closed curve is "topologically equivalent" to a circle; that is, every simple closed curve divides the plane into two regions: the part that lies inside the curve, and the part that lies outside. As a result, every piece in my "TSP Art" series could, in principle, be put into physical form via the careful placement of a loop of one color on top of a background of a contrasting color.

From a distance, the viewer will see my piece *Knot?* as a *black* Celtic knot drawn on a *white* (or light gray) background. But moving closer, he or she will notice that the piece is a single *white* loop (117 feet long) drawn on a 34″ by 34″ *black* square. The question arises: Where did the knot go?

From a distance, the viewer will see my piece *Hands (after Michelangelo)* as a rendering of a close-up of the creation scene. From a distance, the viewer will see that the hand of Adam and the hand of God have just separated. But moving closer, the viewer will note that the entire image is formed of a single black loop (188 feet long) that rests on a 44″ by 19.5″ white background. Again, a question might arise: Are Adam and God really separate?

Robert Bosch
What's Inside?, 2006
(after Warhol)
TSP Art continuous line drawing
342 ft. curve on 34 × 44 in. canvas

Robert Bosch, *Knot?*, 2006
TSP Art continuous line drawing
117 ft. curve on 34 × 34 in. canvas

Robert Bosch, *Hands* (after Michelangelo)
TSP Art continuous line drawing, 188 ft. curve on 44×19 in. canvas

CHAPTER 6

Three-Point Perspective and Beyond

As the above title implies, this chapter contains several topics. We begin by discussing three-point perspective and the role of the viewpoint, and then show how to draw a specified box in three-point perspective. In doing so, we find that we actually need more than three vanishing points. We follow this with a discussion of other types of multiple vanishing point drawings, exemplified by a drawing of the house from Chapter 2. We then describe an apparent paradox in perspective drawing, which we call the skyscraper paradox. In this situation we actually need fewer vanishing points (in fact none!) than one might at first suspect. We close the chapter with a discussion of six-point spherical perspective.

A word about the techniques for drawing and viewing in three-point perspective. These techniques are just a bit more involved than those for one- and two-point perspective. Hence these techniques are unlikely to be used "in the field"—in the museum, or even in the artist's studio, except for special situations. Still, it's natural to ask, "How do I do this correctly?" and so it's intellectually satisfying to be able to know the correct solutions, even if in the future we mostly fudge and approximate.

Three-Point Perspective and the Viewpoint. Three-point perspective is the third common perspective technique in addition to one- and two-point perspective. Again we think of rendering rectangular box shapes such as buildings, but this time the picture plane is oriented so that it is not parallel to any of the edges of the boxes. This is illustrated in Figure 6.1, where we see that in no case do

parallel edges of buildings have parallel images in the picture. The figure shows the three vanishing points needed to draw the lines of the buildings that Spider-Man swings past. If you lay a ruler along any such line, you'll see that the line goes through either V_1, V_2, or V_3.

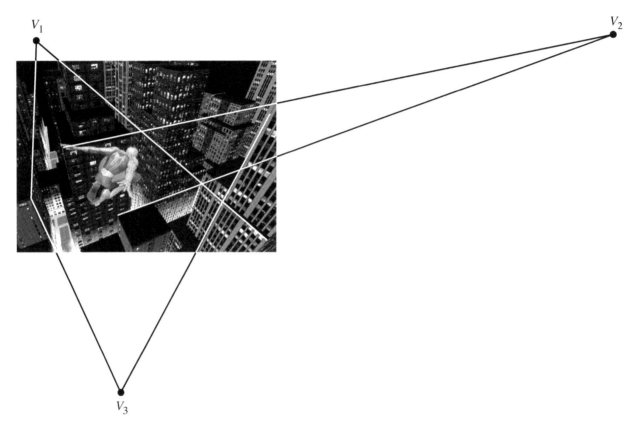

Figure 6.1. The Marvel Comics character Spider-Man leaps into the night in this still from a GameSpot video game. Since no two parallel lines have parallel images, the picture plane is not parallel to any of the edges of the buildings. Consequently, three vanishing points are needed to draw the buildings.

You may have sketched pictures in three-point perspective before, but there are a couple of facts that may surprise you. First, it's not correct to start with just any three vanishing points; the three points must be the vertices of an *acute triangle*—a triangle whose angles are all less than 90° (Figure 6.2). Second, when you sketch the three vanishing points, the viewpoint of your drawing is completely determined—before you even draw anything! We will discuss these and other properties of three-point perspective in terms of two familiar tasks: finding the viewpoint of an existing drawing, and drawing a rectangular box in three-point perspective.

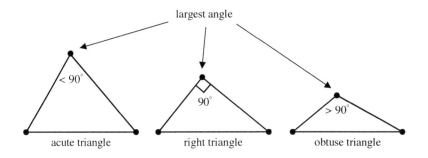

Figure 6.2. A triangle is called acute, right, or obtuse according to whether its largest angle is, respectively, acute (less than 90°), right (90°), or obtuse (greater than 90°). The viewpoints for a correct three-point perspective drawing must form an acute triangle. Try checking this in Figure 6.1.

To begin, recall that in two-point perspective we have two vanishing points V_1 and V_2 (Figure 6.3(a)) and a horizontal semicircle connecting them; the viewpoint must lie somewhere on this semicircle. In three-point perspective, any pair of vanishing points such as V_1 and V_2 are for the images of lines that are perpendicular to each other (such as the edges of the roof of a building), but the viewpoint does not lie in a horizontal plane containing those vanishing points. However, the viewpoint does lie in *some* plane containing V_1 and V_2, and hence it lies on some semicircle with endpoints V_1 and V_2. The set of all such semicircles (Figure 6.3(b)) forms a hemisphere on one side of the picture plane. From any viewpoint E on any of those semicircles (from any point on the hemisphere except V_1 and V_2) a viewer's lines of sight to V_1 and V_2 will be at right angles. We can prove this by applying the proof of Theorem 5.1 to the semicircle containing E, V_1, and V_2. We call this hemisphere the *viewing hemisphere* for the two vanishing points.

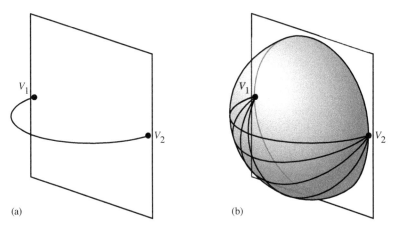

(a) (b)

Figure 6.3. A semicircle (a) with endpoints V_1 and V_2, and a family of semicircles (b) with the same endpoints. The entire family of semicircles forms a hemisphere on one side of the picture plane.

Now consider three noncollinear vanishing points V_1, V_2, and V_3 for a three-point perspective drawing (Figure 6.4). For any pair of vanishing points, say V_2 and V_3, there is a viewing hemisphere \mathcal{H}_1

(Figure 6.4(a)). The viewpoint for the drawing must be somewhere on this hemisphere. The same thing is true for the other two pairs of vanishing points, so there are actually three viewing hemispheres \mathcal{H}_1, \mathcal{H}_2, and \mathcal{H}_3 (Figure 6.4(b)). Since the viewpoint E must lie on all of these hemispheres, E is the unique intersection point of \mathcal{H}_1, \mathcal{H}_2, and \mathcal{H}_3 in a properly set up three-point perspective drawing. The intersection point is unique because any pair of hemispheres meets in a semicircle that lies in a plane perpendicular to the picture plane; this semicircle meets the third hemisphere in a single point.

Figure 6.4. Like the intersection point of three bubbles, the viewpoint E of a three-point perspective drawing is the intersection of the three viewing hemispheres \mathcal{H}_1, \mathcal{H}_2, and \mathcal{H}_3.

 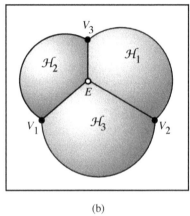

(a) (b)

There is a special relationship between the viewing hemispheres and the "viewpoint triangle" $\triangle V_1 V_2 V_3$. To explain this, we show in Figure 6.5 the equator \mathcal{C}_1 of the viewing hemisphere \mathcal{H}_1, along with the viewpoint triangle (compare with Figure 6.4(a)). The dashed line segments $\overline{V_2 F_2}$ and $\overline{V_3 F_3}$ are *altitudes* of $\triangle V_1 V_2 V_3$; that is, each is a line segment through a vertex perpendicular to the opposite side. Each point F_i, which lies on a side of the triangle, is called the *foot* of the altitude $\overline{V_i F_i}$. In Figure 6.5 it looks like F_2 and F_3 lie on \mathcal{C}_1, and this is in fact true. For example, because $\overline{V_2 V_3}$ is a diameter of \mathcal{C}_1, and because $\angle V_2 F_3 V_3$ is a right angle, the proof of Theorem 5.1 shows that F_3 lies on \mathcal{C}_1. A similar argument proves that F_2 lies on \mathcal{C}_1. Generally, given any viewpoint triangle $\triangle V_1 V_2 V_3$, the equator \mathcal{C}_i of a viewing hemisphere \mathcal{H}_i contains two vertices of the viewpoint triangle and the feet of two altitudes.

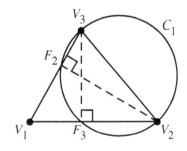

Figure 6.5. The equator \mathcal{C}_1 of the viewing hemisphere \mathcal{H}_1, and the viewpoint triangle. The circle \mathcal{C}_1 passes through the feet F_2 and F_3 of the dashed altitudes $\overline{V_2 F_2}$ and $\overline{V_3 F_3}$.

This relationship is illustrated in each part of Figure 6.6. Each part consists of (1) a vanishing point triangle $\triangle V_1 V_2 V_3$; (2) the respective equators \mathcal{C}_1, \mathcal{C}_2, \mathcal{C}_3 of the viewing hemispheres \mathcal{H}_1, \mathcal{H}_2, \mathcal{H}_3; and (3) the three altitudes of $\triangle V_1 V_2 V_3$. (As we will discuss, V_3 coincides with F_1 and F_2 in part (b).)

Figure 6.6(a) corresponds exactly to Figure 6.7(a); the vanishing

points V_1, V_2, V_3 are the same, and the circles C_1, C_2, C_3 are the equators of the respective viewing hemispheres \mathcal{H}_1, \mathcal{H}_2, \mathcal{H}_3 in Figure 6.7(a). Similarly, Figure 6.6(b) corresponds to Figure 6.7(b), and Figure 6.6(c) corresponds to Figure 6.7(c).

Getting back to Figure 6.6(a), we observe that the common chord $\overline{V_3 F_3}$ of circles C_1 and C_2 is the *orthogonal projection* onto the picture plane of the semicircular intersection of the two hemispheres \mathcal{H}_1 and \mathcal{H}_2. That is, lines from the points of the semicircle that are perpendicular (orthogonal) to the picture plane will collectively meet the picture plane in the line segment $\overline{V_3 F_3}$. The same is true for the other pairs of circles, and the point T is the orthogonal projection of the point E in Figure 6.4(b); that is, T is the viewing target for the drawing. The point T is also the common intersection point of the three altitudes, called the *orthocenter* of the triangle.[1]

The important thing to notice is that in the acute triangle case of Figure 6.6(a), the orthocenter lies in the interior (between the endpoints of) each altitude, and hence it lies in the interior of each circle C_i. Thus, there is a unique viewpoint, and it is not on the equator C_i of any hemisphere, so it does not lie in the picture plane. The viewpoint is therefore practical and the drawing is set up properly when the viewpoint triangle is acute.

[1] We have in effect given a "perspective proof" of an important theorem from geometry, which says that the three altitudes of a triangle meet in a common point. The theorem is also true for right and obtuse triangles.

(a)

(b)

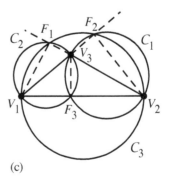
(c)

Figure 6.6. Diagrams for viewpoint triangles that are (a) acute, (b) right, and (c) obtuse. In (a), the three hemispheres meet at a point E outside the picture plane, directly above T (compare with Figure 6.7(a)). If you extend the three dashed altitudes in (c), you will see that they again meet at the orthocenter, which is above C_3.

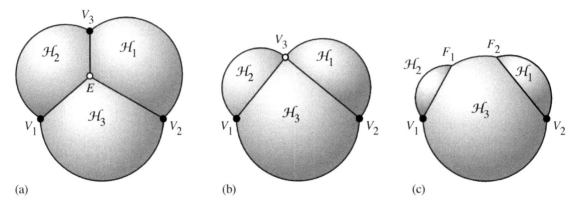

Figure 6.7. The viewing hemispheres corresponding to the respective parts of Figure 6.6. In part (a) the mutual intersection point E of the hemispheres is the viewpoint. In part (b) the mutual intersection point is V_3 and hence lies in the picture plane. In part (c) the three hemispheres do not have a mutual intersection point (in this case V_3 is hidden by \mathcal{H}_3).

This is not the case in the right and obtuse triangle cases of Figures 6.7(b) and (c). In the right triangle case of Figure 6.6(b), all three circles \mathcal{C}_1, \mathcal{C}_2, and \mathcal{C}_3 meet at V_3, and hence the viewing hemispheres intersect in the picture plane at V_3. This is not a practical viewpoint, and hence the drawing is not set up properly. In the obtuse triangle case of Figure 6.6(c), the three altitudes do not meet inside any of the circles, and hence the viewing hemispheres do not have a common intersection point—there is no viewpoint. We summarize these results in a theorem:

Theorem 6.1. Three points in the picture plane form a possible viewpoint triangle for a three-point perspective drawing if and only if the viewpoint triangle is acute. The viewpoint is completely determined once the three vanishing points are drawn. The viewing target is the orthocenter of the viewpoint triangle.

To anyone who has ever drawn or doodled in three-point perspective, this theorem may seem surprising. Why can't we just use any three noncollinear points for vanishing points? Certainly we can make *some* kind of drawing this way. Figure 6.8 shows an attempt at drawing a box in three-point perspective using an obtuse viewpoint triangle. Although the box does not look horribly wrong, the preceding discussion shows that there is no viewpoint from which the image has the same appearance as a rectangular box.

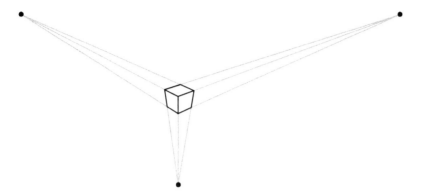

Figure 6.8. An attempt at three-point perspective drawing using an obtuse viewpoint triangle. Because the viewpoint triangle is not acute (the correct method), there is no viewpoint from which the image has the same appearance as a rectangular box.

As we have seen, given a drawing or a photograph in three-point perspective, the viewing target is easy to find—it's the orthocenter of the viewpoint triangle. Just draw any two altitudes, and the place where they cross is the viewing target. But how can we find the viewing distance?

To do this, we start with Figure 6.9(a), which shows the two viewing hemispheres \mathcal{H}_1 and \mathcal{H}_2 from Figure 6.4(b). The two hemispheres intersect in a semicircle, seen edge-on and represented by a dashed line in Figure 6.9(a). In Figure 6.9(b) we see a side view of the semicircle. The line segment \overline{TE}, where T is the viewing target, is perpendicular to $\overline{V_3F_3}$. This splits $\triangle EV_3F_3$ into two similar right triangles $\triangle ETV_3$ and $\triangle ETF_3$; the marked angles are equal (why?). The viewing distance is $d = |\overline{TE}|$, the length of \overline{TE}.

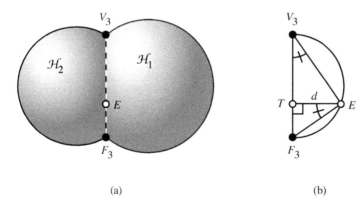

(a) (b)

Figure 6.9. Computing the viewing distance. The viewing hemispheres \mathcal{H}_1 and \mathcal{H}_2 (a) intersect in a semicircle, shown in a side view in part (b).

By the laws of similar triangles, we have

$$\frac{d}{|\overline{TV_3}|} = \frac{|\overline{TF_3}|}{d},$$

or equivalently, $d^2 = |\overline{TV_3}||\overline{TF_3}|$. We can therefore compute the viewing distance d as

$$d = \sqrt{|\overline{TV_3}||\overline{TF_3}|}.$$

[2]We have also given a perspective proof of another fact from geometry, namely, that the products $|\overline{TV_1}||\overline{TF_1}|$, $|\overline{TV_2}||\overline{TF_2}|$, and $|\overline{TV_3}||\overline{TF_3}|$ are all equal.

If we had picked another pair of viewing hemispheres we would have obtained the same result, except that the index 3 would have been a 1 or a 2. But there can only be one viewing distance, so we have the following theorem.[2]

Theorem 6.2. In a three-point perspective drawing, the viewing distance d satisfies

$$d^2 = |\overline{TV_1}||\overline{TF_1}| = |\overline{TV_2}||\overline{TF_2}| = |\overline{TV_3}||\overline{TF_3}|.$$

There is also a way to find d based on the idea of Figure 6.9. Figures 6.11 and 6.12 show how to do it for the Spider-Man picture.

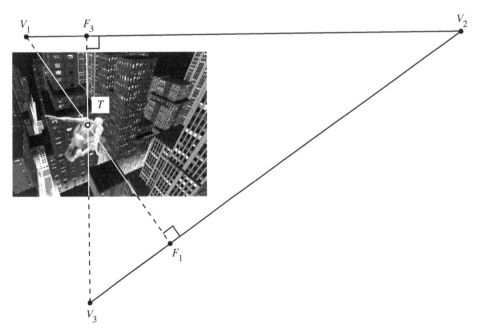

Figure 6.10. Finding the viewing target T.

In Figure 6.10 we draw any two sides of the viewpoint triangle and the altitudes to them. The point where the altitudes intersect

is the viewing target T (and also the orthocenter of the viewpoint triangle). In Figure 6.11 we choose an altitude, in this case $\overline{V_3F_3}$, and draw a semicircle with that altitude as a diameter. Then we draw a perpendicular \overline{TU} to the altitude, where U is on the semicircle. The viewing distance d is the distance between T and U. This method will work for any three-point perspective drawing or photograph.

At first glance, the Spider-Man computer game picture has a feel that is common to many pictures of computer games and computer graphics: it looks "computery." That is, the lines that converge to vanishing points seem to converge too rapidly, giving the picture an artificial feel. But if we consider the viewing distance in Figure 6.11, the reason becomes clear. The picture as reproduced here, and consequently the viewing distance, are so small that we can't comfortably get close enough to view the picture properly. This is a phenomenon we have seen again and again. Whenever lines in a perspective picture seem to converge too rapidly to vanishing points, you should suspect that you are looking at the picture from too far away.

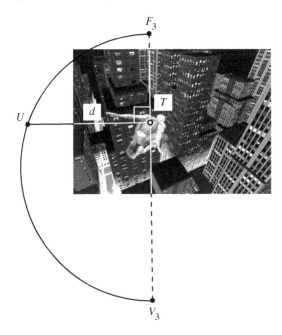

Figure 6.11. Finding the viewing distance d.

Drawing a Box in Three-Point Perspective. We now know how to find the viewpoint for a three-point perspective drawing. The other task we set for ourselves was to draw a box in three-point perspective. By this we mean not some vague box whose shape we don't know, but a box of specified proportions. Figure 6.12(a) shows a folded-out schematic of a box we want to draw, and Figure 6.12(b) is an inverted version of the acute triangle diagram of Figure 6.6(a). Interestingly,

the diagram enables us to draw the box. For the purpose of drawing the box, we can use any acute triangle. We call any such diagram an *altitude diagram*, because it can be used to prove the concurrency of the altitudes at the orthocenter. We call the circles \mathcal{C}_1, \mathcal{C}_2, and \mathcal{C}_3 the *altitude circles*, because each contains the endpoints of two altitudes. Note that we have labeled three more points W_1, W_2, and W_3. For $i = 1, 2, 3$, W_i is the intersection of the altitude circle \mathcal{C}_i with the altitude $\overline{V_iF_i}$. These points will be helpful in drawing the box.

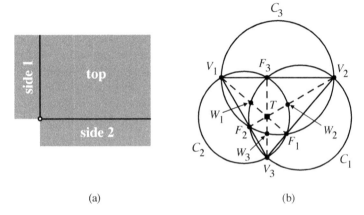

Figure 6.12. Folded-out schematic of a box we want to draw (a), and a fully labeled altitude diagram (b). The points V_i are the vanishing points, the circles \mathcal{C}_i are the altitude circles, and the points F_i are the feet of the altitudes. The points W_i will be helpful later.

(a) (b)

[3]This is an important point. If your eye is at the correct viewpoint E, then your line of sight to any point on $\overleftrightarrow{V_1V_2}$ lies in the plane containing V_1, V_2, and E. This plane is parallel to the top face of the box, so any line in the top face will have an image whose vanishing point is on $\overleftrightarrow{V_1V_2}$.

To do this, we refer to Figure 6.13(a), where we have drawn a diagonal of the top face of the box. The edges of this face vanish at V_1 and V_2, and hence the line $\overleftrightarrow{V_1V_2}$ is the *vanishing line* for the top face; that is, any line in the top face—such as the diagonal—must vanish on $\overleftrightarrow{V_1V_2}$.[3] To locate the desired vanishing point D_3, observe that the viewpoint must lie on a semicircle with endpoints V_1 and V_2. This semicircle stands out from the picture plane, but we can imagine rotating it about its diameter until it lies in the picture plane and coincides with \mathcal{C}_3, as in Figure 6.13(b).

Now observe also that the viewpoint lies in a plane through the altitude line $\overleftrightarrow{V_3F_3}$ orthogonal to the page. Consequently, when the semicircle containing the viewpoint is rotated into \mathcal{C}_3, the viewpoint rotates into W_3. From the actual viewpoint, the vanishing points V_2 and D_3 must subtend the same angle as the diagonal and the near right edge of the top face, indicated in Figure 6.13(a). Thus in Figure 6.13(b), $\angle V_2W_3D_3$ must be equal to this angle. The easiest way to arrange this is to place a replica of the top face of the box with the corresponding corner at W_3 and the corresponding edge through V_2.

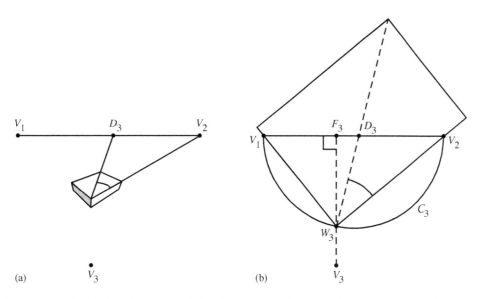

Figure 6.13. The points V_1, V_2, V_3, F_3, W_3, and the (semi)circle C_3 are all from Figure 6.12(b); the other lines and circles have been deleted for clarity. When drawing the box in a position like (a), locate the diagonal vanishing point D_3 as in (b). That is, draw the altitude $\overline{V_3 F_3}$ and the semicircle C_3, and either measure the angle $\angle V_2 W_3 D_3$ as measured on the box, or place the top of the box as shown.

Figure 6.14 shows this procedure applied to the three faces of the box from Figure 6.12. In Figure 6.14(a) the marked corner (white dot) of the top face is placed at the intersection of the upper altitude circle and the vertical altitude (a point W_i). The two marked edges go through the vanishing points that are endpoints of a diameter of that circle. A white square marks the intersection of the diameter and the dashed face diagonal. For later use, a black square marks the orthocenter of the viewpoint triangle. In Figure 6.14(b) the marked corner of side 1 (as labeled in Figure 6.12) is placed at the intersection of the left altitude circle and the corresponding altitude. The marked edge of side 1 goes through the same vanishing point as the corresponding marked edge of the top face did in Figure 6.14(a). Figure 6.14(c) shows an analogous procedure for side 2.

Now that we have the three main vanishing points for the edges of the box, and the three vanishing points for the face diagonals, it is easy to make a drawing of the actual box (Figure 6.15). We can begin by drawing any edge of a visible face in the interior of the viewpoint triangle; the edge, of course, must lie on a line through one of the three main vanishing points. After that, the reader will find upon experimentation that the remaining edges are completely determined. In Figure 6.15 the corner marked by a white dot represents the same marked corner as in Figures 6.13 and 6.15. Again the black square marks the orthocenter of the viewpoint triangle. This is the viewing

target; the viewer's one open eye must be placed directly in front of this target (i.e., on a line through the target orthogonal to the page). All that remains is to calculate the viewing distance. We leave that to you as an exercise.

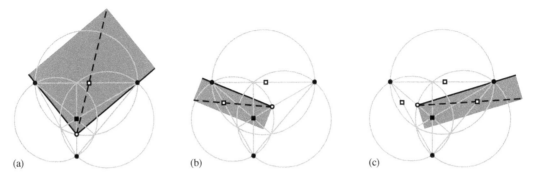

Figure 6.14. Placement of the faces of the box to mark the diagonal vanishing points.

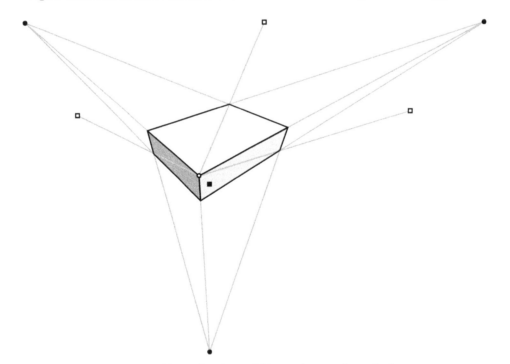

Figure 6.15. Using the six vanishing points to draw the box.

The viewing distance in Figure 6.15 is rather close, so we have enlarged the image and the viewing distance in Figure 6.16 for the reader's convenience. If one views the image with one eye closed and the other sufficiently close to the viewing target (black square),

the apparent distortion of the box will disappear and the image will closely resemble the appearance of the actual box.

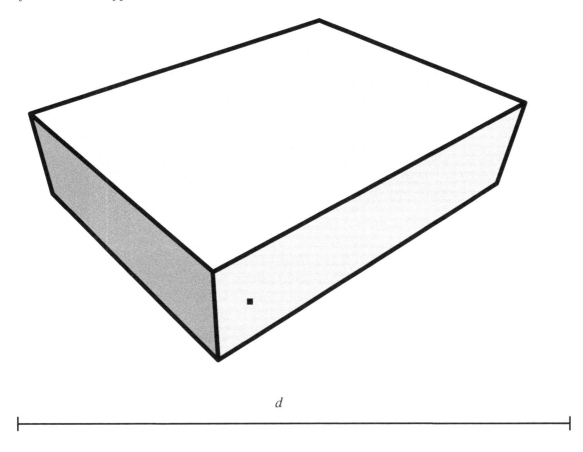

d

Figure 6.16. Enlargement of the box with the viewing target (black square) and viewing distance d.

While the general case of drawing a box in three-point perspective is a good exercise in geometry, it's also a pretty complicated drawing procedure. However, we can apply what we've learned to simplify things a bit, and summarize a few drawing tips:

1. Use an equilateral, or nearly equilateral vanishing point triangle. We know that if a vanishing point triangle is a right triangle, it has a viewing distance of zero. Thus we want to avoid vanishing point triangles with angles that are almost 90°, to avoid small viewing distances. A good way to do this is to use an equilateral vanishing point triangle, in which all the angles are 60°. In this case the largest angle (60°) is as far away from 90° as possible. (No triangle can have a largest angle of less than 60° or else the

angles would not add up to 180°.) In fact, it can be shown that the ratio of the viewing distance to the longest side of the vanishing point triangle is a maximum if and only if the vanishing point triangle is equilateral.

2. Keep your drawing clustered near the viewing target. From the correct viewpoint we look "straight at" the viewing target—that is, our line of sight to the viewing target is perpendicular to the picture plane. On the other hand, to look at a part of the drawing that is far from the viewing target, we must look at a glancing angle to the picture plane, and hence that part of the drawing will appear more distorted to someone looking from the wrong viewpoint. Clustering your drawing near the viewing target will prevent this. Moreover, clustering the drawing near the viewing target will make it more likely that viewers will view the drawing from somewhere near the correct viewpoint. It's easy to locate the viewing target before you begin drawing (see Figure 6.10).

3. It's easy to draw a cube using an equilateral vanishing point triangle. With an equilateral vanishing point triangle, locating the vanishing points for the face diagonals is easy—they are the midpoints of the sides of the vanishing point triangle. You'll find this is true if you follow the procedure of Figure 6.14 using an equilateral vanishing point triangle and a cube. Thus you can actually skip the procedure and just locate the midpoints.

Beyond Three-Point Perspective. It's not hard to see that the classifications we call one-, two-, and three-point perspective are rather narrow. For example, even when drawing a simple box in three-point perspective (Figure 6.15), it's helpful to have six vanishing points. A similar example is illustrated in Figures 6.18 and 6.19, where we show how to draw the house from Chapter 2 in "two-point perspective"; we actually use five vanishing points. In Figure 6.17 we start two main vanishing points V_1 and V_2 and a semicircle connecting them. This is the horizontal "viewing semicircle," folded down into the picture plane. On the semicircle we choose a point U that would coincide with the viewpoint E if the semicircle were horizontal. For simplicity we choose U at the midpoint of the semicircle.

Now consider the circular arc through U centered at V_2. If the semicircle were horizontal, this arc would be the base of a cone with apex V_5. If the viewer's eye were anywhere on the dashed arc, its line of sight to V_5 would have slope $1/3$. Why $1/3$? Take a look at how V_5 is used in Figure 6.18 and recall the proportions of the house from Chapter 2.

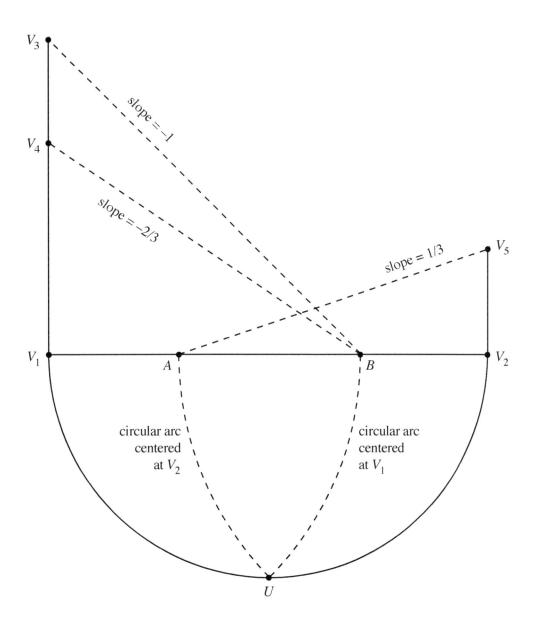

Figure 6.17. Establishing the vanishing points for the drawing in Figure 6.18.

We'll leave the rest of the explaining as a project for you. In addition, try tracing the vanishing points V_1–V_5 and the near vertical edge of the house on a piece of paper and see if you can reproduce the rest of the drawing.

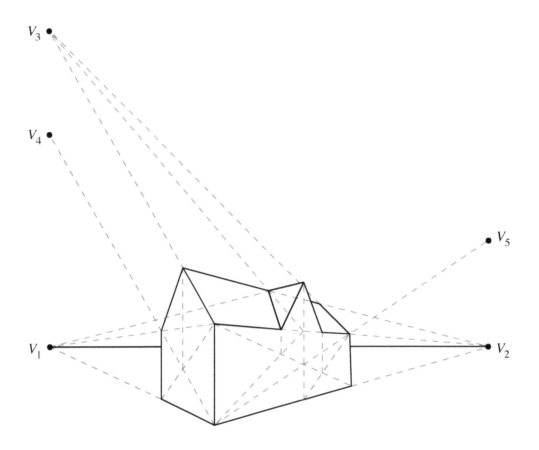

Figure 6.18. The house from Chapter 2 drawn with five vanishing points.

It's clear that a perspective drawing may require more vanishing points than we might at first guess. Another side of the coin is that a perspective drawing can have *fewer* vanishing points than we might suspect—in fact, none at all. That's the idea of a phenomenon we call the *skyscraper paradox*.

The Skyscraper Paradox. A question that often arises in perspective drawing is whether ordinary perspective is capable of capturing our visual experience of tall buildings. To see why the question comes up, let us consider a fictitious skyscraper, the Viewpoints Mutual Insurance building, depicted in Figure 6.19. To simplify the discussion we assume that the building is a rectangular box with smooth faces—that is, with no indentations or protrusions. If the picture plane is parallel to the front face of the building, the rules of perspective say that the building must be drawn as an undistorted rectangle, with the borders of the windows either vertical or horizontal (see Rule 5 of

Chapter 4). In this case we don't need any vanishing points to draw the building. In Figure 6.19 the result looks reasonable because the setting shows that the building is seen from a distance, as say, from across a river.

The apparent paradox arises when we consider the building to be very close to us. Let's suppose we are suspended in midair, halfway up the building and close to the front face. Thinking about this situation, we see in our mind's eye two different views (Figure 6.20) that seem incompatible with the perspective approach. Looking up toward the top of the building, we would see the vertical lines of the building appearing to converge to a vanishing point. To make things worse, as we look down toward the bottom of the building we see the vertical lines of the building appearing to converge to yet *another* vanishing point. Thus, instead of *no* vanishing points, it almost seems as if our perspective drawing of the building should have *two* vanishing points! Sometimes people conclude from this apparent paradox that perspective is just plain wrong. Perhaps there is some fundamental flaw in perspective that the artists/mathematicians of the Renaissance missed, but before we hang up a sign saying

<div align="center">

THE RENAISSANCE HAS BEEN CANCELED
DUE TO TECHNICAL DIFFICULTIES

</div>

we should try to understand the problem mathematically.

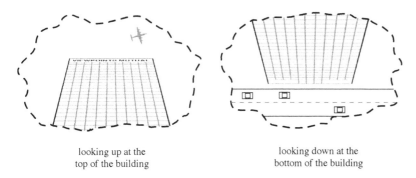

<div align="center">

looking up at the looking down at the
top of the building bottom of the building

</div>

Figure 6.19. A tall building as seen from a distance, with the picture plane parallel to the face of the building.

Figure 6.20. In our mind's eye, it seems that a painting of the building must have two vanishing points.

To repeat, the laws of perspective say that if the picture plane is parallel to the face of the building, then a perspective painting of the building must be a simple rectangle, as in Figure 6.21. Looking at the figure, it seems impossible to reconcile with our perception of the actual building as illustrated in Figure 6.20. But remember, we have not yet applied our usual analysis with a side view that includes the building, the picture plane, and the viewer. A side view of the situation appears in Figure 6.22.

By counting windows in Figure 6.21, we see that the building is about 40 stories high. Allowing about 10 feet per floor, we estimate

the height of the building at 400 feet, as indicated in Figure 6.22. By assumption, the viewpoint E is halfway up the building, and close to the front face, so let's say the distance from the viewpoint to the building is 40 feet, as indicated in Figure 6.22 (not to scale). Let h denote the height of the canvas we need to paint the picture, and as usual let d be the viewing distance.

Now we can apply some basic geometry. Figure 6.22 contains a large triangle whose base is the front of the building (400 feet long) and whose altitude from that base to the vertex E is 40 feet long. This triangle is similar to the smaller triangle with base h and altitude d. In similar triangles the ratios of corresponding bases to altitudes is always the same, and hence $h/d = 400/40 = 10$. Solving for h gives

$$h = 10\,d,$$

so the height of the canvas is 10 times the viewing distance.

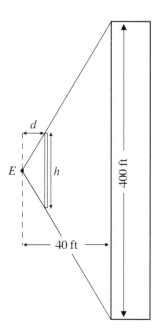

Figure 6.22. A viewer's eye E looks at a 400-foot building from 40 feet away (not to scale). The letter h denotes the height of the canvas needed to paint the building when the viewing distance is d.

It's worth noting that if $h = 6$ inches, as is approximately true in Figure 6.21, then the viewing distance d is a mere 0.6 inches. The reader ought to try this. It's a miserable distance for looking (because you can't focus), but nonetheless, you can roughly get the skyscraper effect by rolling your eye up or down.

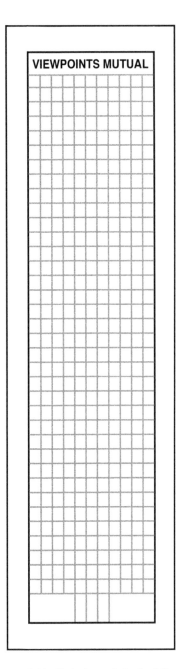

Figure 6.21. Painting of the building on a narrow canvas, assuming a picture plane parallel to the face of the building.

Now let's think about a more comfortable viewing distance for our painting. Even for ordinary reading we normally use a distance of at least a foot, so let us conservatively put the viewing distance d equal to 2 feet. But that means the canvas must be 20 feet high— the height of a two-story building! If we made the viewing distance greater than 2 feet, the canvas would be even taller.

To see what this situation looks like, look at the scale drawing in Figure 6.23 of a viewer looking at a 20-foot-high painting from 2 feet away. That's a very close look at a very big painting! Assuming that the painting is the picture of the Viewpoints building in Figure 6.21, we imagine what the viewer sees using the sketches in Figure 6.24. As the viewer looks upward at the big canvas, the sides of the canvas appear to converge to a vanishing point. (You can convince yourself of this by lying down in a doorway and looking up with your viewing eye not quite under the doorframe. You will see the sides of the doorframe appear to converge, just as the sides of the canvas would.) But the sides of the building are painted parallel to the sides of the canvas, so they appear to converge as well. Similarly, when the viewer looks downward, the sides of the building appear to converge to a second vanishing point. Thus the big painting has *no* vanishing points, but when it's viewed from the correct viewpoint it appears to have *two* vanishing points, just like the real skyscraper!

Figure 6.23. A viewer looks at a 20-foot painting from a viewing distance of 2 feet.

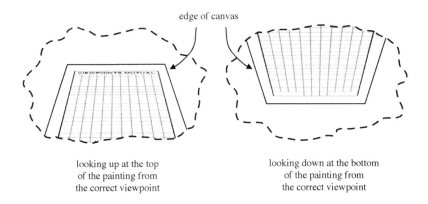

edge of canvas

looking up at the top
of the painting from
the correct viewpoint

looking down at the bottom
of the painting from
the correct viewpoint

Figure 6.24. What the viewer in Figure 6.23 sees.

"Now wait a minute," you might say, "that's cheating. Of *course* this works when you have a painting that's as big as a small building." But this is no trick. The mathematics shows that the tall canvas is a natural consequence of the viewer being relatively close to a very tall building. The height of the canvas must therefore be much greater than the viewing distance.

In answer to our original question, the perspective is not wrong, nor is it incapable of capturing our visual experience of tall buildings. In fact, the necessity for the viewer in Figure 6.23 to look both

Figure 6.25. Light rays from the skyscraper heading toward the viewer's eye pass through both the large canvas and the smaller sphere.

[4] Just as the skyscraper paradox isn't a true contradiction, these "counterexamples" don't contradict the theorems and definitions of mathematics. Rather, they are counterintuitive examples meant to enhance understanding of the theorems and definitions.

upwards and downwards in order to take in the whole painting exactly mirrors the necessity to do the same thing when looking at a skyscraper from close up.

On the other hand, it could be argued that while the perspective approach just described is not wrong, it is very inconvenient in this case, because of the requirement of a large canvas. How could we give the viewer the same "skyscraper experience" by painting on a smaller surface?

Figure 6.25 illustrates one possible answer. We imagine the viewer's eye to be at the center of a sphere. Since the sphere is capable of "catching" all the light rays that come from the skyscraper to the viewer's eye, a type of perspective painting could be painted on the inside of the sphere that would send the eye the same image it sees on the big canvas. This idea is the starting point for the spherical paintings of artist Dick Termes, discussed later in this chapter.

Apparent paradoxes provide a great way of enhancing our understanding of a subject. They force us to practice important basic techniques in order to resolve what seem to be contradictions. In doing so, we better understand these techniques and we gain confidence in them. For this reason, mathematicians compile whole books of apparent paradoxes, which they refer to as "counterexamples."[4] In art, the contemplation of such examples sometimes leads to new techniques such as spherical perspective.

The Six-Point Perspective of Dick Termes. South Dakota artist Dick Termes has made a career of studying and painting in spherical perspective. In this kind of perspective, the viewer's eye is at the center of a sphere that replaces the picture plane. As light rays from objects outside the sphere pass through the sphere on the way to the viewer's eye, we imagine them leaving appropriately colored dots on the sphere. The sum total of the colored dots makes an image on the sphere that, to the viewer at the center, is indistinguishable from the real world. In spherical perspective the viewer has the freedom to look in any direction and see a continuous image.

An interesting aspect of Termes's paintings, called *Termespheres*, is that the viewer is forced to look at the paintings from the *outside—* that is, from the "wrong" viewpoint. This leads to some interesting visual paradoxes. For example, Figure 6.26(a) shows a viewer in a restaurant looking through a sphere at a table. Since the viewer looks down at the table, the image of the table appears near the bottom of the sphere. This is illustrated in Figures 6.26(b) and (c), which are photographs of the Termesphere called *Food for Thought*, a painting of a restaurant in the La Fonda Hotel in Santa Fe, New Mexico. If we look at Figure 6.26(c) by itself we are tempted to think we are looking through the top of the sphere down onto the table. But, as

the other figures show, the top of the table actually appears on the *bottom* of the sphere. When we're outside the sphere, we must gaze up at the bottom of the sphere to look down at the floor!

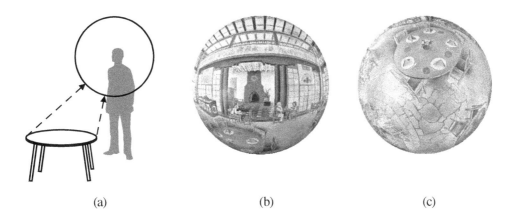

<div align="center">(a) (b) (c)</div>

Figure 6.26. A tabletop (a) projects onto the bottom of a Termesphere (b) and (c).

These kinds of paradoxes seem to disappear, however, when the spheres are seen while rotating. Even seen from the outside, the illusion of looking at an actual scene is very convincing; the scene seems to be contained in the sphere itself. At the time of this writing, a video of rotating Termespheres is available at www.termespheres.com.

Just as in ordinary perspective, vanishing points appear in spherical perspective. As a first example, let's go back to the idea of painting a skyscraper in spherical perspective. Figure 6.27 shows the front of a tall building projected onto a sphere. The vertical edges of the building project onto *great circles* of the sphere, like the lines of longitude on the globe. A great circle on a sphere is any circle whose center is the center of the sphere. These particular great circles meet at the north and south poles, which are in fact vanishing points for the vertical edges of the building. To see why, observe that if you were a viewer at the center of the sphere you would look straight up at the "north pole," hence your line of sight would be parallel to the vertical edges of the building. The same is true of the "south pole." This is analogous to vanishing points in ordinary perspective, except that for each vanishing point there is another one associated with the opposite direction.

More generally, if we want to draw a box—say a cube—in spherical perspective, we can have as many as six (not three) vanishing points. Figure 6.28 illustrates this idea when the sphere is located at the center of the cube. In this case the lines connecting the centers of opposite faces of the cube meet the sphere in the six vanishing points,

Figure 6.27. Projection of the face of a tall building onto a sphere.

three of which are visible as black dots. For this reason, Dick Termes refers to his art as "six-point perspective."

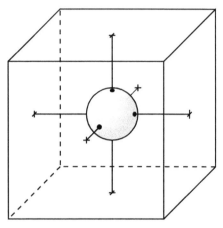

Figure 6.28. Locating the six vanishing points for the edges of the cube.

Exercises for Chapter 6

1. Altitude diagrams are good for more than just drawing in three-point perspective; we can also use them to analyze three-point perspective drawings and photographs. Figure 6.29 shows Spider-Man and parts of the altitude diagram associated with the three vanishing points V_1, V_2, and V_3. The top of the building just below Spidey is outlined in white, and we have marked a vanishing point D_3 of one of its diagonals. Make a copy of the diagram, and on the diagram construct a rectangle that represents the true shape of the top of the building.

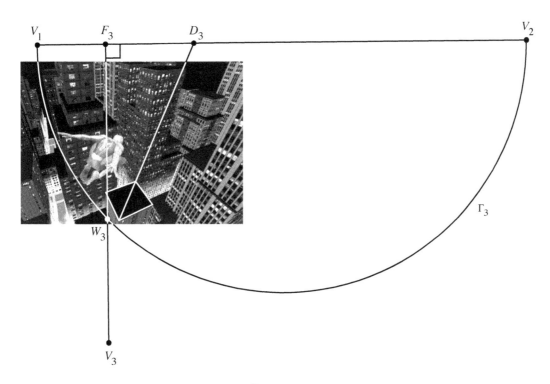

Figure 6.29.

2. Figure 6.30 shows an acute triangle and one of its altitude circles. Using only a straightedge, and without drawing any circles or measuring any angles or distances, draw the three altitudes. Explain how you did it so easily.

Figure 6.30.

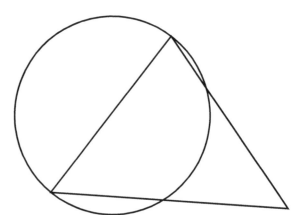

3. Figure 6.31 is a setup for a three-point perspective drawing of a bird's eye view of a tall building. It includes the viewpoint triangle, two vanishing points for face diagonals, and the near vertical edge of the building (in black). Finish the drawing.

Figure 6.31.

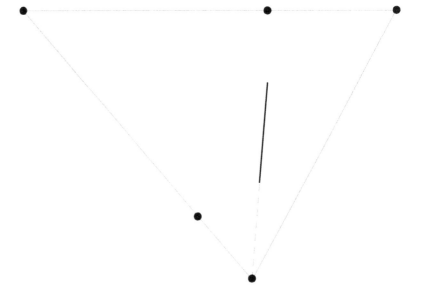

4. Figure 6.32 shows a rectangular block floating in the air. Find the viewing target and viewing distance. (You'll need a compass.)

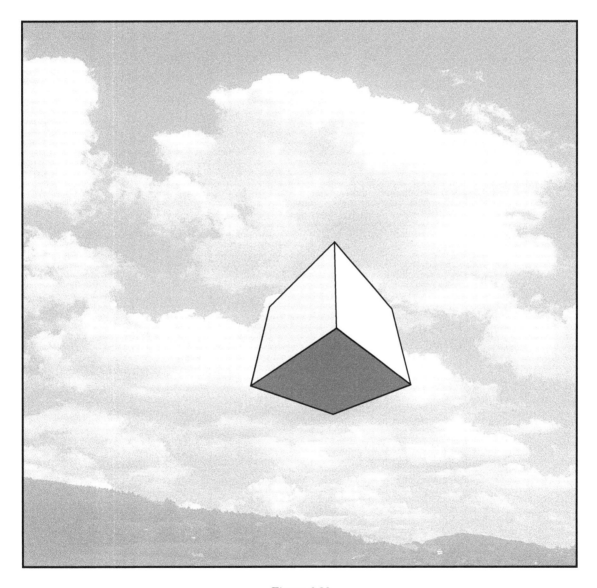

Figure 6.32.

5. Figure 6.33 shows three vanishing points (black) and the associated altitude diagram. Locate the three diagonal vanishing points for a cube. You may use a protractor, or you may cut out squares of paper and trace them, if you like.

Figure 6.33.

6. Figure 6.34 shows the viewpoint triangle from Figure 6.33 and the near vertical edge of a cube. By measuring along the sides of the viewpoint triangle, transfer your diagonal vanishing points from Exercise 5, and then finish drawing the cube.

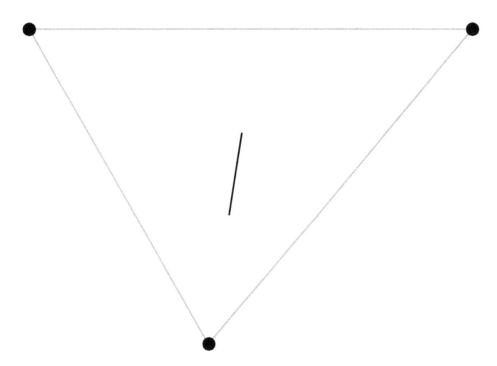

Figure 6.34.

7. In three-point perspective, draw a box whose proportions are $1 \times 2 \times 3$, with a viewing distance of approximately 8 inches.

Artist Vignette: Dick Termes

DICK TERMES is an artist from the Black Hills of South Dakota where he lives with his wife Markie Scholz in five geodesic domes. Three of the domes are their home, one is a double-story studio, and the other is a gallery where the spherical paintings are shown. Termes has a Master's degree in Painting from the University of Wyoming and a Master of Fine Arts degree in Design from Otis Art Institute in Los Angeles, California. He has worked for the past 37 years developing and refining six-point perspective on spherical canvases that hang and rotate from ceiling motors. His concepts are a wonderful bridge between art and math.

I WAS BROUGHT UP in the small town of Spearfish, South Dakota, in the northern Black Hills. I went through most of my first sixteen years of school there and concluded with a Bachelor of Science degree in Art from Black Hills University in 1964. My father was a very fine house builder in Spearfish where he built over 35 houses by himself. I was brought up with that trade. My mother helped with the interior design and furnishing of these houses and also kept the books. We lived in 18 different houses by the time I graduated from high school. My dad would build the houses, Mom would make them look wonderful, and soon they were sold and we were living in a new home. I was brought up knowing you can do what it is you like to do and somehow make a living.

My interest in art started early. I saw I could draw a house a lot faster than my dad could build one. I have memories of art in the third grade where we did murals in our classroom. I did my first perspective drawing in junior high. When I was a junior, a painting class I was in made me aware, all of a sudden, that worlds could be created within that flat canvas like a window to another world—a world that was within my mind. My first painting was a copy of a Charlie Russell painting, but soon I was looking at the world around

"When I was a junior, a painting class I was in made me aware, all of a sudden, that worlds could be created within that flat canvas like a window to another world—a world that was within my mind."

me and inside my mind for ideas. I began to realize that the many questions I had could be used for my subject matter.

My connection with math and geometry started with wanting my paintings to have harmony within them. I had a couple of wonderful instructors at the University of Wyoming who helped me with this. I realized that if each line drawn or painted had some relationship with every other line, or if every color had some mental relationship with every other color, there would be a good reason why the compositions looked good or "worked." Little did I know I was using geometry in my work. When we say an art piece "works" in art, we mean it all looks good, nothing bothers the eye. In math it means there is an underlying system connecting it together. There is, therefore, a strong relationship between design in the art world and geometry in the math world. Later I realized that if you started with the geometry and created the drawing out of it, or if you conformed to the geometry with the drawing, some wonderful things could happen. M.C. Escher's art taught me some of these ideas of mixing geometry with the drawing. Having the realistic drawing grow from the geometry forces greater creativity. With geometry involved, every line is related to every other one. The challenge with this kind of thinking is to not let it become boring by having it be a repeated pattern. Creativity is forced into overtime to find a variety of interesting images to help make the composition exciting and also say something important.

The six-point perspective I use when painting on spherical surfaces came out of this same kind of thinking. How to organize the whole visual world around you into one picture was my problem. I didn't just want to do a 360-degree picture. I wanted to find a system that would help organize this. This is what led me to the math and geometry side.

When I do my spherical paintings, which are called *Termespheres* (Termes and spheres), I imagine I am on the inside of a transparent sphere looking out. With one eye turning in the center of the sphere, I copy onto the sphere everything I see in the environment outside the sphere. I not only turn in a circle but look up and down too. It is like a panoramic photo except it goes all the way above and below you. It is a simple idea, one that we experience every day when we are in those environments that are great in every direction. These are the environments you take pictures of and when you get home and look at the results you are disappointed because you didn't get enough of the picture. Some scenes just need the total picture.

The spherical paintings are usually not large enough to paint the scene from inside the ball, so I do the painting on the outside. Most of the subjects I paint are the interiors of famous architecture, surrealistic worlds from my imagination, or geometric patterns that fit

"When we say an art piece 'works' in art, we mean it all looks good, nothing bothers the eye. In math it means there is an underlying system connecting it together."

". . . I imagine I am on the inside of a transparent sphere looking out. With one eye turning in the center of the sphere, I copy onto the sphere everything I see in the environment outside the sphere."

on the sphere.

When I paint the famous interiors I use six-point perspective to help keep me organized. This system is very mathematical. If I didn't use some organized system, I might come around to the opposite side of the spherical painting and be three inches off. This would not be good. As I still am imagining I am inside the sphere when I paint on the outside, I am dealing with a total up, down, and all-around environment.

Most of the famous architecture in the world is based on the cube. The cube has six different square sides to it. Buildings like Notre Dame of Paris, even though they look very complicated, are still just an expansion of the cube. They still only have six planes within them and three sets of parallel lines. One set of these lines, you could say, runs north and south, another runs east and west, and the third runs up and down. Each of these sets of lines run to opposite points on the sphere. Because there are three different sets of parallel lines to the cubical architecture, we need six points around the sphere. These points need to be equally spaced around the sphere like the six vertices of the octahedron.

I have produced over 300 one-of-a-kind spherical paintings, which show many different kinds of concepts. As the sphere has many properties that the flat surface does not have, new ideas can be expressed that have never existed before. Some of these new ideas deal with unique geometries. Others take advantage of the motion I use and that the sphere has one side always hidden from the viewer. Subjects that transform from one thing on one side to a totally different thing on the other side can take place. The transparent sphere also inspires many new ideas. Some of these ways of using the sphere can be seen below.

Different views of *Gargoyles in St. Denis* (below) show the use of six-point perspective on the sphere. This shows it is one continuous picture that comes back upon itself no matter which way you turn the spherical painting.

Dick Termes, *Gargoyles in St. Denis*, 2005, acrylic on polyethylene sphere, 16-in. diam.

Brain Strain plays with a six-point perspective system five different times on this sphere. The five sets of points of the six-point perspective come from the geometry of the center of the edges of the dodecahedron. The dodecahedron has thirty edges on it, so this sphere ends up with thirty-point perspective.

Dick Termes, *Brain Strain*, 2004
acrylic on polyethylene sphere, 24-in. diam.

Food for Thought portrays a beautiful restaurant in the La Fonda Hotel in Santa Fe, New Mexico. It is said to be the oldest hotel in America. Its structure has wonderful lines that show off the six-point perspective very well. The round tables added an extra structural problem to this painting.

Dick Termes, *Food for Thought*, 2004
acrylic on polyethylene sphere, 24-in. diam.

The Old Ball Game (see the Plates section) shows what it would be like if you had a transparent sphere on your head and copied the up, down, and all-around view you would see if you were standing on the stadium stairs at Wrigley Field in Chicago.

Hagia Sophia (Plates section) in Istanbul gives you a view of the inside of this great building about 60 feet above the floor. The six-point perspective system works perfectly from any vantage point within the building. The six vanishing points are at the top, bottom, north, south, east, and west points of the sphere.

▣ For more of the artist's work, see the Plates section.

CHAPTER 7

Anamorphic Art

THERE are times when the correct viewpoint for a painting is in a surprising location, and there are even paintings for which there is more than one intended viewpoint. Such paintings are included in the category called *anamorphic art*, which became popular in the sixteenth century. An example of anamorphic art with more than one intended viewpoint is the painting in Figure 7.1: *The French Ambassadors* by Hans Holbein the Younger (1497–1547).

When viewed from directly in front as in Figure 7.1(a), the painting seems perfectly normal, except for a strange, elongated object which seems to float above the floor. If we change our viewpoint to one at an oblique angle at the extreme right of the painting as in Figure 7.1(b), the object is seen to be a human skull! The skull is sometimes interpreted as representing the transience of life. For us the main point is that there is no single correct viewpoint for this painting.

Another example of a painting which requires an unusual viewpoint is the anamorphic portrait of Edward VI in Figure 7.2. In order to see the portrait correctly, we must view the painting from so far to the right of the canvas that the picture frame had to be cut away to keep from blocking our view! Not surprisingly, this picture looks distorted when viewed from the front, as can be seen in Figure 7.3.

(a) (b)

Figure 7.1. In (a), Hans Holbein the Younger, *Jean de Dinteville and Georges de Selve ("The French Ambassadors")*, oil on oak, 81 × 82 in. National Gallery, London. In (b), the side view from the viewpoint for the skull.

How did the artist manage to do it? For something as "ungeometrical" as a human head, mathematical computation alone would be too difficult. What is needed is the artist's skill in painting, combined with some sound mathematical reasoning to achieve the correct "distortion."

Figure 7.2. *King Edward VI* by William Scrots. Oil on panel, 1546, 16.75 × 63 in. National Portrait Gallery, London.

Figure 7.3. Frontal view of the painting in Figure 7.2.

Let's try the trick ourselves, using a smiley face as the subject. We begin by visualizing the situation in the top view of Figure 7.4. A circular smiley face on a wall is projected through a picture plane to the viewpoint E in such a way that the line from E to the center of the face is perpendicular to the wall. Thus the viewer at the correct viewpoint E sees the smiley face image as being undistorted, just as we see the face in Figure 7.2 as being undistorted.[1] On the other hand, the viewer at the point F directly in front of the picture plane image sees the image as being distorted, since F is not the correct viewpoint. The viewer at F sees a face that is stretched horizontally, with the mouth and eyes skewed to the right side of the face. This is like the view of *King Edward VI* in Figure 7.3, where we see the face skewed to the right side of a horizontally stretched ellipse. Therefore, the picture plane image in Figure 7.4 is exactly what we want: it is "anamorphic" in the sense that we must view it from an unexpected viewpoint E in order to remove the distortion.

As a guide to creating such an image, we imagine in Figure 7.4 a square grid superimposed over the face on the wall. Both the wall and the picture plane are vertical with respect to the floor, but the picture plane makes a nonzero angle θ with the wall. The picture plane image of the grid therefore has a vanishing point V, and as always, the line of sight from E to V is parallel to the lines whose images converge to V. Thus V is directly to the right of the viewer at E, and the line of sight from E to V is perpendicular to the line of sight from E to the center of the face.

We begin with an undistorted smiley face in Figure 7.5 and draw an 8×8 grid of squares over it; this corresponds to the face on the wall at the top of Figure 7.4, although we have used more squares for greater accuracy in our end result.

Next, we must draw a perspective image of our 8×8 grid, corresponding to the dotted grid on the picture plane in Figure 7.4.

We do this in Figure 7.6, using our fence-dividing techniques from Chapter 4. Because we want the viewer's eye to be level with the center of the grid (as in Figure 7.4), we make the grid in Figure 7.6 symmetrical about the horizontal line through V. Thus the left edge of the grid extends equally above and below the horizon line through V, as indicated. There is another requirement which we will explain later. Namely, the grid should be sufficiently elongated in the horizontal direction so that a diagonal line that goes through the image C' of the center of the grid and through the corners of neighboring grid squares makes an angle α that is less than $45°$.

[1] Meaning that the viewer sees the outline of the smiley face and the smile as concentric circular arcs. In this sense the setup minimizes the distortion of the anamorphic drawing when seen from E. Other subjects may not suggest any particular choice of setup. It's up to you to make those creative decisions!

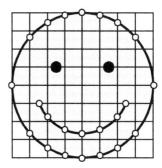

Figure 7.5. An undistorted smiley face with a square grid superimposed on it. This corresponds to the face and the grid on the wall at the top of Figure 7.4.

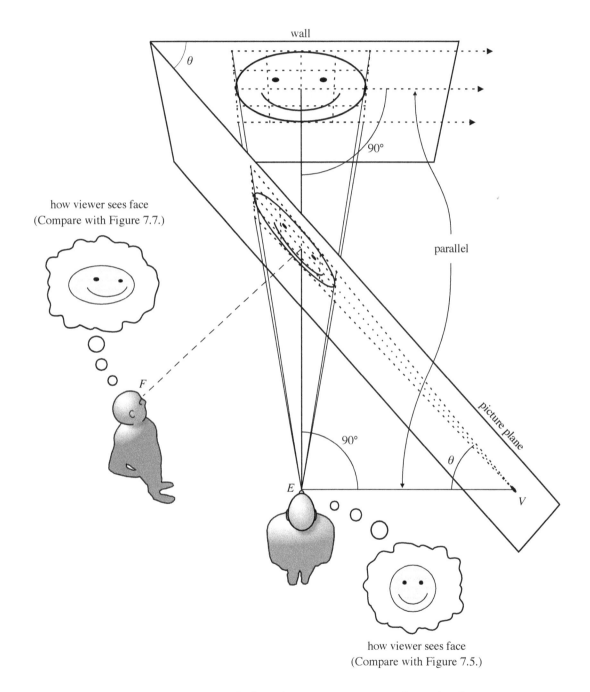

wall

θ

90°

parallel

how viewer sees face
(Compare with Figure 7.7.)

F

picture plane

90°

θ

E

V

how viewer sees face
(Compare with Figure 7.5.)

Figure 7.4. Two viewers look at the perspective image of a smiley face.

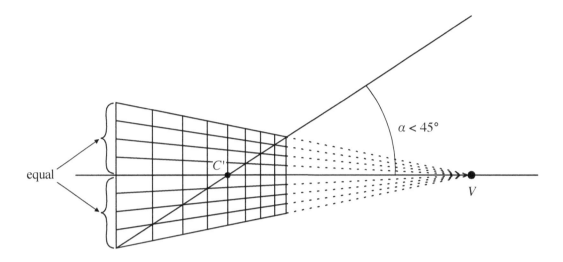

Figure 7.6. A perspective drawing of the square grid from Figure 7.5.

Figure 7.7 shows the final step of transferring the face from Figure 7.5 onto the perspective grid copied from Figure 7.6. We first transfer each white dot from Figure 7.5 to its corresponding location on the grid of Figure 7.7; we locate each point visually, trying to be as accurate as possible. We then sketch in the rest of the face. Notice that in doing so, we made the eyes elliptical, with the left one larger than the right one. (This could be done more accurately by using a finer grid with more squares.) An enlarged version of the face appears in Figure 7.8.

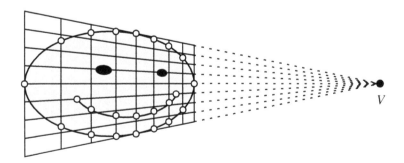

Figure 7.7. Transferring the face to the perspective grid.

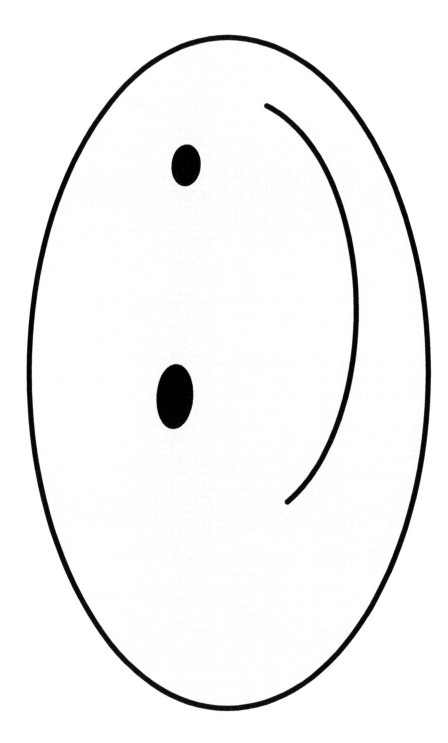

Figure 7.8. Enlarged version of the anamorphic face.

If you view the enlarged anamorphic drawing in Figure 7.8 from the extreme right side of the face with one eye, you can see it as being undistorted. (You have to get very close to the page to make the eyes seem the same size.) A similar technique could be used by a portrait painter to achieve effects like that in Figures 7.2 and 7.3.

The drawing in Figure 7.8 does indeed have a very close viewpoint. Technically, this should be fixed by making the face much larger. Similarly, our examples of anamorphic paintings are quite large: the painting in Figure 7.3 is actually more than five feet wide, and the Holbein in Figure 7.1 is almost seven feet high—the figures in it are essentially life-sized.

In order to know how large to make an anamorphic drawing, so that it has a comfortable viewing distance, we must know how to compute the viewpoint. We will specifically tackle the problem of finding the viewpoint of Figure 7.7; in doing so we will also show why the angle α in Figure 7.6 must be less than $45°$.

In Figure 7.9 we have redrawn the setup of Figure 7.4. Circumscribed around the face on the wall at the top of the figure is an undistorted square—the outline of the grid we used before. We use C to denote the center of the square (the intersection of the diagonals), and we use C' to denote the perspective image of C' in the picture plane. Because $\angle VEC'$ is a right angle, the viewpoint E lies on the horizontal semicircle Γ (Greek letter Gamma) whose endpoints are V and C'.

To determine exactly where on Γ the point E lies, we construct a second horizontal semicircle Δ (Delta) in Figure 7.10 as follows. We extend a diagonal Λ (Lambda) of the undistorted square; the perspective image of Λ is the line $\overleftrightarrow{C'V_1}$, whose vanishing point is V_1 (V_1 lies in the picture plane). Now the line of sight from E to V_1 must be parallel to Λ as indicated, hence V_1 lies directly above V and the angle $\angle VEV_1$ is a $45°$ angle. Since the viewer must therefore look up to V_1 from E at a $45°$ angle of elevation, the viewpoint E lies on a right circular cone (shaded in cutaway form) with axis $\overrightarrow{VV_1}$, vertex V_1, and an opening angle of $2 \times 45° = 90°$. The cross section of this cone in the horizontal plane containing E is a circle, half of which is the semicircle Δ; E must lie somewhere on this semicircle. Since E also lies on Γ, it follows that E is precisely the intersection of the semicircles Γ and Δ.

One thing we must make sure of is that the semicircles Γ and Δ actually do intersect; if Δ were too big, Γ would lie entirely inside of it and the two semicircles would not meet. Thus in order for the semicircles to meet at a meaningful viewpoint E, the angle $\alpha = \angle VC'V_1$ must be less than $45°$; this is exactly the same angle α as in Figure 7.6.

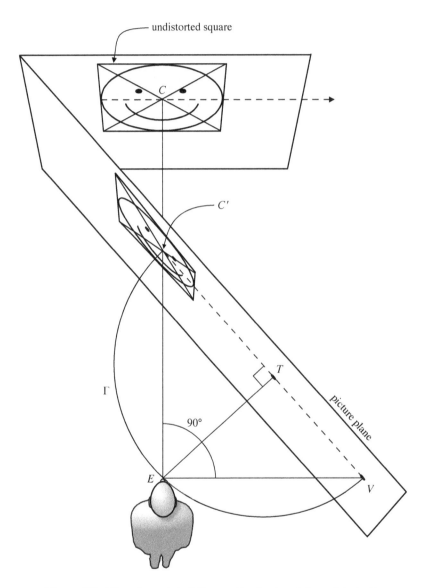

Figure 7.9. The viewpoint E lies on the horizontal semicircle Γ.

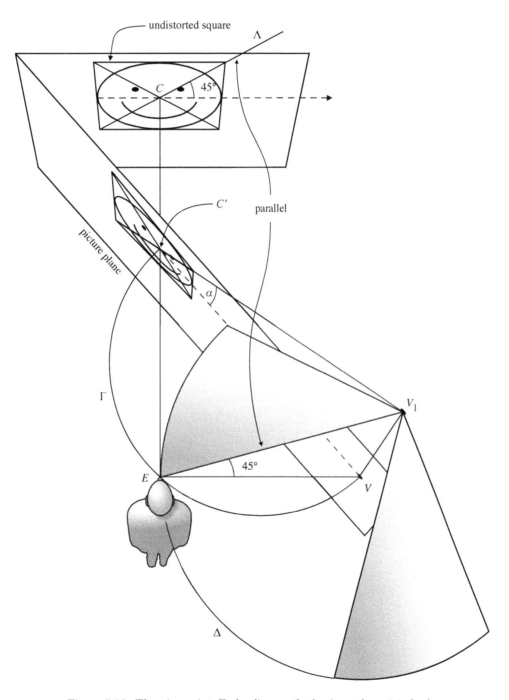

undistorted square

Λ

C 45°

C′

parallel

picture plane

α

Γ

V_1

45°

V

E

Δ

Figure 7.10. The viewpoint E also lies on the horizontal semicircle Δ.

We can now determine the viewpoint of the perspective grid in Figure 7.6. This is useful, because before we transfer a drawing to the grid, it's important to know whether the viewpoint will be comfortable for viewers. In Figure 7.11 we started with the perspective grid from Figure 7.6 and added two circular arcs $\tilde{\Gamma}$ and $\tilde{\Delta}$ ("Gamma tilde" and "Delta tilde"), along with some extra points and lines. We claim that the viewpoint E for the grid lies directly in front of T at a distance equal to $|\overline{TU}|$. Can you explain why?

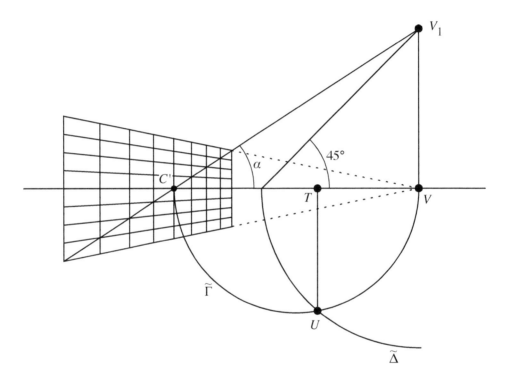

Figure 7.11. Finding the viewpoint for the perspective grid.

Finally, we emphasize what we said at the beginning of this chapter: the type of art described above is just one kind of anamorphic art. Exercise 5 below lists several other examples you can explore.

Exercises for Chapter 7

1. Figure 7.12 shows a perspective grid ready for an anamorphic drawing of the kind just described. Make a copy of Figure 7.12 or draw your own version of it. Then, using a straightedge and compass, duplicate the steps in Figure 7.11 to find the viewpoint. The idea is to see for yourself what order the lines, points, and circles must be drawn in.

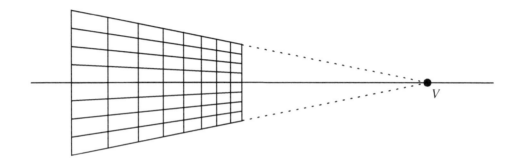

Figure 7.12.

2. Take a cartoon image from the newspaper or a comic book and trace it onto a square grid, or draw a square grid on the comic. Use it to create your own anamorphic art.

3. When we draw a perspective grid for an anamorphic drawing as we did in Figure 7.6, we automatically determine a distance from the viewpoint to the paper equal to $|\overline{TU}|$ in Figure 7.11. However, we might want to do things in the reverse order by choosing the distance from the viewpoint to the paper first. Suppose you want to make a piece of anamorphic art for which the distance between the viewer's eye and the paper is 1 inch. How would you construct a grid that helps you accomplish this drawing?

4. Is it possible to find the viewpoint of *King Edward VI*? (See Figures 7.2 and 7.3.) It seems pretty hard, since we don't have the original perspective grid the artist used—assuming that's how it was done. However, if we make an additional simplifying assumption, we can not only estimate the viewpoint, we can essentially recover the original perspective grid!

Specifically, we assume that the camera was not quite at the correct viewpoint in Figure 7.2 because the seal behind the king still looks elliptical, rather than circular as most official seals do. That is, we assume that the distorted seal, reproduced on the left of Figure 7.13(a), is meant to be seen as an annulus (the washer-shaped region between two concentric circles), as indicated on the right of Figures 7.13(a), (b), and (c).

Using the diagrams of Figure 7.13 as hints, explain how to determine the viewpoint for the gallery viewer in Figure 7.13(e). What order are the lines, points, and circles drawn in? You may need to add more labeling to aid your discussion. (The woman viewing the painting is shown approximately to scale—notice how large the painting is.)

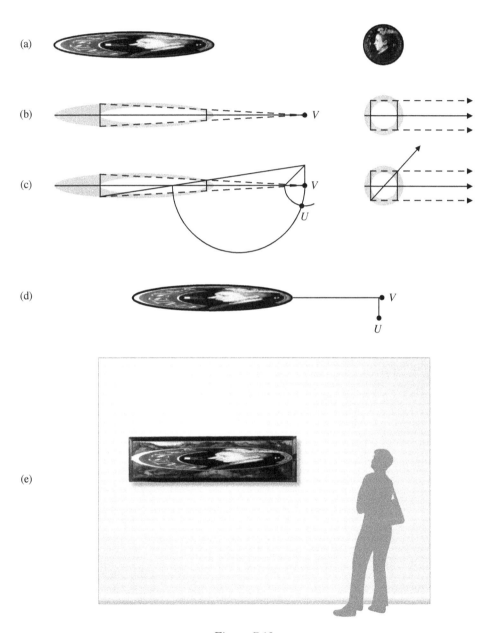

(a)

(b)

(c)

(d)

(e)

Figure 7.13.

5. Anamorphic Assignment

Perspective techniques can make a 2-dimensional painting or drawing seem 3-dimensional: part of the real world. But as we have seen in this chapter some people use perspective to create unrealistic or unnatural effects. In this project, you will investigate a piece of art that uses (or perhaps deliberately misuses) perspective to create an illusion. The goal of this project is to describe the effect that the artist intends, and also describe carefully and accurately the role that perspective geometry plays in creating this effect.

You will follow three steps.

Step 1. Choose the piece of art from the list below, or use this list as a guide for choosing another piece of art.

Step 2. Describe your piece and place it in an artistic and historical context.

In this step, you should focus on describing the piece itself; do not worry (yet) about the mathematical and perspective techniques that your artist uses. You will probably want to address basic factual details: the title of the piece, the name of the artist, materials used, size, color, texture, when it was made, where it is currently located, and other important physical details.

To be thorough, you will have to do some library research, which may include the history of this particular piece, biographical information about the artist who created it, and/or the artistic genre out of which this piece arose. In addition, you will probably want to investigate reactions to the piece: from the artist him- or herself, from other artists, or from critics.

It may help to compare and contrast this piece with other pieces of art. This comparison might take the form of describing your piece as existing within or growing out of a particular genre of art; it might also take the form of describing how this piece breaks with tradition.

Step 3. On your own, using the techniques in this book, investigate the mathematical perspective in this piece.

In this step, you will examine the geometrical and perspective techniques that your artist uses. The previous step described a piece of art and how the artist attempted to distort reality. Step 3 should focus rather on technical aspects of perspective in your piece of art. (In other words, it is in this step that you get to prove you've understood the techniques of this book.) Your descriptions should be precise and specific. "The artist uses 6 vanishing points" is not specific (why six? where are

they?), but "The top of the sphere is the vanishing point for all vertical lines, because ..." is specific.

List of possible art pieces. Choose a piece of art from one of these categories below. Since artists often create several pieces using the same technique, we list the artists rather than individual pieces.

Drawings on nonplanar canvases:

- Dick Termes paints perspective paintings on spheres; he was strongly influenced by M.C. Escher and Buckminster Fuller.

- The Ames Room deceives the eye: this visual psychology tool has been so intriguing that many science museums and children's museums feature one.

- Salvador Dali, who is famous for his surrealism, excelled in part because he was so adept at perspective that he knew exactly how to break the rules. He played with anamorphic art that creates new images when reflected in mirrored cylinders (see *Matthew*, *Harlequin*, and *Man and Woman* (1974)). Other artists who create anamorphic art with reflective cylinders are Istvan Orosz and Kelly Houle.

- Patrick Hughes is an artist who creates "reverse perspective" pieces, where the front of a folded canvas seems to be the back, and vice versa. Norman D. Cook is a professor of informatics who studies Hughes's work and creates his own reverse perspective pieces. These pieces have an eerie sense of motion to them.

Looking with two eyes:

- Dali also did stereoscopic panels (see *Gala's Christ* (1978)) and projections of four dimensions onto three dimensions.

Impossible figures:

- There are many living artists who play with "impossible figures." M.C. Escher is one of the most popular and well-known of these. Others include Sandro del Prete, Jos De Mey, and Oscar Reutersvärd. Sir Roger Penrose is a living mathematician who discovered an impossible figure.

Sculptures with forced perspective tricks:

- Roy Lichtenstein created a perspective illusion in a sculpture called *House I* (1996/1998).

- Mathieu Hamaekers adds another dimension to the impossible figures by constructing 3-D sculptures of them. From most angles, they are twisted objects, but from one viewpoint they become the impossible cubes of Escher's drawings. See *Impossible Possibility* and *Impossible Cube* (1984).

- Among Shigeo Fukuda's many amazing works are several "shadow sculptures." A collection of bottles, glasses, shakers, and openers casts a shadow of a woman with a parasol in *Bonjour Mademoiselle* (1982). A hanging mobile of welded forks, knives, and spoons cast the shadow of a motorcycle on the ground in *Lunch with a Helmet On* (1987).

- Shigeo Fukuda also has a series of sculptures which seem distorted and bizarre, but when reflected in a mirror turn into familiar objects (*Van Gogh's Sunflowers* and *Fresh Guy, Archimboldo* (1988), *Underground Piano* (1984), and *Mixed Rice in Chinese Style* (1986)).

Trompe l'oeil:

- Trompe l'oeil (French for "fool the eye") is one of the most popular illusions using perspective. Artists too numerous to count have used this "trick" to make rooms seem larger, to pretend that plaster is peeling from walls, or to fool the viewer into thinking the wall isn't even there. A version of trompe l'oeil that creates the illusion of arches or domes on a flat ceiling has its own Italian name: *di sotto en su*. Modern street artists alter the facades of exterior walls to create interesting, vibrant spaces on otherwise monotonous walls. In 2008, the city of Philadelphia announced it was experimenting with trompe l'oeil speed bumps as an inexpensive way of calming traffic.

Postmodernism (deliberate rejection of perspective):

- David Hockney's *The Chair* (1985) intentionally rejects traditional perspective (where the viewer stands still), and instead attempts to draw the experience of walking around a chair. *Pearblossom Highway, 11–18th April 1986 #2* (1986) is a photographic collage that combines "correct" perspective in each photograph with multiple viewpoints.

- Giorgio de Chirico painted moody streetscapes (such as *Melancholy and Mystery of a Street* (1914)) that intentionally misuse perspective to create a mood.

Special viewpoints:

- Julian Beever is a sidewalk artist who has gathered quite a pop following. He creates pieces that seem to tunnel down into the pavement or rise up above it, at least when seen from the right place.

- William Cochran created a mural on the Community Bridge in Frederick, Maryland. The entire bridge is worthy of study—lots of interesting trompe l'oeil. But the most stunning piece is an anamorphic painting on the bridge, whose "correct" viewpoint is through a window of the museum shop.

- The artist John Pfahl created a series of photographs called *Altered Landscapes*, in which he placed objects in certain special arrangements using perspective. For example, for one scene he laid out 6 orange spheres of differing size at certain points in a scene, using perspective to make all of them look like they're exactly the same size.

Viewpoints at the Movies: Forced Perspective and the Hitchcock Zoom

MANY PEOPLE use words like "realistic" or "accurate" when they describe perspective drawing; these words describe what many people regard as the difference between pre-Renaissance and Renaissance paintings. But perspective is a tool, and good artists can use tools in creative ways that the originators hardly intended, including making perspective art that is deliberately misleading. We see that kind of misdirection in the anamorphic art of Chapter 7, where the artist chooses an unusual viewpoint for the drawing.

Photographers and filmmakers automatically create perspective pictures: the camera ensures that. And the camera also dictates a viewpoint. But a good photographer or filmmaker still has some good perspective tricks up the sleeve that can create interesting illusions. Here, we'll describe two of these.

Forced Perspective. Figure A shows a typical "forced perspective" shot: it looks like Dorothy Uhland is holding a very tiny Sarah Berten in her upraised hand! Of course, in reality, Sarah was standing on a tall sculpture far behind Dorothy. You might have seen "photographs" of fishermen holding giant fish (with the real, tiny fish close to the camera and the fisherman far back at the end of the pier). Those are forced perspective, too.

Such photographs don't need special equipment, but getting them just right often requires several attempts. The reason is hidden in the title of this kind of photograph: the camera forces the viewer into a particular spot that makes the illusion work. And getting into the right spot is tricky, because small shifts in location can spoil the illusion completely. For example, compare the two photographs below. The photograph on the left is an amateur attempt at forced

Figure A. An illusion created by forced perspective.

perspective. It is unconvincing, but it gives a vague impression of Sarah standing next to a giant purse. In the photograph on the right, the photographer moved up only 12 inches, but there is no chance that anyone would think that the purse was larger than usual. Location matters.

Figure B. Making a purse seem large (or a person seem small) depends strongly on camera placement.

The Hitchcock Zoom. This film technique goes by many different names, including "dolly zoom" (because the camera is pulled on a dolly) or "Vertigo zoom" (because one of its earliest uses was in the Alfred Hitchcock film *Vertigo*). The zoom is usually used in a scene where the director wants to give the audience a sense of dread or impending doom.

The mechanics of the zoom are easy to describe: the camera is on a dolly on a track; the camera is simultaneously pulled back while the lens is zoomed in. In this way, the character who is the focus of the shot stays the same size, but (as we'll describe), the background changes.

Let's see what effect this zoom has on what our audience sees. Suppose our movie camera is looking at a young boy in front of a house, as in Figure C. Because the camera starts close to the boy in (a), at first his face is relatively large in the picture. For example, the door and one shutter appear to be about the same width as the boy's head, even though these objects are much larger in reality. This is shown schematically by viewpoint E_a in the diagram below. A viewer at E_a would see the images of the gray disc and the black line segment on picture plane A as about the same size. In photograph (b), the camera has been moved back and the picture enlarged and cropped to make the image of the boy's head appear the same size as before. Even though the boy has not moved relative to the building, the door appears much larger; the entire background appears to have expanded. This is illustrated by viewpoint E_b in the diagram below, where the new picture plane B is located to keep the gray image of the disk the same width as before. Notice, however, that more black appears on picture plane B; more of the background object

is now visible, so the background appears larger. The movement of the viewpoint from E_a to E_b is analogous to the pulling back of a movie camera from E_a to E_b, and the movement of the picture plane is analogous to the zooming in of the lens to keep the image of the boy's head the same size.

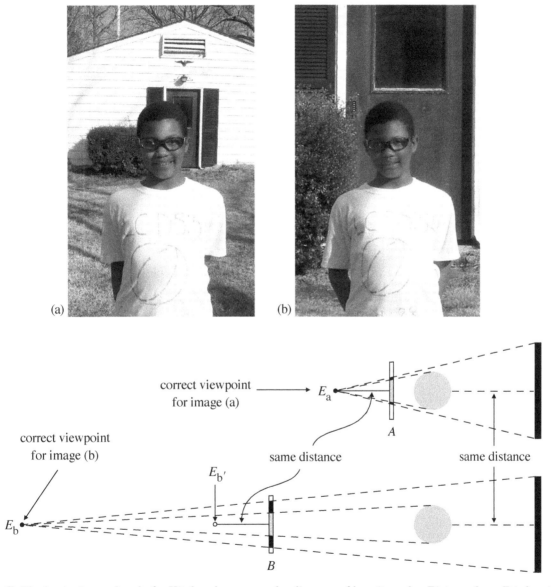

Figure C. The beginning and end of a Hitchcock zoom, and a diagram of how it works. Picture plane B is located to keep the gray image the same size as in A, but more of the background is visible.

The Hitchcock zoom is much more effective in movies than in photographs for two reasons. First, the real Hitchcock zoom takes place continuously—it's not just a pair of photos.

The second reason is tied to an obvious but important fact: at the movies you can't leave your seat and run up and down the aisle to keep up with a moving viewpoint. Assuming that your seat was at the correct viewpoint E_a at the beginning of the zoom, you could only stay at the correct viewpoint during the rest of the zoom by jumping out of your seat and sprinting backwards up the aisle, ending up at E_b. If you did that, you wouldn't see anything unusual on the screen—it would just look like things normally look if you're backing away from a boy and a building. But Hitchcock knew that kind of behavior wasn't allowed in theaters. Having viewers trapped in their seats, he could rush the viewpoint away from them with breathtaking speed, giving them no chance to catch up and make sense of what they were seeing on the screen. In the bottom diagram of Figure C we can think of the viewer's seat as point $E_{b'}$, the same distance from the picture plane (the screen) as before, which is much closer than the correct viewpoint E_b.

The zoom is usually very quick (sometimes it lasts only half a second). Since the audience is focusing on the main character and not on the scenery, it's hard for the people who are watching the movie to understand exactly what's going on. Instead, they get a sudden sense that the world seems to explode around the poor character.[1] This zoom appears at key emotional points in movies: when the heroine sees her father die in *Ever After*, just before an evil Ringwraith comes for Frodo in *The Lord of the Rings*, and as Police Chief Brody witnesses a shark attack in *Jaws*. You can also see a slow, tense zoom toward the end of *Goodfellas* as Henry talks with his buddy Timmy and realizes that things are getting very, very bad.

[1] The world can also appear to rush in toward the character if the zoom is reversed (dolly in and zoom out). This happens in a humorous tribute to the Hitchcock zoom in *Shrek*, just before Monsieur Hood gets clobbered by Princess Fiona.

Sherry Stone, *Parrot Girl*, 2006, oil on board 12 × 16 in.

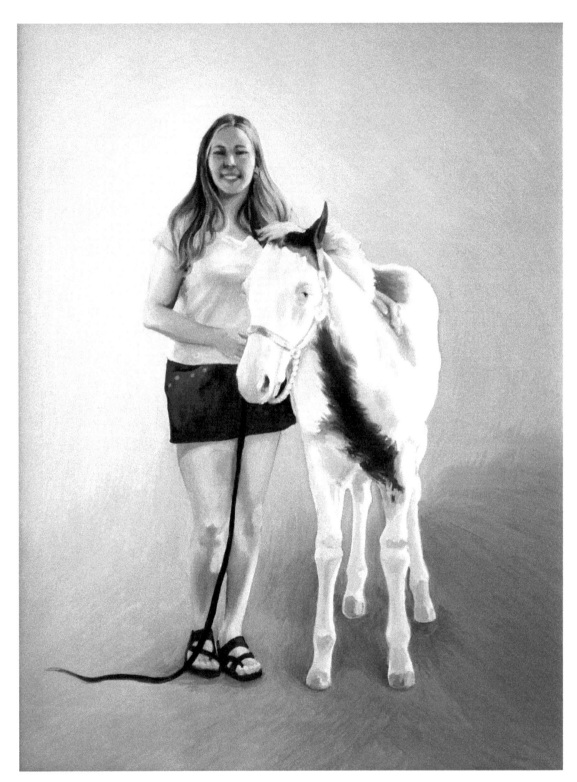

Sherry Stone, *Blue-eyed Filly*, 2006, oil on board 12 × 16 in.

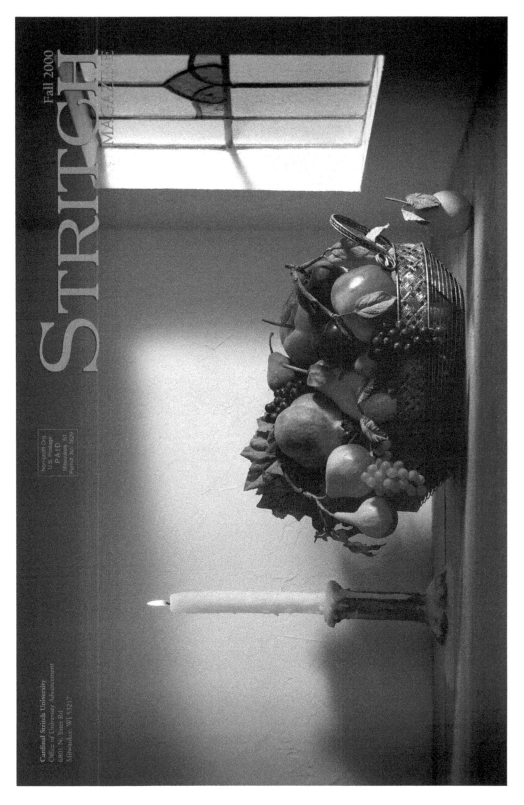

Peter Galante, Cover, *Stritch* Alumni Magazine, 2000. Conceptual theme: Values in the workplace
Transmedia, 4 × 5 in. film originals, Office of University Advancement, Cardinal Stritch University

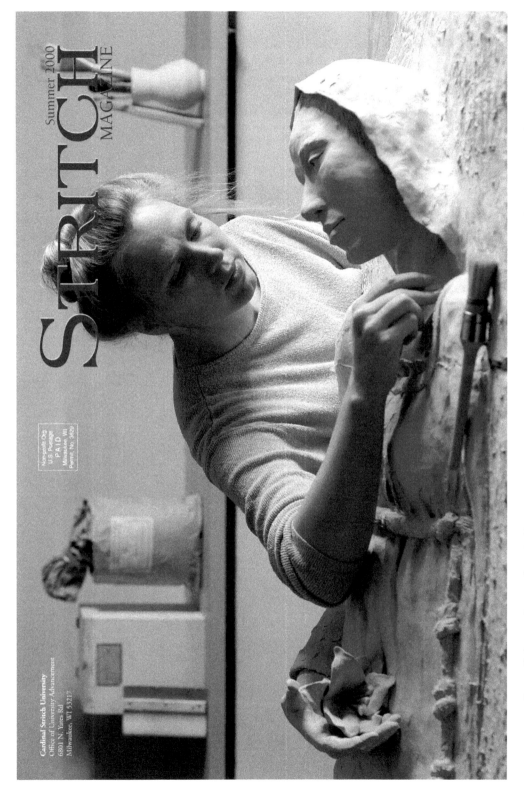

Peter Galante, Cover, *Stritch* Alumni Magazine, 2000. Conceptual theme: Visual and performing arts at Stritch Transmedia, 4 × 5 in. film originals, Office of University Advancement, Cardinal Stritch University

Jim Rose, *Lurches Clouds*, 2005, watercolor

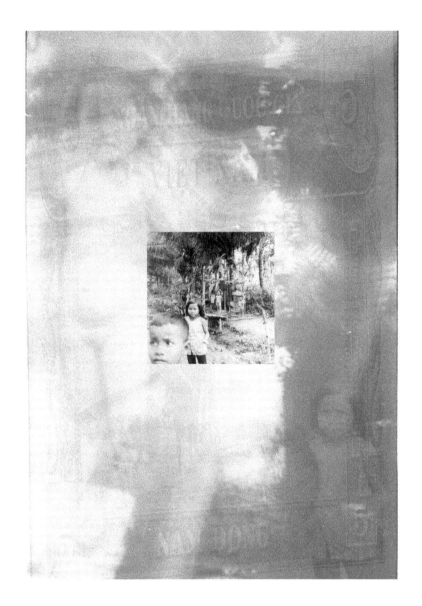

Shower of Dreams

Washing and watching, naked children wait for their
chance in the shower, surrounded by palms and
unsecured shacks. Not a calm place to view, not a safe
place to be, standing erect and waiting for the cool water.

Immediate comfort drops gently on them in the heat of
Saigon. Perhaps no future, war years in the past.
How long will this comfort last?

A little one waits to be clean for today; washing the war
and childhood fears away.

Jim Rose
Clarion, PA 2005

Dick Termes, *The Old Ball Game*, 2006
acrylic on polyethylene sphere, 16-in. diam.

Dick Termes, *Hagia Sophia*, 2000
acrylic on polyethylene sphere, 24-in. diam.

Teri Wagner, *Yggdrasil: Wild Sphere*, 2006, colored pencil, photo transfer, ink on paper 41 × 27 in.

Teri Wagner, *Crone*, from *Maiden, Mother, Crone*, 2004
pencil on porcelain, hand dyed and printed textiles,
photo transfers, embroidery, 14 × 14 in.

Kerry Mitchell, *Kind of Blue: All Blues*, 2003, digital

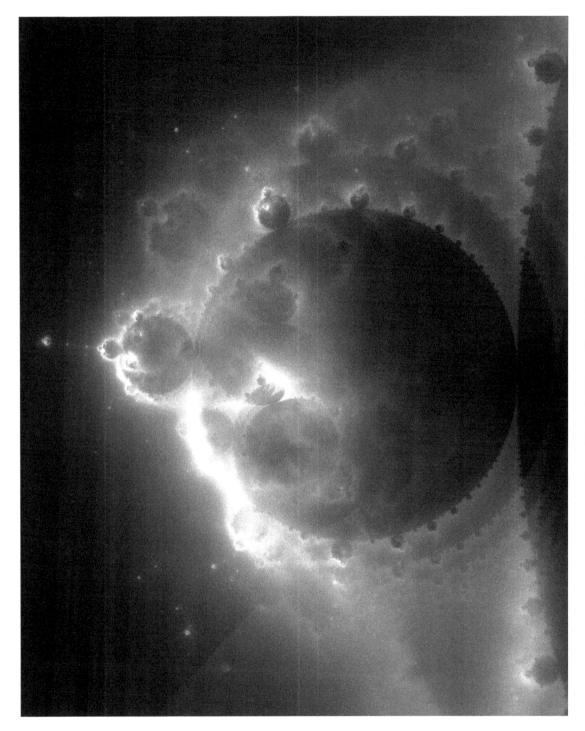

Kerry Mitchell, *Warm Glow*, 2003, digital

CHAPTER 8

Introduction to Fractal Geometry

THE techniques of perspective are particularly helpful for the realistic drawing of "man-made" objects such as houses, roads, fences, etc. With regard to drawing and understanding the appearance of natural objects such as trees, clouds, mountains, and much more, there is another useful branch of mathematics which we introduce in this chapter.

Consider the pictures in Figure 8.1. Can you tell what they represent?

(a)

(b)

Figure 8.1. Two pictures from nature.

In Figure 8.1(a), many people would recognize a gnu standing in a field; in Figure 8.1(b), even more of us would be able to identify the sport of rock climbing. But if we compare these two pictures to Figure 8.2(a) and (b), we see something strange going on. What has happened?

Figure 8.2. A small stuffed panda (a) next to the "gnu" from Figure 8.1(a), and the same toy panda (b) on the rock where we superimposed the image of a rock climber in Figure 8.1(b).

(a) (b)

In fact, the "field" and the "mountain" were some dry grass and a large rock (Figure 8.3), both near a baseball field at the south end of Franklin & Marshall College; the gnu was a 10-inch plastic toy, and we Photoshopped the mountain climber in. We used simple tricks to create the effect of larger landscapes than we actually had available.

What made this switch so effective is that many objects look the same at different scales. Dry grass looks somewhat like tall grass. Small rocks look like big rocks, and both look like the side of a mountain. Small pieces of clouds have the same shape and structure as the whole cloud. A small piece of cauliflower (a floret) looks like the whole cauliflower (Figure 8.4).

Figure 8.3. The toy panda bear on the "mountain"—a large rock.

Figure 8.4. A small piece of cauliflower looks like a miniature version of the whole cauliflower. (In fact, a piece like this is called a *floret*, which means a small flower.)

In the 1970s mathematician Benoit Mandelbrot described self-similar objects by coining the name "fractals," from the Latin root *fractus* meaning fractured or broken. That is, if you "fracture" (or break off) a little piece of a fractal, it looks like the whole thing. Many natural objects have this property of "self-similarity," and this property is of interest both artistically and scientifically.

To see how fractals approximate natural forms, and at the same time suggest techniques which an artist might use to render such

forms, consider the sequence of pictures in Figure 8.5. The first picture shows a rudimentary tree branch with 5 branch tips. It is not a fractal, because it lacks an important property of fractals called *self-similarity*, which in a broad interpretation means that parts of a shape are exact, or nearly exact, miniatures of the whole shape. In the second picture, each of the 5 branch tips is replaced with an exact miniature of the branch in the first picture. The second branch is not a fractal either, because the 5 subbranches each have 5 tips, while the whole branch now has $5^2 = 25$ branch tips. The third branch in the sequence is an attempt to remedy this; each of the 5 subbranches is a 25-tipped miniature of the second branch. Of course, the problem is that the current branch now has $5^3 = 125$ branch tips, so self-similarity has not yet been attained. Indeed, the figure will not become self-similar—a fractal—until the process has in effect been repeated an infinite number of times.

Figure 8.5. A fractal tree branch made by algorithmic drawing.

Fortunately, we don't need to wait forever to see the true fractal branch. The fourth branch in the sequence is the result of repeating the process 3 more times ($5^6 = 15,625$ branch tips), and it is visually indistinguishable from the true fractal limit. This is because the subsequent branch tips which would be added would be so small as to be virtually invisible. Most importantly, notice how the character of the branch has changed in the fourth picture. It is "organic" as opposed to "mechanical" or "geometrical," even though we have used a mathematical algorithm—a rigid step-by-step process—to create it. In this computer rendering, the branch tips have even merged to form

[1]For a readable and fascinating introduction to these ideas, see Lindenmayer, A., and Prusinkiewicz, P., *The Algorithmic Beauty of Plants*, Springer-Verlag, New York, 1996.

Figure 8.6. Traditional Japanese woodblocks (left) and their modern fractal counterparts (right).

[2]Paterson, L., Diffusion-limited aggregation and two-fluid displacements in porous media, *Physical Review Letters*, **52**, 1621–1624.

leaves, reminding us that not only do trees contain leaves, but leaves also contain trees, in the form of their treelike vein structure. Results like this not only give hope to the artist seeking hints on drawing from nature, but they also suggest ideas about the structure and growth of plants—a notion that plant biologists have taken seriously.[1]

Evidence suggests that artists have also taken fractal algorithms seriously, and not just recently. Compare, for example, the Japanese woodblocks in Figure 8.6, which we've paired with modern computer-generated images. Figure 8.6 features three pairs of images. The left member of each pair is a nineteenth-century Japanese woodblock print, and the right member is a computer-generated fractal. Though startlingly similar to their companion images, the woodblocks predate the fractals by more than 100 years! The first image is a detail from the woodblock *Shono: Driving Rain*, from the series *The Fifty-Three Stations of the Tokaido* by Ando Hiroshige (1797–1858). The fractal to its right was generated by a process called an "Iterated Function System," which we discuss later. The second woodblock is *Boats in a Tempest in the Trough of the Waves off the Coast of Choshi* (detail), from the series *A Thousand Pictures of the Sea* by Katsushika Hokusai (1760–1849). The fractal to the right of it is called a "quadric Koch island," a name coined by Mandelbrot. The third woodblock is a panel from the triptych *Short History of Great Japan* by Ikkasai Yoshitoshi (1839–1892). The accompanying fractal is a mathematical model of two-fluid displacement in a porous medium after Paterson.[2]

At this point we take a different approach to the usual presentation. One of the best ways to learn about fractals is to draw as you read. Therefore, rather than present the usual exercises at the end of the chapter, we intersperse with the narrative some practice exercises to help you become familiar with fractals. To emphasize the difference between these and the usual exercises, we number them with Roman numerals. Drawing fractals is much more meditative than drawing in perspective. Patience, repetition, and time are all good attributes to have. Give yourself a half hour to an hour to do each practice exercise; playing good music helps as you work.

Practice Exercises.

I. Draw a fractal tree. Start with a figure like the one at the left, which consists of a trunk and three main branches (notice that the left branch begins slightly below the right branch). Then turn each of the three branches into a tree by adding two new branches at approximately the same angle as on the original tree; you'll now have 9 branches. Repeat this process (on each of the 9 branches, create a tree by adding two new branches; then create trees on the resulting 27 branches, and so on). In Figure 8.7 we show you several initial steps, plus a version that appears after many iterations.

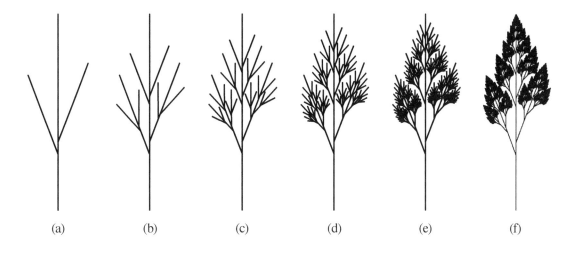

Figure 8.7. Steps in drawing a fractal tree (a–e), and a computer rendering (f) after many iterations.

II. Use a ruler to draw a fractal "cauliflower." Begin with a horizontal line across the bottom of the paper. From now on, every time you see a line segment, you will add on an inverted "V" whose height is approximately 1/3 that of its length, as in Figure 8.8.

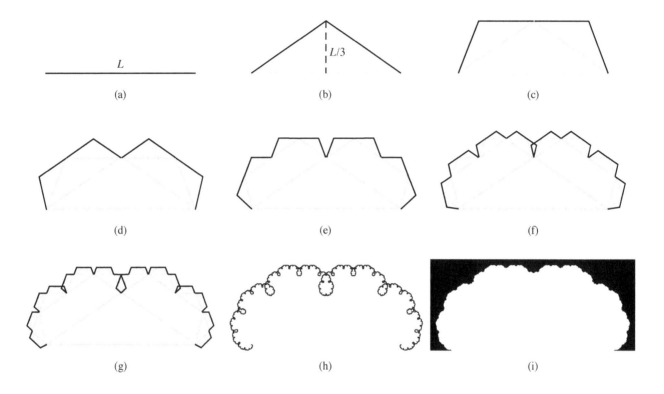

Figure 8.8. Steps in drawing a "cauliflower" (a–g), and a computer rendering (h) after many iterations. Part (i) shows the region above the cauliflower shaded in black.

Here's an example of a slightly different version of the cauliflower-drawing technique applied to lightning bolts. On the right of Figure 8.9 is a detail from a photo of a lightning storm over Boston. We begin by marking four dots A, B, C, D on one of the lightning bolts. In step (i) of the figure, we draw the polygon $ABCD$ as a first approximation to the lightning bolt. In each of the subsequent steps (ii)–(iv), we connect the pairs A, B and B, C and C, D with a scaled copy of the previous approximation. As indicated, the drawing in step (iv) compares pretty well with the actual lightning bolt. This approach isn't completely scientific, but it shows that iterative drawing techniques can lead to nice results. In the next chapter, we'll see how a more scientific study of coastlines helped spur the development of fractal geometry.

Figure 8.9. Left: Recursive drawing of a lightning bolt. Right: Detail from photograph of a lightning storm over Boston. Step (iv) is a fair approximation of the lightning bolt. Photo: U.S. National Oceanic and Atmospheric Administration.

III. A "mathematical-looking" fractal that's easy to sketch is the *Sierpiński triangle* (or *Sierpiński gasket*), named after Polish mathematician Wacław Sierpiński. In Figure 8.10 we start with an equilateral triangle (a), then draw an upside-down triangle inside it by connecting the midpoints of the larger triangle (b). At first you might want to lightly mark a dot inside this "midpoint triangle" to indicate that you won't draw inside that triangle anymore. In (c) we draw midpoint triangles inside the remaining three (right-side up) triangles and mark dots to keep the new midpoint triangles empty. In (d) we draw midpoint triangles inside the nine remaining triangles. Try this out and keep drawing until the triangles become so small you can't draw inside them anymore. The "limiting shape" you have approximated is the Sierpiński triangle.

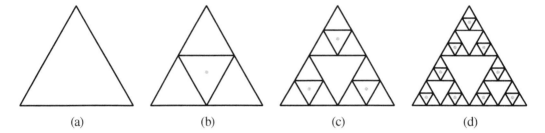

Figure 8.10. Steps in drawing the Sierpiński triangle. The dots indicate triangles that remain empty.

IV. There's a right-angled version of the Sierpiński triangle that you can build up using squares instead of triangles. Figure 8.11(a) shows a square on a grid, and Figure 8.11(b) shows the three half-sized squares you draw in the next step. One half-sized square goes on top of the big square, one goes in the lower left corner of the big square, and one goes immediately to the right of the big square as shown. (The grid is for precision.) Figure 8.11(c) shows how to proceed next. The rule is this: at the end of each completed stage, focus only on the smallest squares you just drew. For each such square, draw a square half as big on top of it as indicated, a square half as big in the lower left corner, and a square half as big immediately to the right of it. Use the grid lines to be precise, and keep going. Now start over in Figure 8.12 (or a photocopy of it). Be sure to count squares to keep your drawing accurate. You'll see that the fractal is in a sense a union of squares, but it doesn't really look like it when it's fully developed!

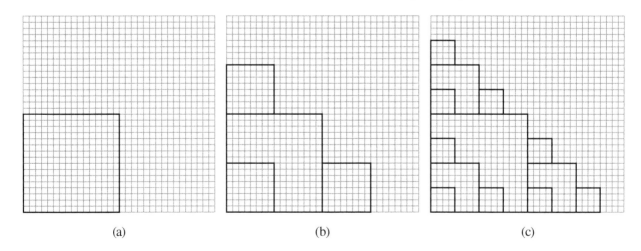

Figure 8.11. Guide for drawing a right-angled Sierpiński triangle using squares.

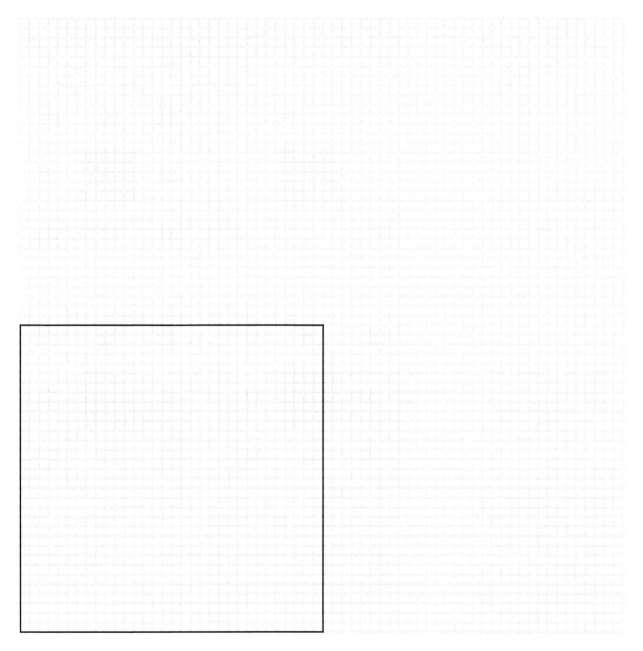

Figure 8.12. Template for drawing the right-angled Sierpiński triangle.

Another classic fractal attributed to Sierpiński is the *Sierpiński carpet*, whose construction appears in Figure 8.13. This time we make the fractal white on a black background.

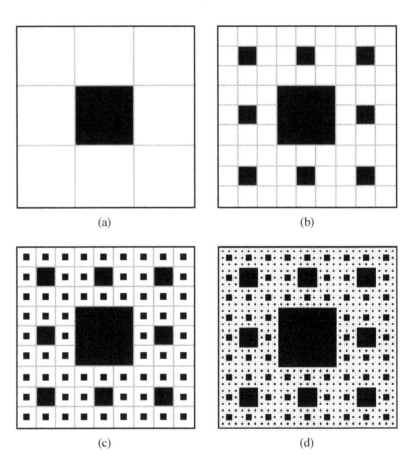

(a) (b)

Figure 8.13. The first three steps in drawing the Sierpiński carpet (a–c), and the appearance of the actual fractal (d). The fractal is the remaining white part after the (infinitely many) holes have been subtracted.

(c) (d)

To draw the Sierpiński carpet we start with a white square in Figure 8.13(a), use lines to divide it into nine equal-sized squares, and then blacken in the "middle ninth" square. In (b) we apply the same procedure to the remaining 8 white squares, and in (c) we apply it to the remaining 64 white squares. Part (d) shows the fractal (the white part) after the procedure has been carried out indefinitely.

While the Sierpiński triangle and the Sierpiński carpet may look more "mathematical" and not as natural as the fractal tree and the fractal cauliflower, they nevertheless contain essential features of patterns in nature. As an example, we modify the construction of the Sierpiński carpet in Figure 8.13 to model cratering patterns in Figure 8.14.

In Figure 8.14(a) we punch a "giant" crater of width w into the surface, much like punching the square hole in Figure 8.13(a). In Figure 8.14(b) we add 8 randomly placed "large" craters of width $(1/3)w$, much like we added the 8 square holes in Figure 8.13(b). In Figure 8.14(c) we randomly place $8^2 = 64$ "medium" craters of width $(1/3)^2 w = (1/9)w$, like we added the 64 square holes in Figure 8.13(c). In Figure 8.14(d) we randomly place $8^3 = 512$ "small" craters of width $(1/3)^3 w = (1/27)w$, and in (e) we randomly place $8^4 = 4096$ "tiny" craters of width $(1/3)^4 w = (1/81)w$. Compare (e) with a map of the moon (f); the arrow indicates Sierpiński Crater!

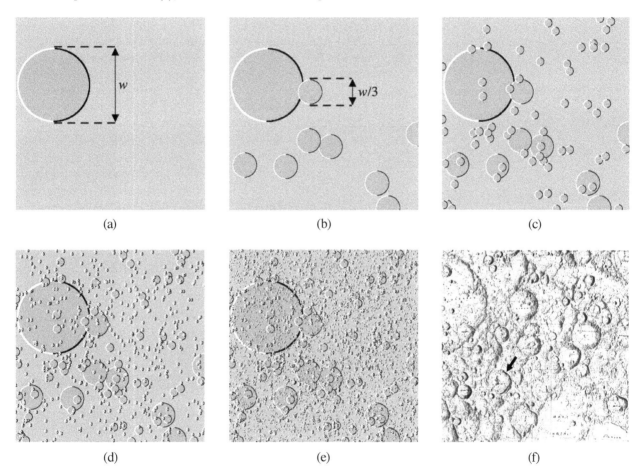

(a) (b) (c)

(d) (e) (f)

Figure 8.14. Sierpendipity: Mimicking the construction of the Sierpiński carpet, we start with one "giant" crater (a) of width w; add 8 "large" randomly placed craters, each 1/3 the size of the giant one (b); then $8^2 = 64$ "medium" craters, each 1/3 the size of the large ones (c); then $8^3 = 512$ "small" craters, each 1/3 the size of the medium ones (d); and $8^4 = 4096$ "tiny" craters, each 1/3 the size of the small ones (e). At each step we use a computer program to randomly place the craters in the gray square. Part (f) is a map of the moon; an arrow indicates Sierpiński Crater. (Credit: Lunar and Planetary Institute/Defense Mapping Agency)

Even with the simplistic "craters" we were drawing, the comparison is not too bad. In fact, for many bodies in the solar system the observed mathematical relationship between the number of craters in a given region and their diameters bears a strong relationship to the number and sizes of the holes in the Sierpiński carpet, the Sierpiński triangle, and other fractals.[3] In this case we have modeled the surface of the moon as a kind of random Sierpiński carpet with round holes.

[3]Benoit Mandelbrot made this comparison in *The Fractal Geometry of Nature*, W. H. Freeman, New York, 1983, pp. 302–303.

We will make this comparison more precise in the next chapter. For now, we simply wish to note that even highly regular, geometric fractals like the Sierpiński carpet can embody important aspects of the rugged and apparently irregular forms of nature. By comparing fractals with nature, we can more fully understand nature's patterns and thus do a better job of drawing them. For example, the previous comparison immediately shows that when drawing craters, we should draw only a few large craters, many more medium-sized craters, and many, many more small craters.

Iterated Function Systems.[4] How do computers draw fractals? They often uses a process called an "Iterated Function System," or IFS. For our purposes we will think of a *function* as a rule for transforming shapes (sets) in the xy-plane into other shapes. For example, Figure 8.15(a) shows the unit square P—the square with corners at $(0, 0)$, $(1, 0)$, $(1, 1)$, and $(0, 1)$. We have labeled it with a big "P" to keep track of the way it gets transformed. A function is usually denoted by a letter, so let us define a function f by the way it transforms P into the shape labeled $f(P)$ (read "f of P") in Figure 8.15(b). The new shape $f(P)$ is called the *image* of P under the function f. The image $f(P)$ is a square half the size of P in each direction; it has been flipped (reflected) so that we see the "back side" of P; it has been rotated $90°$ so that it lies on its side; and it has been moved so that its lowest side stretches from $1/2$ to 1 on the x-axis. By showing the flipped-over letter P as being undistorted in Figure 8.15(b), we mean to suggest that f does not distort the interior of the unit square as it shrinks it and moves it around.[5]

[5] Such a function is often called a *contracting similitude* because any shape inside the unit square, say a little triangle, gets transformed into a smaller (contracted) triangle that is similar to the original.

Having defined how f transforms the unit square and its interior, we now have a function that takes its inputs as shapes inside the unit square and transforms them to other shapes inside the unit square in a well-defined way. For example, Figure 8.15(c) shows a catlike shape C; to see how it is transformed by f into its image $f(C)$, we imagine it being painted onto the unit square and going along for the ride, as in Figure 8.15(d). The transformed cat $f(C)$ is half the size of the original, it's located in the same relative position inside the transformed square, and of course it gets flipped around backwards with the square, so its tail appears to point to the opposite side of

its body.

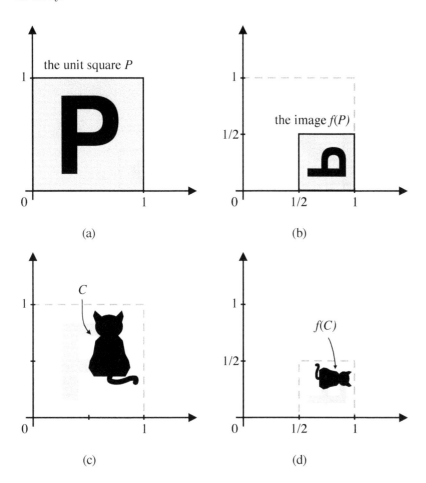

(a)

(b)

(c)

(d)

Figure 8.15. How the function f transforms the unit square P and the cat C. Notice that because the unit square gets flipped (reflected) the cat does too, so its tail points in the opposite direction.

We'll deal with several functions at once (that's why these are called "Function Systems"), and we'll repeatedly apply (iterate) the functions over and over (that's why this section is called "Iterated Function Systems"). By this we mean that we will apply a function to a shape, then apply the same or another function to the resulting shape, and so on.

An example of the repeated application of functions appears in Figure 8.16. Parts (a) and (b) illustrate a new function g that also transforms shapes inside the unit square. The function g transforms the unit square P by shrinking it toward the origin by a factor of $1/2$. In Figure 8.16(c) we then transform $g(P)$ with the function f of Figure 8.15 to obtain the set $f(g(P))$ ("f of g of P"), which is also written as $f \circ g(P)$. That's because we can think of this application

of two functions as a single function denoted by $f \circ g$, called the *composition* of two functions.

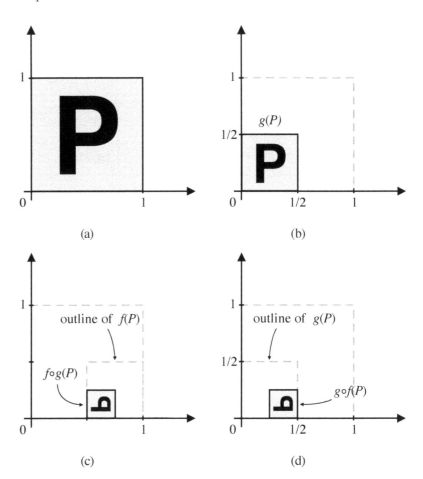

Figure 8.16. Parts (a) and (b) illustrate the function g. Parts (c) and (d) illustrate compositions involving f and g, where f is the function illustrated in Figure 8.15. Notice that the images $f \circ g(P)$ and $g \circ f(P)$ are not the same. Can you sketch $g \circ g(P)$ and $f \circ f(P)$?

Notice that the notation $f \circ g(P)$ tells us to first apply g to P, then apply f to the result. In Figure 8.16(d) we apply the functions in the reverse order to obtain $g \circ f(P)$; notice that $g \circ f(P)$ and $f \circ g(P)$ are different, hence $g \circ f$ and $f \circ g$ are different functions. Can you sketch $g \circ g(P)$ and $f \circ f(P)$?

In our modern world we use function compositions all the time. Let's say you take a digital photo T of a tree and you turn the camera sideways to get the whole thing in the photo. When you transfer it to your computer, the photo T appears sideways, so you rotate it with a function r provided by your computer's image processing software. Now you can enjoy looking at the corrected photo $r(T)$ on your computer. Later you want to e-mail the photo to a friend, but

it's too big—it takes up too much memory—so you shrink it to a smaller size with another function s. What you send your friend is the image $s \circ r(T)$. The function s is a contracting similitude. The rotation function r is also a similitude, but it is not contracting since it preserves the size of T.

Now let's look at an Iterated Function System. Consider the three functions f_1, f_2, f_3 illustrated in Figure 8.17. The first iteration in Figure 8.17(b) shows that all three functions shrink the unit square P to half its size and then move it somewhere. The function f_1 moves the reduced version of P to the top center of the square, f_2 moves it to the lower left corner, and f_3 moves it to the lower right corner.

In Figure 8.17(c)—the second iteration—we have labeled the sets $f_1 \circ f_1(P)$ and $f_1 \circ f_3(P)$. Which square is the set $f_3 \circ f_1(P)$? Which is $f_2 \circ f_3(P)$? In the third iteration in Figure 8.17(d) are even smaller squares, representing sets like $f_1 \circ f_3 \circ f_3(P)$—which square is that? The tiny squares in the fourth iteration in Figure 8.17(e) represent images of P under fourfold function compositions, such as $f_2 \circ f_1 \circ f_1 \circ f_3(P)$.

Now we can see the value of functions and function compositions in fractal geometry. As we use more and more complex compositions in Figures 8.17(a)—(e), the resulting collection of squares more and more closely resembles an isosceles Sierpiński triangle whose altitude and base are equal. Figure 8.17(f) depicts the 6th iteration. It consists of $3^6 = 729$ images of P, each $(1/2)^6 = 1/64$ the width of P. All the images were easily created in the computer drawing program Lineform, as they could have been in, say, Adobe Illustrator. (There is also another important way computers generate fractals with Iterated Function Systems, called the *Random Iteration Algorithm*, described in detail in Michael Barnsley's book *Fractals Everywhere*.[6] It makes use of the formulas that define functions like f_1, f_2, and f_3.)

[6]Barnsley, M., *Fractals Everywhere*, Academic Press, San Diego, 1988.

Notice how closely Figure 8.17(f) resembles the isosceles Sierpiński triangle A in Figure 8.18. The set A just fits inside the unit square, so its altitude and base both have length 1. Using more iterations would have increased the resemblance further. The set A is called the *attractor* of the IFS; you can see how the successive iterations are "attracted" to it. In terms of functions, the true fractal A consists of three smaller copies of itself; it is the union of the sets $f_1(A)$ (the top part), $f_2(A)$ (the bottom left part), and $f_3(A)$ (the bottom right part). In set notation, $S = f_1(A) \cup f_2(A) \cup f_3(A)$.

Figure 8.17. Iterating functions to approximate an isosceles Sierpiński triangle with successively smaller and more numerous images of the unit square P. After 1 iteration (b) there are $3^1 = 3$ images of P, each $(1/2)^1 = 1/2$ the width of P. After 2 iterations (c) there are $3^2 = 9$ images of P, each $(1/2)^2 = 1/4$ the width of P. After 3 iterations (d) there are $3^3 = 27$ images of P, each $(1/2)^3 = 1/8$ the width of P. After 4 iterations (e) there are $3^4 = 81$ images of P, each $(1/2)^4 = 1/16$ the width of P. Part (f) shows the result after 6 iterations: $3^6 = 729$ images of P, each $(1/2)^6 = 1/64$ the width of P. All the images were created in a standard computer drawing program.

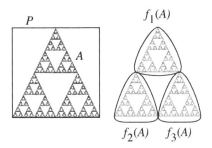

Figure 8.18. The isosceles Sierpiński triangle A on the left just fits inside the unit square P. As suggested on the right, A satisfies

$$S = f_1(A) \cup f_2(A) \cup f_3(A).$$

In the next example, we're going to change one of the functions a little and see what happens. In the previous example, we assumed that the functions preserved orientation and direction: there were no rotations and no flips. In Figure 8.19, we'll forego that assumption, but we'll still have f_1 move the reduced version of P up and center, f_2 move it down and left, and f_3 move it down and right. The difference is that f_1 flips the reduced version of P and rotates it 90°.

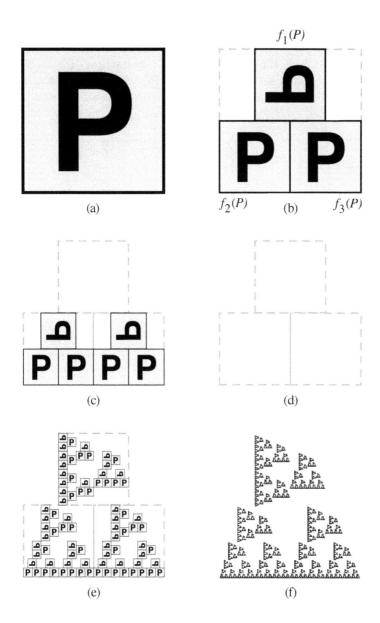

Figure 8.19. Part (a) shows the first iteration of an IFS. Your job is to draw the rest of the second iteration in (c) and all of the third iteration in (d). Part (e) shows the fourth iteration, and part (f) is the attractor of the IFS.

In Figure 8.19 we draw the first iteration (b) and part of the second iteration (c) of the IFS. Your job is to finish the second iteration, and draw the third iteration (d). Part (e) shows the fourth iteration, and (f) shows the attractor of the IFS.

In Figure 8.20 below, we don't tell you the steps we took to draw the fractals; we ask you to figure that out yourself. Each of the pictures in Figure 8.20 is the attractor of an Iterated Function System

(each with three functions that send images to the top center, lower left, and lower right). Each attractor is shown inscribed in the unit square. Determine the direction of the Ps in the first iteration of the process—for example, as in Figure 8.19(b). Assume that the initial stage is a P in the usual position as in Figure 8.19(a). In cases where there is a lot of symmetry, there can be more than one correct answer.

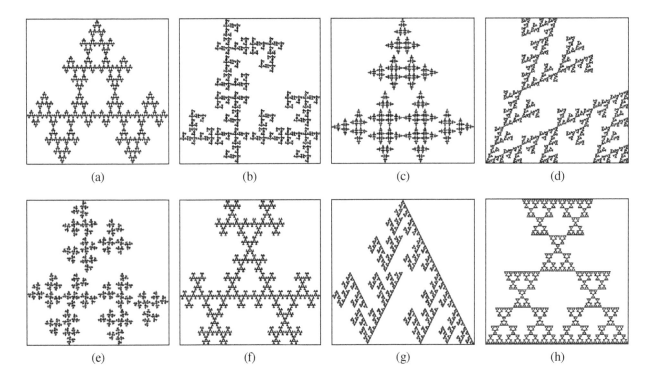

(a) (b) (c) (d)

(e) (f) (g) (h)

Figure 8.20. Can you guess the IFS in each case?

Artist Vignette: Teri Wagner

TERI WAGNER is Associate Professor of Art and Chair of the Art Department at Cardinal Stritch University in Milwaukee, Wisconsin, where she teaches sculpture, ceramics, printmaking, textiles, metals, and basic visual studies. Her work has been exhibited around the United States and in Europe. She loves to travel, particularly to Italy. She is trying very hard to learn Italian and hopes someday to be capable of telling stories in that most beautiful language. (Photograph by Peter Galante)

THE WORLD is full of things that people have made: frescoes and motorcycles and soap and cell phones and so forth. Every detail of every object has occurred to somebody sometime to meet a need, express a notion, satisfy a desire.

As an artist, I have spent most of my life thinking about things I could make and then making them (or not). Drawings, paintings, and sculptures all begin with ideas sparked by everything I have encountered as a person living in the world. Art works, like everything designed by humans, are thoughts, "materialized."

My students often struggle with the process of generating ideas for art works. This is partly due to the widespread notion that "real artists" get a packet of brilliant ideas delivered with the Talent gene, right there on the DNA chain next to the Crazy gene. This may be true in a few cases but generally it's not. In fact, artists are just people who learn to attend to the world in a particular set of ways. The language that we use is a visual one, complete with grammar,

"Artists are just people who learn to attend to the world in a particular set of ways."

syntax, and metaphor. And, as with all languages, art is useless unless we have something to talk about. In art, the whole range of human experience and history is our topic.

My work takes many forms, including drawing, painting, printmaking, photography, digital imaging, film, stone carving, metal work, ceramic sculpture, textiles, and sometimes several of these in one piece. I consider myself a collagist, mixing up the ideas and the materials to create the kind of complexity that I think reflects the world in which we live.

Growing up as an only child, I had a huge appetite for reading. Stories, both real and fictional, kept me company and soon I was inventing my own versions. The next logical step was then to write my stories down and to illustrate them in imitation of the books I loved so much. My very first art work was just such a book. I took some sheets of lined paper and wrote my story of a rabbit with wings and her adventures in careful block letters. Each of the three pages had an illustration drawn in crayon. I used my mother's tape to hold it together. Then I smuggled it into the library and tucked it on a shelf. I was so excited—who might check out my book and read it? Each time I looked for it after that, it was not on the shelf. Clearly it had become a very popular book. I was seven years old.

"I consider myself a collagist, mixing up the ideas and the materials to create the kind of complexity that I think reflects the world in which we live."

Teri Wagner
As Above, So Below, 2004
wood, clay, oil paint,
organza, found objects
16 × 30 × 3 in.

Some time later, when I was in college, a group of my friends and I decided that in order to become real artists, we had to live in Italy, birthplace of the Renaissance. We organized our trip by locating the cheapest hotel we could find, which happened to be in Assisi, the historic home of St. Francis.

Assisi is an ancient pilgrimage site that survives to this day on the revenue from visitors of all faiths seeking spiritual connections. It was there that I encountered a particular kind of story, the narratives of the lives of the saints, called hagiographies. These stories are different from biographies in that they tell of symbolic events, forming a parallel, simultaneous reality with ordinary experience. I am fascinated by the multiple meanings that can be communicated by this kind of tale.

In one, the story of St. Margaret of Antioch, I was struck by the possibility of parallels between some details in the extraordinary life of this first-century woman and my Norwegian immigrant grandmother's life. I wrote a story, "St. Margaret of Antioch, Illinois," and made several art works including a painting, a series of collages, and a sculpture inspired by this confluence of the spiritual and the ordinary superimposed upon one another. In one episode of the original story, St. Margaret was devoured by a dragon and then the dragon was forced to spit her back up. I drew an analogy to my grandmother who was swallowed into the hold of the ship that brought her to America and then spat out onto Ellis Island. In my version, strange events reminiscent of the original stories occur in contemporary settings. Since that first series of pieces, this kind of composite idea has been an abiding theme in my work.

Like many visually oriented people, I always thought that I was not good at math. Numbers, equations, theorems were all too immaterial for me. So, a few years ago when I was asked to attend a conference on art and math, I went under protest. It turns out that I was the only artist attending. The rest were mathematicians and a really groovy group, to my delight. They all liked art and practiced some form of it, from playing dulcimer to painting to making the most complex and gorgeous origami that I have ever seen.

The topic one night after dinner was topology of the sphere and the torus, something I had never heard of. I was amazed to discover that even though I couldn't follow the equations, I understood the principle. It seems that despite visual evidence to the contrary, more than one hundred years ago, mathematicians proved that every closed surface in space is some version of a sphere, a bagel-like shape called a torus, or a torus with extra holes. This means that every familiar object, say a coffee cup or a desk drawer, has a secret identity as a torus or a sphere—a binary reality!

Inspired by this notion that an object can be proven to have certain qualities that only exist in the mind, I began a series of drawings that depict sculptures that I can never make but that can exist in the imagination of the viewer. In one of these drawings, I envisioned a mathematical object known as the "horned sphere."

The horned sphere is a really interesting item that has an ongo-

Teri Wagner
Canis Latrans: Golden Section
2005
ink, pencil, acrylic on paper
41 × 27 in.

"Inspired by this notion that an object can be proven to have certain qualities that only exist in the mind, I began a series of drawings that depict sculptures that I can never make but that can exist in the imagination of the viewer."

Teri Wagner
Baba Yaga, 2004
wood, clay, human hair, wax
28 × 16 × 18 in.

ing chronicle of its own. It starts out as a sphere, then through a mathematical transformation, it elongates into a sausage, the ends of which curve magnetically toward each other, almost forming a donut. Then, just as they are about to touch, each end forms a set of two buds that grow toward each other, looping through the other set and again almost forming a pair of interlocking donuts. But wait! Just before each donut closes, the ends again sprout pairs of buds, grow toward each other and then . . . well, you get the idea. This continues as the mathematicians say, "up to but not beyond infinity," a phrase that makes them sound exactly like mystics.

In my drawing I depicted the horned sphere as the mythological World Tree, Yggasdril (see the Plates section), sprouting interlaced branches and growing up to but not beyond infinity.

In another series based on the same notion, I made an assortment of peculiar objects in clay. Mathematically each one is a torus but they actually look like strange, spiky magnifications of pollens or amoebas.

You are reading a book about math and art. What does one practice have in common with the other? Just this: both are based on the designs that occur in our minds in response to the world around us. And sometimes those designs can have a great conversation.

Teri Wagner
St. Sebastian/Narcissis
2005
porcelain, welded steel,
resin, wood, raw wool
18 × 20 × 20 in.

▣ For more of the artist's work, see the Plates section.

CHAPTER 9

Fractal Dimension

THE SUBJECT of the ancient Chinese philosophy of Taoism is the *Tao*, which can be interpreted as the "way" or the "course" of nature. In a series of lectures around 1970, the popular philosopher Alan Watts used the notion of the Tao to summarize the apparent difficulty in finding a mathematical description of the geometry of nature:

> The Tao is a certain kind of order, and this kind of order is not quite what we call order when we arrange everything geometrically in boxes or in rows. That is a very crude kind of order, but when you look at a bamboo plant, it is perfectly obvious that the plant has order. We recognize at once that it is not a mess, but it is not symmetrical and it is not geometrical. The plant looks like a Chinese drawing. The Chinese appreciated this kind of nonsymmetrical order so much that they put it into their painting. In the Chinese language this is called *li*, and the character for *li* originally meant the markings in jade. It also means the grain in wood and the fiber in muscle. We could say, too, that clouds have *li*, marble has *li*, the human body has *li*. We all recognize it, and the artist copies it whether he is a landscape painter, a portrait painter, an abstract painter, or a non-objective painter. They all are trying to express the essence of *li*. The interesting thing is that although we all know what it is, there is no way of defining it.[1]

[1] Alan W. Watts in *Taoism: Way Beyond Seeking, The Edited Transcripts*, ed. Mark Watts, Charles E. Tuttle Co., Boston, 1997.

Figure 9.1. Preceding page: Wen Zhengming, *Old Tree and Cold Spring*, 1594. Ink on silk. Gugong Museum, Taipei, Taiwan.

[2]Mandelbrot, Benoit B., *Les objects fractals: forme, hasard et dimension*, Flammarion, Paris, 1975.

[3]Mandelbrot, Benoit B., *The Fractal Geometry of Nature*, W. H. Freeman, New York, 1983.

At the time he spoke these words, Watts was quite correct, at least in terms of any widespread knowledge of such things. However, Alan Watts died in 1973, and that is significant, for only two years later there appeared a book entitled *Les objects fractals: forme, hazard et dimension*,[2] which later evolved into an English version entitled *The Fractal Geometry of Nature*.[3] The author of these books, a mathematician named Benoit Mandelbrot, had discovered a new kind of geometry, called *fractal geometry*, which would radically change the way mathematicians and scientists—as well as many artists—viewed the natural world. Mandelbrot coined the word "fractal" from the Latin word *fractus*, meaning "fragmented" or "irregular," because of the forms fractal geometry describes. In his introduction to *The Fractal Geometry of Nature*, Mandelbrot echoes the sentiments of Watts concerning the discrepancies between traditional geometry and nature, but goes on to announce that the scope of "geometry" has now been widened dramatically:

> Why is geometry often described as "cold" and "dry"? One reason lies in its inability to describe the shape of a cloud, a mountain, a coastline, or a tree. Clouds are not spheres, mountains are not cones, coastlines are not circles, and bark is not smooth, nor does lightning travel in a straight line.
>
> More generally, I claim that many patterns of Nature are so irregular and fragmented, that, compared with *Euclid*—a term used in this work to denote all of standard geometry—Nature exhibits not simply a higher degree but an altogether different level of complexity. The number of distinct scales of length of natural patterns is for all practical purposes infinite.
>
> The existence of these patterns challenges us to study those forms that Euclid leaves aside as being "formless," to investigate the morphology of the "amorphous." Mathematicians have disdained this challenge, however, and have increasingly chosen to flee from Nature by devising theories unrelated to anything we can see or feel.
>
> Responding to this challenge, I conceived and developed a new geometry of Nature and implemented its use in a number of diverse fields. It describes many of the irregular and fragmented patterns around us, and leads to full-fledged theories, by identifying a family of shapes I call *fractals*.

Parts (a) through (f) of Figure 9.2 illustrate the development of a spiky, self-similar curve presented by Mandelbrot in *The Fractal Geometry of Nature*. Part (f) shows the ultimate fractal; notice how the white voids look like tree branches, and the black part is nearly space filling. It's a type of curve we'll study later called a *Koch curve*, named after the Swedish mathematician Helge von Koch. The lower part of the figure is the photograph *Canopy* by Craig Harris.

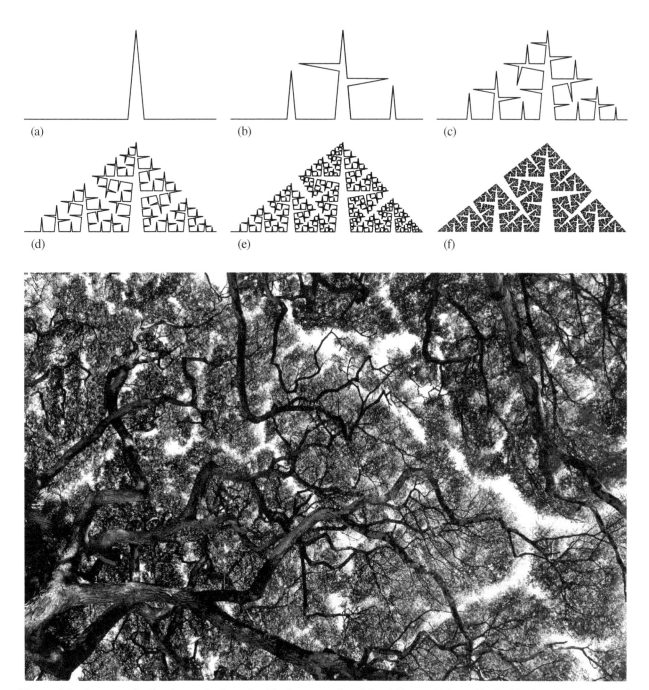

Figure 9.2. In parts (a–f), the evolution of a Koch curve after Mandelbrot. Below: Craig Harris, *Canopy*, digital photograph, 2008.

Notice the qualitative similarity between *Canopy* and the Koch curve; the canopy is nearly space filling, and the light areas of sky even look like branches. Notice also the similarity between Figure 9.2 and the Chinese painting in Figure 9.1. Even though the Koch curve is obviously too simple and rectilinear to pass for a real tree canopy, Mandelbrot saw in such curves, and in other fractals, the possibility of doing what Alan Watts said could not be done: defining, measuring, and meaningfully comparing the beautiful but seemingly irregular forms we see in nature.

The mathematics that Mandelbrot uses is more computational than the geometry we used in perspective drawing. For that reason, this chapter will have more "advanced" mathematics than anywhere else in this book. By "advanced," we mean that this is the kind of mathematics students usually learn after geometry, not that the mathematics is inherently more difficult. To understand what Mandelbrot saw in his fractals, we will use algebra, graphs, exponents, and logarithms. We include a gentle review (or perhaps introduction) of exponents and logarithms at the end of the chapter.

In this chapter we'll look at a way of comparing fractals—in mathematics and in nature—by measuring their "crinkliness" or space-filling tendency with a number called the *fractal dimension*. In mathematics there are many competing definitions of fractal dimension, most of which are equivalent in the simplest cases. We'll concentrate on one of the easiest to implement. It applies to fractal curves and it's called the "divider dimension" (or "compass dimension") because all it requires is a pair of dividers (like a compass with two needles and no lead).

How long is the coast of Britain?[4] From the standpoint of drawing forms in nature, curves are a good place to start. It's important to be aware of the character of the edges and outlines of shapes. Later we'll take a look at how versatile fractal curves are in achieving different "qualities of line." A type of natural curve we see all the time on maps is the coastline of a country. It was a study of this type of curve that gave some of the first hints that there might be a hidden mathematical order in irregular natural forms.

Around 1921, the British mathematician Lewis Fry Richardson, who loved applying mathematics to unconventional subjects, started thinking about the lengths of coastlines, a concept sometimes mentioned in encyclopedias and geography books. Richardson's idea was to measure a coastline, such as the west coast of Britain in Figure 9.3, by choosing a "step size" s and then seeing how many steps it took to "walk" along the coast. For example, in Figure 9.3, such a walk goes from Land's End to Duncansby Head, Richardson's starting and ending points. A particular value of s takes 5 steps plus an extra half

[4]This is the question (and these are the ideas) explored in Mandelbrot, Benoit B., How long is the coast of Britain? Statistical self-similarity and fractal dimension, *Science*, **156** (1967), 636–638.

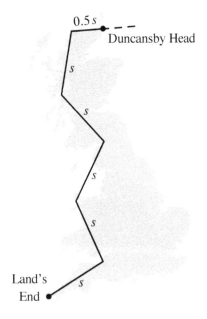

Figure 9.3. Pacing off the west coast of Britain.

a step to get to Duncansby Head, so Richardson would estimate the resulting length L to be $5.5\,s$.

However, we see that such a large step size misses a lot of the detail of the coast—a lot of the "ins and outs"—so Richardson used successively smaller steps s and each time recorded the corresponding total length L. Instead of plotting L versus s, Richardson had the clever idea of plotting the *logarithm* of L versus the *logarithm* of s, as in Figure 9.4. (If you feel a bit rusty on logarithms, you should read through the review at the end of the chapter.) Although the coastline seems highly irregular and random—apparently free of any simple mathematical pattern—an amazing thing happened. The data for the coast of Britain and for several other countries seemed to line up in straight lines!

Each line has an equation of the form[5]

$$\log L = m \log s + b. \tag{9.1}$$

Using Richardson's original data (see Exercise 1) we find that the line associated with the length in kilometers of the west coast of Britain roughly satisfies the equation

$$\log L = -0.25 \log s + 3.7. \tag{9.2}$$

[5]If we make the substitutions $y = \log L$ and $x = \log s$, then (9.1) becomes the slope-intercept equation of a line: $y = mx + b$. What is the slope of the corresponding line in (9.2)? Does that seem to describe the line for the coast of Britain in Figure 9.4?

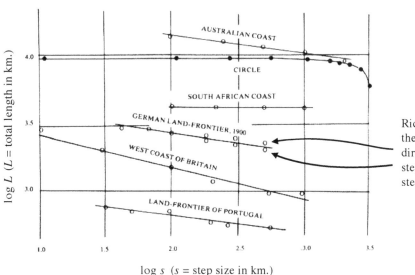

Richardson walked some of the boundaries in both directions using the same step size, and got a different step count in each direction.

Figure 9.4. Richardson's coastline plots.

To see what equation (9.2) tells us about the coast of Britain, we can rearrange the formula to one that uses exponents instead of

logarithms (see Exercise 1). What Richardson discovered is that

$$L \approx 5000 \, s^{-0.25} \, . \tag{9.3}$$

That is, with lengths measured in kilometers,

the measured length of the coastline $\approx 5000/(\text{step size})^{0.25} \, .$

If this is really true, then a very strange thing happens, because intuitively, as the step size s becomes smaller and smaller, we divide 5000 by smaller and smaller numbers, so we get larger and larger answers for the length L of the coastline. For instance, if $s = 0.001$ km (or 1 meter), then we get a length of $L \approx 5000/0.001^{0.25} \approx 28,000$ km. That's about 70% of the earth's circumference! As the step size s approaches 0, the length L gets larger without limit. According to Richardson's formulas, the actual length of the coastline of Britain (or any other coastline) is infinite!

What is the size of a fractal? But perhaps there's a mistake. Let's ask the question, "Is it possible to measure a geometric object, and—by some odd mistake—get an infinite measurement?" The answer is yes, and an example is measuring the *length* of a square. By "measuring the length of a square" we don't mean just measuring the perimeter, we mean measuring the whole thing, including the interior. Let's take a 1-by-1 square and measure it by trying to cover it with line segments of unit length, as in Figure 9.5.

Figure 9.5. The "length" of a square is infinite.

length = 3·1 = 3 length = 8·1 = 8 length = 25·1 = 25

On our first try, we use 3 line segments, each 1 unit long, and get an approximate length of $3 \cdot 1 = 3$. The three segments make a pretty sparse covering, so on the second try we straighten them up a bit and manage to get 8 segments on the square, for a better approximation of $8 \cdot 1 = 8$. On our third try, we straighten them up even more and get a length of 25. Definitely the length of the square is at least 25, because a small bug could crawl back and forth on the square, following the line segments, and travel a distance of 25 units without crawling over the same point twice. However, as you probably realize, this covering process could go on forever. Since

line segments have zero width, we could easily fit a million of them on the square, side by side without overlapping, so the length of the square is at least one million. In fact, by this line of reasoning, the square has infinite length, but there's no big mystery here, because— as you're probably ready to shout at this point—we're not *supposed* to measure the *length* of a square—we're supposed to measure its *area*! That is, a square is a two-dimensional object, so we should take a two-dimensional measurement (area), not a one-dimensional measurement (length). Here is what happened:

> *Our measurement came out infinite because our dimension of measurement was too small.*

As long as we're talking about inappropriate measurements, think what would happen if we measured the *volume* of the square (a three-dimensional measurement). The square has width and height, but no thickness, so it occupies no volume; the measurement would be zero.

> *If our dimension of measurement is too large, the measurement will be zero.*

This suggests that perhaps the coastline measurement came out infinite because we should not have used the one-dimensional measurement of length, but some higher-dimensional measurement instead. However, we are idealizing the coastline as a crinkly curve, so it seems that a two-dimensional measurement (area) would give us an area of zero, implying that a dimension of 2 is too large. If dimension 1 is too small, and dimension 2 is too large, is it possible that the true dimension of our coastline-curve is some number *between* 1 and 2? The very strange answer is *yes*, and to understand it, let's remeasure the square by a different method that will give us a mathematical way to express dimension.

In Figure 9.6 there is a 1×1 square, covered with cubes of side s. If we use the cubes to measure the area of the square, a reasonable way to do it would be to add the areas of the tops of the cubes; of course, the top of each cube has area s^2. Notice that the cubes are in rows and columns, and we have

$$(\text{number of rows}) \cdot s = 1 \quad \text{and} \quad (\text{number of columns}) \cdot s = 1,$$

so

$$\text{number of rows} = 1/s \quad \text{and} \quad \text{number of columns} = 1/s.$$

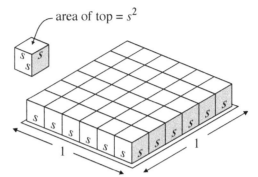

Figure 9.6. Cubes as measuring tools.

Thus the number of cubes is $(1/s)(1/s) = 1/s^2$. We then get

$$
\begin{aligned}
\text{area of square} \ &= \ \text{(number of cubes)(area of top of a cube)} \\
&= \ (1/s^2)(s^2) = 1,
\end{aligned}
$$

which is not only correct, but true for any positive value of s, no matter how small.

Since we got the measurement right, let's now try to get it *wrong*. Instead of adding the areas of the tops of the cubes (raising s to the power 2), let's add the lengths s of the cube edges (raise s to the power 1). We get the strange result

$$
\begin{aligned}
\text{``length'' of square} \ &= \ \text{(number of cubes)(length of cube edge)} \\
&= \ (1/s^2)(s^1) = 1/s,
\end{aligned}
$$

and thus the measurement becomes infinite as s approaches 0; this is the same result we got when we measured the "length" of the square using line segments.

Now let's deliberately do it wrong again, by adding the *volumes* of the cubes (raising s to the power 3). We get

$$
\begin{aligned}
\text{``volume'' of square} \ &= \ \text{(number of cubes)(volume of cube)} \\
&= \ (1/s^2)(s^3) = s,
\end{aligned}
$$

which obviously approaches 0 as s approaches 0; this implies that the volume of the square is zero, as we said before.

The purpose of these deliberate mistakes is to show that, intuitively, we can think of the "dimension of the measurement" as the exponent D in the formula

$$
\text{``size''} = \text{(number of cubes)} \cdot s^D. \tag{9.4}
$$

When "size" means length, use $D = 1$; when "size" means area, use $D = 2$; when "size" means volume, use $D = 3$. Moreover, the square is a two-dimensional object, and when we use a measurement dimension of 2, we get a result (an area) of 1, which is a finite, positive number. This suggests the following.

The true dimension D of an object is the measurement dimension that causes the measurement to converge to a finite, positive value as the edge length of the measuring cubes approaches zero (provided such a dimension exists and is unique).

We can apply this rule to coastlines by thinking of measuring the steps along the coast with the edges of cubes, as in Figure 9.7, where there are $N = N(s)$ cubes of edge length s. With respect to the coast of Britain, we have by equation (9.3) the approximate relation

$$5000\, s^{-0.25} = \text{length } L \text{ of coastline} = Ns$$

for each chosen step size s. Getting all our variables on the same side of the equation (multiplying both sides by $s^{0.25}$), we have approximately

$$5000 = Ns^{1.25} \tag{9.5}$$

for each chosen step size s. In view of (9.4) this suggests that we think of 5000 as the true "size" of the coastline, and $D = 1.25$ as the true dimension of the coastline.[6]

The "size" of 5000 is not a length, since we're actually measuring in the dimension of $D = 1.25$. In fact, the number 5000 is not so important—it's the noninteger dimension D that characterizes the fractal nature of the coastline. This dimension is called the *divider dimension* (or *compass dimension*) of the coastline. The coastline is in some sense a 1.25-dimensional object!

Finding the divider dimension. The advantage of hindsight gives us a bit of a shortcut to Richardson's estimate of the divider dimension D of a coastline. The Richardson model of the west coast of Britain led to equation (9.5), which can be rewritten as $N = 5000s^{-1.25}$. More generally, the Richardson model of a coastline obeys the equation

$$N = Cs^{-D}, \tag{9.6}$$

where C is a constant, $N = N(s)$ is the number of steps with size s, and D is the dimension of the coastline. For that reason we do not need to plot a graph of the logarithm of the total length L versus the logarithm of the step size s, as Richardson did. It's easier to plot a graph of the logarithm of N versus the logarithm of s and fit a straight line to the graph; the slope will be $-D$. We can see why by taking logarithms of both sides of equation (9.6) and rearranging to get $(\log N) = -D(\log s) + (\log C)$, which is linear in the variables $\log N$ and $\log s$. Here are the steps, with illustrations:

1. **Mark two points A and B at opposite ends of the coastline.** Figure 9.8 shows two such points marked on the southwest coast of the island of Borneo.

Figure 9.7. Measuring steps with the edges of cubes.

[6] In view of the subtle issues we address here about measuring things, you may not find it surprising that there is a whole branch of mathematics called *measure theory*, which is devoted to a more sophisticated analysis of such problems. In measure theory, the generalized notion of the "size" of a coastline (our word) would be called its "measure." The length of something is called its one-dimensional measure, the area is its two-dimensional measure, etc. However, we're already using the words "measure" and "measurement" so much that we decided on "size" for our informal approach.

[7]We follow Richardson's procedure as described in Richardson, L. F., The problem of contiguity: an appendix of deadly quarrels, *General Systems Yearbook*, **6** (1963), 139–187.

2. **For each chosen step size *s*, use dividers or a compass to walk off *N* steps along the coast from *A* to *B*.** There are a couple of fine points to address here.[7] First, notice that the circular arc in Figure 9.8(a), which has center *A* and radius *s*, actually meets the coastline in more than one place. In this case, we choose the point a person would arrive at first if walking along the coast starting from *A*. Second, notice that when 3 steps of length *s* reach the point *F* in Figure 9.8(b), one more step would take us beyond *B*. We therefore consider the last step from *F* to *B* to be a partial step of length $|\overline{FB}|$. In this case, the number *N* of steps is not a whole number; rather, we count it as $N = 3 + |\overline{FB}|/s$.

3. **For each chosen step size *s*, plot the point $(\log s, \log N)$ on graph paper or in a spreadsheet.** We did this in Figure 9.9 for six different step sizes on an enlarged version of the Borneo map in Figure 9.8.

4. **Fit a straight line to the finished collection of points. The slope of the line is $-D$.** Again, we did this in Figure 9.9, letting a spreadsheet fit the line for us. The slope came out to be about -1.12, so the divider dimension is approximately given by $D = 1.12$.

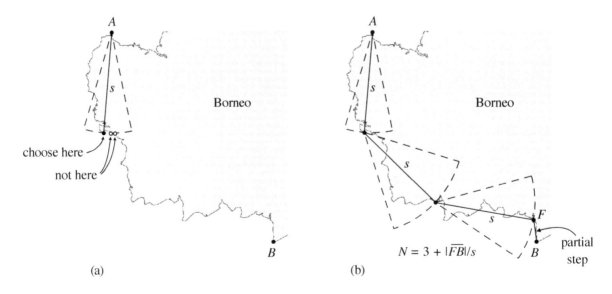

Figure 9.8. Walking off the southwest coast of the island of Borneo with a divider or compass. In (a), choosing where to step. In (b), the walk ends with a partial step of length $|\overline{FB}|$. If, say $|\overline{FB}| = 0.22\,s$, then $N = 3 + 0.22 = 3.22$.

More precisely, the equation of the line in Figure 9.9 (in xy-coordinates) is

$$y = -1.1187\,x + 0.933,$$

and we interpret the equation as follows:

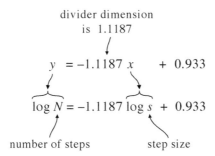

That is, y stands for $\log N$, x stands for $\log s$, and the slope of -1.1187 is the negative of the divider dimension D. Hence $D = 1.1187 \approx 1.12$.

Intuitively, the divider dimension of 1.12 for the southwest coast of Borneo suggests that the coast is not as crinkly as the west coast of Britain, which had a divider dimension of 1.25. The fact that both dimensions were greater than 1 suggests that mathematical models of coastlines should be curves that in some sense have infinite lengths, with divider dimensions close to those of the coastlines they model.

Computing dimensions of fractals. A classic fractal of this type is the symmetrical Koch curve in Figure 9.10 (we saw a nonsymmetrical version of it in Figure 9.2). We can find its divider dimension exactly, and it's not a whole number.

It's helpful to think of the Koch curve as being constructed in stages, as in Figure 9.10. The first stage, Stage 0, is just a line segment of length $s = 1$. In Stage 1, the middle third of the line segment is removed and replaced by two slanted segments of length $s = 1/3$; since the other two remaining segments also have length $1/3$, the number of segments of length $s = 1/3$ is $N(s) = N(1/3) = 4$. In Stage 2, the middle third (having length $1/9$) is removed from each of the four previous segments, and replaced by two more segments of length $s = 1/9$. The number of segments of length $s = 1/9$ is $N(s) = N(1/9) = 16$. As indicated in the figure, the process just keeps going. At Stage m, the length of the segments is $s = 1/3^m$ and the number of segments is $N(1/3^m) = 4^m$. Actually the "real" Koch curve is never achieved, because the process goes on forever. However, the bottom picture in Figure 9.10 is a good approximation to the real curve, and in practice we only use approximations, because it is not really possible to draw the actual curve.

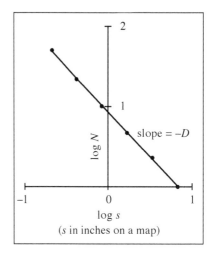

Figure 9.9. Fitting a line to the divider data for the southwest coast of Borneo. The divider dimension is the absolute value of the slope.

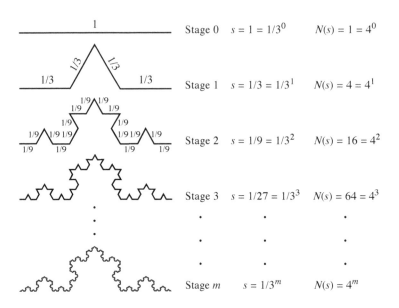

Stage 0 $s = 1 = 1/3^0$ $N(s) = 1 = 4^0$

Stage 1 $s = 1/3 = 1/3^1$ $N(s) = 4 = 4^1$

Stage 2 $s = 1/9 = 1/3^2$ $N(s) = 16 = 4^2$

Stage 3 $s = 1/27 = 1/3^3$ $N(s) = 64 = 4^3$

Stage m $s = 1/3^m$ $N(s) = 4^m$

Figure 9.10. Development of the Koch curve.

Figure 9.11. Measuring the length of the Koch curve with step sizes of $1/3^m$. Here $m = 2$, so the step size is $s = 1/3^2 = 1/9$. The number of steps is $N = 4^2 = 16$, and the estimated length at this stage is $N \cdot s = 16/9$.

Now here is one way in which the Koch curve is a good model for a coastline: it has infinite length! To see why, consider the Koch curve in Figure 9.11, and think about measuring its length by Richardson's method, using step sizes of $1, 1/3, 1/9, 1/27$, etc. The steps are just the corresponding line segments in Figure 9.10. At Stage m, we would compute the length as

$$
\begin{aligned}
\text{length} &= (\text{number of steps})(\text{step size}) = N(s) \cdot s^1 \\
&= 4^m (1/3^m)^1 = (4/3)^m.
\end{aligned}
$$

But $4/3 > 1$, so the length becomes infinite as $m \to \infty$; that is, the length becomes infinite as s becomes smaller and smaller, just like the length of the west coast of Britain.

It's easy to compute the divider dimension of the Koch curve if we restrict attention to step sizes $s = 1/3^m$ as above. If we can write $N = N(s)$ in the form $N = Cs^{-D}$ as in equation (9.6), we can identify D as the divider dimension. Now we saw that $N = 1$ when $s = 1$, so we must have $C = 1$, hence $N = s^{-D}$. Since we have $N = 4^m$ for $s = 1/3^m$, we want D to satisfy

$$
4^m = s^{-D} = (1/3^m)^{-D} = (3^{-m})^{-D} = 3^{mD} = (3^D)^m.
$$

Thus $4 = 3^D$. Taking logarithms of both sides gives $\log 4 = \log(3^D) = D \log 3$, hence

$$
D = \frac{\log 4}{\log 3} \approx 1.26.
$$

So, just as the west coast of Britain was a 1.25-dimensional object, the Koch curve is a 1.26-dimensional object!

It's easy to make variations of the Koch curve that have any dimension between 1 and 2. As in the upper left of Figure 9.12, start with the unit interval $[0, 1]$ and place two line segments of length s, where $1/4 < s < 1/2$ at either end, connected by two more segments of the same length forming the sides of an isosceles triangle in the middle. This corresponds to Stage 1 in Figure 9.11. At stage m, replace each line segment with a copy of the preceding figure, scaled by a factor of s^m. Thus at Stage m the figure will consist of 4^m line segments of length s^m. By reasoning as we did above, the divider dimension D of the ultimate fractal will be given by

$$D = \frac{\log 4}{\log(1/s)}.$$

Figure 9.12 shows the variety of shapes that result. The sequence begins with a lightning bolt or river-like curve ($D = 1.006$) and ends with a symmetric version ($D = 1.785$) of the foliage-like texture we saw in Figure 9.2. As the dimension increases, the space-filling appearance of the curves increases also.

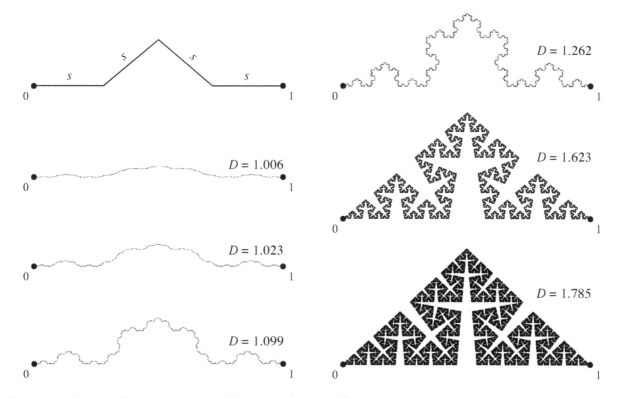

Figure 9.12. Initiator for a general type of Koch curve (upper left) and some examples with various divider dimensions.

Figure 9.13. This ghostly skull by Hokusai has fractal sutures.

Figure 9.14. A self-affine fractal curve.

An example of a Koch-like curve from Japanese art appears in Figure 9.13. It's a detail from a Hokusai woodblock print with a most sensational subject: *Kohada Koheiji's skull appears as a ghost at the burning mosquito net before his wife's lover who murdered him*, from a book called *One Hundred Stories* by Hyaku Monogatari (c. 1830). The sutures, or cracks, in the ghost's skull are a good match for a Koch curve.

Of course the various versions of the Koch curve are too regular and symmetrical to convincingly imitate most fractal curves in nature. Each Koch curve is exactly self-similar: it is the union of four smaller but undistorted copies of itself. (Can you identify them in each picture?) We can create a greater variety of curves by expanding the meaning of "self-similar" to include curves that are *approximately* self-similar—curves that are the union of smaller, approximate copies of themselves.

For example, consider the crinkly black curve in the top part of Figure 9.14. The curve reaches from one side of the unit square P to the other. The bottom part of Figure 9.14 shows four images of P under four *affine transformations*—transformations that map squares to parallelograms, not just other squares. (Similarity transformations are a special case of affine transformations.) In this case the four images of P and hence the four images of the curve are a little distorted. Nevertheless, as you can see from the figure, the four images of the curve connect at their endpoints and their union is precisely the original curve. Such a curve is only approximately self-similar; this curve would instead be called *self-affine*. Adobe Illustrator Affine transformations are extremely useful in computer illustration. Any good computer drawing program will have a "transform" palette that allows the artist to subject shapes to affine transformations like those in Figure 9.14.

The five points indicated by open circles in both parts of Figure 9.14 were selected because they lie on the mountain skyline in the photograph in Figure 9.15. The mountains are displayed above an enlarged version of the self-affine curve of Figure 9.14. The artificial curve coincides with the actual skyline at the five selected points, but it differs elsewhere. Nevertheless, the imitation does a pretty good job of capturing the rugged character of the original. This particular type of fractal portrait of a curve, which we have used rather intuitively, is called a *fractal interpolation function*.

The mountains are the Grand Tetons in Wyoming, often photographed because of their rugged fractal texture. Notice how the fractal skyline curve dominates the composition. It's not uncommon to see landscape photographs featuring natural objects backlit by the sun or sky, so that they are essentially reduced to their fractal outlines. How beautiful would a sunset or a sunrise be without fractals,

and fractal curves in particular?

Figure 9.15. Above, a photograph of Jenny Lake in Grand Teton National Park, Wyoming. Notice how the beautiful fractal skyline of the mountains dominates the composition. Below, a fractal curve created with four affine maps.

Quality of Line. In art there is an important concept called *quality of line*. It's a notion in drawing that has to do with whether a drawn line is rough or smooth, awkward or graceful, bold or fine, natural or forced, angry or tranquil, etc. Self-affine fractal curves offer a wide range of quality of line.

Figure 9.16 shows that a symmetric arc of a parabola is self-affine, and is thus a kind of fractal even though it is very smooth. The left side of the figure shows that given a positive constant a, the graph of $y = ax(1 - x)$ goes through $(0, 0)$ and $(1, 0)$, and has its vertex at $(1/2, a/4)$. The right side of the figure shows two affine images of the gray rectangle (now parallelograms) and corresponding images of the parabola, one solid and one dashed. The two images of the parabolic arc combine to form the original arc. Self-affine

curves range from smooth arcs to rugged mountain skylines to many other curves. Figure 9.17 displays an assortment of self-affine curves exhibiting various qualities of line.

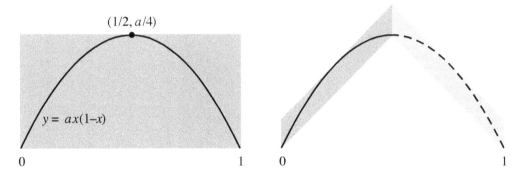

Figure 9.16. The parabolic arc $y = ax(1 - x)$ is self-affine via two affine transformations.

It's irresistible to play with fractal images, since they can convincingly imitate so many things. Perhaps that's why we see faces, dragons, castles, and so forth in puffy fractal cumulus clouds. A fractal geometer can sit under a tree or gaze out a window at the sky, and claim to be doing research! One way to play with the fractals you already know is to assemble several of them into a picture, the way we have done in Figure 9.18. Using the photo of Figure 9.15 as inspiration, we put in mountains, clouds (the cauliflower from Figure 8.8), lightning from Figure 8.9, trees from Figure 8.7, and craters from Figure 8.14. We assembled them using the drawing program Lineform, which has an affine transformation tool. We used the tool to vertically squeeze the craters into ellipses, to make them appear to be lying on the ground. To make the shadow of the tree, we made a transparent copy of the tree and then reflected and skewed it with an affine transformation.

Mathematical perspective and fractal geometry in art.
The concept of the divider dimension has an important place in the development of fractal geometry. Mandelbrot's seminal *Science* article on the length of Britain's coastline drew the interest of mathematicians, scientists, engineers, economists, and others. Mandelbrot knew very well that the divider dimension and the simulation of coastlines by fractal curves was only a crude beginning. In particular, a coastline is more properly the intersection of a plane (the ocean's surface) with a rugged fractal surface (the land). In the pursuit of more authentic coastlines, Mandelbrot and his colleagues generated startlingly believable fractal landforms, which in turn drew the interest of many artists.

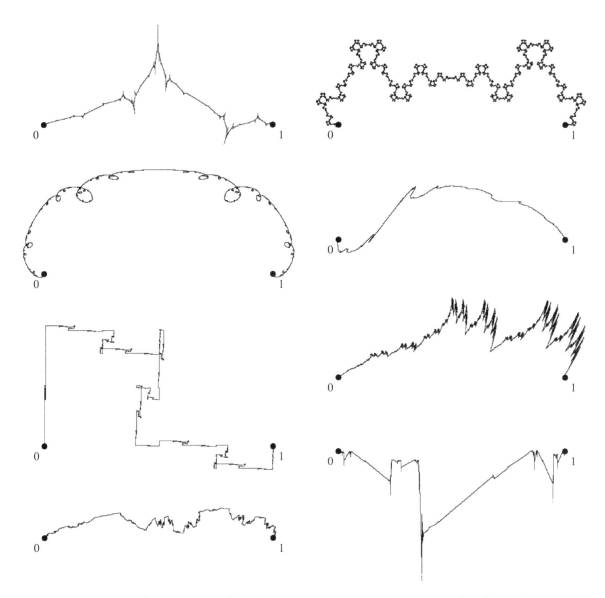

Figure 9.17. An assortment of self-affine curves illustrating the concept of quality of line.

Figure 9.18. A playful fractal portrait of a thunderstorm over a mountain lake, made with the fractals of Chapters 8 and 9.

The mountains in Figure 9.18 are just flat silhouettes. How can we make them appear to have real volume? The images in Figure 9.19 (d–f) illustrate a simplified algorithm for generating a fractal surface, as compared with the algorithm in Figure 9.19 (a–c) for drawing the cauliflower curve of Figure 8.8. Recall that to draw the cauliflower curve, we begin with a line segment (a), then select a point in its interior and raise it to determine two new, but shorter segments. At each subsequent step we repeat the procedure on the new line segments, a process that ultimately leads to the cauliflower curve of Figure 8.8. To obtain a crumpled fractal surface instead of a crinkly fractal curve, we start with a triangle in (d), then select a point in its interior and raise it to determine three new triangles that form the upper faces of a tetrahedron (e). At each subsequent step we repeat the procedure on the new triangular surfaces, as in (f). Of course we must specify a method for selecting interior points and displacing them. Variations of this method have led to continual improvements in the simulation of actual land surfaces. Fractal-based methods can also be used to create clouds, trees, fog, water, and other natural objects and textures.

Figure 9.20 shows an example of landscape artwork created with a commercially available, fractal-based, software package called Terragen. The result is an obvious improvement on our humble attempt in Figure 9.18. At first glance the image is hard to tell from a photograph!

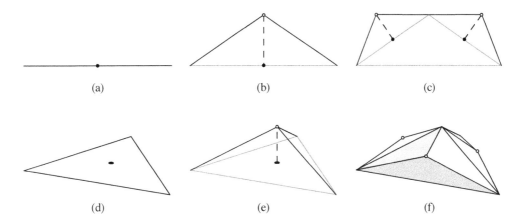

Figure 9.19. In (a–c), the first steps in generating the crinkly cauliflower curve of Figure 8.8. In (d–f), the analogous steps in generating a crumpled fractal surface.

Figure 9.20. Landscape image rendered with the fractal software Terragen. The rugged mountain surfaces were made using a mathematical technique called *Perlin noise*, named after computer scientist Ken Perlin. (In 1997 Perlin won an Academy Award for Technical Achievement for his computer texturing techniques, which are widely used in movies and television.)

Mathematical perspective is a key component of the image in Figure 9.20. The objects in the picture are modeled as shapes in three-dimensional space; what we see are the correctly rendered perspective images of these shapes, and that's one reason why the finished result looks so real. Because the picture is based on a collection of shapes in three-dimensional space, it's possible to virtually fly through the landscape along any desired path, seeing what a camera would see as it moves along the path. The software allows the artist to choose such

a path as a sequence of viewpoints and picture planes, and also to generate an associated sequence of perspective images as seen from these viewpoints. These sequential pictures of fractals (and other shapes) become the frames of a movie. Thus viewpoints, mathematical perspective, and fractal geometry team up to create the experience of flying through a world of the artist's own creation!

Not surprisingly, this method of creating images and animations has found applications outside the field of traditional art. In addition to Terragen, there are other fractal-based software packages, including MojoWorld, VUE, and Bryce. Terragen environments appear in feature films including *Stealth*, *Star Trek Nemesis*, *The Golden Compass*, and *The Wicker Man*, as well as in many games and TV commercials. Professional illustrators have used Terragen to create realistic still images for books and magazine articles. Users of VUE include special effects artists working for Industrial Light and Magic (*Pirates of the Caribbean 2*), Sony Pictures Imageworks, Weta Digital, BBC, and Walt Disney Pictures. Artists have used VUE to create animated architectural renderings, as well as simulations for NASA, Boeing, and the U.S. Air Force. Dr. F. K. "Ken" Musgrave, a former student of Mandelbrot, is CEO of Pandromeda, Inc. (the maker of MojoWorld), and designer of the initial fractal-based programs on which Bryce was based. MojoWorld is in one sense the most ambitious software package of its kind. Rather than model a small patch of the earth as most other programs do, the goal of MojoWorld is to model entire planets along with their moons and even solar systems.

We have already seen how mathematical perspective and fractal geometry have appeared separately in art. The advent of the computer has now brought them together in new forms of art and entertainment, as well as in the study and simulation of nature. In both art and science, mathematical perspective and fractal geometry serve the expression of the human imagination, and they help remind us of the marvelous combination of order and complexity in the world around us.

Artists and Fractals. We close this chapter with the work of three famous artists—a photographer, a painter, and an architect—who included fractal curves and surfaces in their palettes of lines and textures.

ANSEL ADAMS (1902–1984) was an American photographer who was best known for his photographs of the American West. Adams's work is typically filled with beautiful fractal textures: gnarled juniper trees, rugged rocks and mountains, and dramatic clouds. Figure 9.21 features one of his most famous photographs, *The Tetons and the Snake River*, taken while he worked for the National Park Service. We've already seen how the skyline of the Tetons can be modeled by

a fractal curve. This photograph features repeated fractal curves in the clouds and mountains, contrasting beautifully with the smooth curve of the Snake River.

Figure 9.21. Ansel Adams, *The Tetons and the Snake River*, 1942. Grand Teton National National Archives and Records Administration, Records of the National Park Service.

LI CHENG was a Chinese painter who lived in the tenth century. In his day, Li Cheng was considered to be the finest landscape painter of all time. His painting on the left of Figure 9.22, *A Solitary Temple amid Clearing Peaks*, features fantastic-looking mountains drawn with vertically oriented fractal curves. The photograph of mountains in Zhangjiajie, Hunan Province, which appears on the right of the figure, shows that Li Cheng's style is actually quite realistic.

Figure 9.22. Left: Li Cheng, *A Solitary Temple amid Clearing Peaks*, ink on silk hanging scroll, 111.4 × 56 cm., circa 960. Above: a recent photograph of mountains in Zhangjiajie, Hunan Province, China, shows that Li Cheng's style is actually quite realistic.

FRANK LLOYD WRIGHT (1867–1959) was one of America's most famous architects. In 1991, the American Institute of Architects recognized Wright as "the greatest American architect of all time." Wright designed many private residences, the most famous of which may be Fallingwater, the Edgar J. Kaufmann Sr. residence, pictured in Figure 9.23. Completed in 1937 in southwestern Pennsylvania, the home was built partly over a waterfall, and is a National Historic Landmark.

Dramatic perspective drawings, including ones from the house's most famous viewpoint in Figure 9.23, were an early part of the planning process. The idea was for the house to blend harmoniously with the stream (Bear Run) and the surrounding forest. In our terms, the resulting work is a masterpiece of mathematical perspective and fractal geometry in art. Wright told his client, "I want you to live with the waterfall, not just to look at it, but for it to become an integral

part of your lives."[8] The house is built of concrete and stone quarried from the site to blend with the rough, fractal stone of the stream bed. In fact, one end of the living room was built around a large boulder, which protrudes through the stone floor at the hearth of the fireplace! In 1991 the American Institute of Architects named Fallingwater the "Best All-Time Work of American Architecture." Fallingwater is now a property of the Western Pennsylvania Conservancy, and may be seen by guided tour from April through November.

[8]Donald Hoffmann, *Frank Lloyd Wright's Fallingwater: The House and Its History*, second revised edition, Dover, New York, 1993.

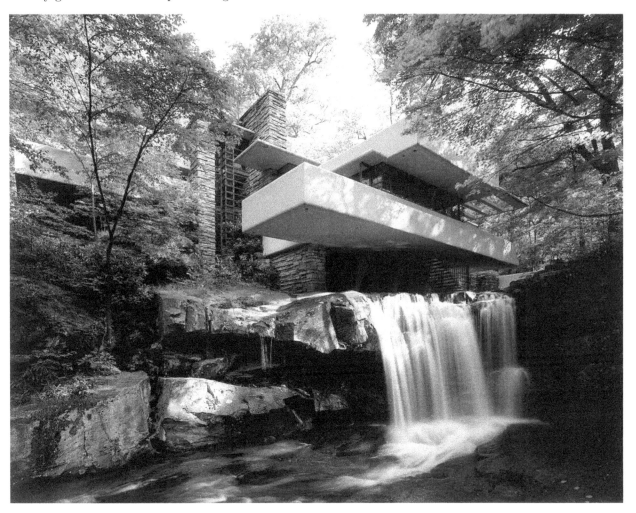

Figure 9.23. What a viewpoint: mathematical perspective and fractal geometry in art—and life. This is Fallingwater, the Edgar J. Kaufmann Sr. residence, designed by Frank Lloyd Wright. Completed in 1937 in southwestern Pennsylvania, the home was built partly over a waterfall, and is a National Historic Landmark. In 1991 Fallingwater was named the "Best All-Time Work of American Architecture" by the American Institute of Architects. Both the exterior and interior of the home extensively feature rough, fractal stone cut from Bear Run, the creek that runs under the house. Perspective plays a deliberate, dramatic role when the home is seen from its most popular viewpoint.

Frank Lloyd Wright loved traditional Asian art, and his designs were heavily influenced by it. Figure 9.24 compares a view of Fallingwater with a detail of Li Cheng's *Solitary Temple*. The similarity between the two compositions is striking, despite the almost ten centuries separating the lives of their creators. Notice the strong, horizontal lines of the buildings and the harmonious way they blend with their fractal-filled environments. Wright, in fact, adhered to a philosophy called *organic architecture*, which held that a building should be designed so as to form a single, unified composition with its surroundings.

Figure 9.24. View of Frank Lloyd Wright's Fallingwater (left) compared with a detail of Li Cheng's *Solitary Temple* (right). Notice the striking similarity between the two compositions, despite the almost ten centuries separating the lives of their creators.

Review of exponents and logarithms. We give here a brief, informal review of exponents and logarithms, with a refresher on the meaning of logarithmic expressions. We've already seen plenty of examples of exponential expressions arising in the study of fractals. For instance, at the nth stage of drawing the fractal tree branch in Figure 8.5, there are 5^n branch tips; for the tree in Figure 8.7 it's 3^n branch tips. The widths of craters in Figure 8.14 have the form $w \cdot (1/3)^n$, and so on.

We assume that you've already studied exponents and logarithms, and that you're familiar with the fact that if b is any positive number

($b > 0$) and if x is any real number, then the expression b^x is defined. The number b is called the *base* and x is the exponent. Of course we may need a calculator to compute the value of an exponential expression accurately. For example, using a calculator we find that $3.7^{-\sqrt{2}} \approx 0.157196$.

We also assume that you recall exponent rules (E1)–(E9) in the margin. Some of the rules in the list apply to negative or zero bases a and b, but we won't need those cases. The last two rules are probably the strangest looking, but they make sense if we want the other ones to work for all exponents x and y. For example, we can write b for $b \neq 0$ as

$$b = \frac{b \cdot b \cdot b}{b \cdot b} = \frac{b^3}{b^2} = b^{3-2} = b^1,$$

so we choose to define $b^1 = b$. Similarly, we can write the number 1 as

$$1 = \frac{b^2}{b^2} = b^{2-2} = b^0,$$

so we choose to define $b^0 = 1$ for $b \neq 0$. Recall also that if $b \geq 0$ and n is a positive integer, then $b^{1/n} = \sqrt[n]{b}$.

Sometimes it's easy to learn the rules of a subject and still not be able to say what it really means. People often have this experience with logarithms. Before reviewing some of the rules of logarithms, let's review the meaning of the concept. *Logarithm* comes from *logos* (word) and *arithmos* (number), so it stands for "a word that means a number"—but what number? If b and x are positive real numbers, and $b \neq 1$, the expression $\log_b x$ (pronounced "log base b of x") is defined, and here is what it means:

Rules of Exponents

If a and b are positive real numbers, and x and y are any real numbers, then

(E1) $b^x b^y = b^{x+y}$

(E2) $(b^x)^y = b^{xy}$

(E3) $(ab)^x = a^x b^x$

(E4) $\left(\dfrac{a}{b}\right)^x = \dfrac{a^x}{b^x}$

(E5) $\dfrac{b^x}{b^y} = b^{x-y}$

(E6) $b^{-x} = \dfrac{1}{b^x}$

(E7) $b^1 = b$

(E8) $b^0 = 1$

(E9) $b^x = b^y$
 if and only if $x = y$.

<div align="center">

**The expression "$\log_b x$" means
"the power we raise b to in order to equal x."**

</div>

For example, $\log_3 9$ means "the power we raise 3 to in order to equal 9." Therefore, our thoughts should look something like this:

$$\log_3 9 = \text{The power we raise 3 to in order to equal 9.} \qquad 3^? = 9 \quad \nearrow^{\log_3 9}$$

That is, we have 3 and we want to raise it to some power (the question mark) in order to equal 9. As the thought balloon indicates, that power is called "$\log_3 9$." In this case we know that the question mark should be a 2, because $3^2 = 9$. Thus $\log_3 9 = 2$.

We practice this kind of thinking in the "See, Say, Think" chart below, which reads from left to right. For example, when we get to the end of the third row we realize that $\log_{25} 5$ stands for the power we raise 25 to in order to equal 5. This seems impossible at first, until we realize that $25^{1/2} = \sqrt{25} = 5$, so $\log_{25} 5 = 1/2$. Carefully read the chart to be sure you understand the reasoning of each row.

This kind of reasoning is extremely important when we come to complicated-looking expressions involving logarithms. Stop for a minute and think about the following statement, which hopefully seems obvious—it's not a trick question!

$$b^{(\text{the power we raise } b \text{ to in order to equal } x)} = x.$$

If necessary, read this over and over until you agree that it's painfully obvious. It's like asking, "Who's buried in Grant's Tomb?" Grant, of course! (And his wife.) And if we take b, and we raise it to the power we're *supposed* to raise it to in order to equal x, what else can we get, but x? If you're wondering why we're even bothering with this, then here's the answer: when many students are confronted with an expression like

$$b^{\log_b x}$$

they freeze up! But if you know what logarithms actually are, you realize it's the same thing:

$$b^{\log_b x} = b^{(\text{the power we raise } b \text{ to in order to equal } x)} = x.$$

Thus $b^{\log_b x} = x$. Similarly, if you see $\log_b b^x$, you think to yourself

$$\log_b b^x = \text{the power we raise } b \text{ to in order to equal } b^x.$$

So, just as in the chart, you come to this mental picture:

$$b^? = b^x.$$

And what goes where the question mark is? It's x, of course! We therefore conclude that

$$\log_b b^x = x.$$

The important thing is, we did it not by memorization or symbol pushing, but by actually understanding what logarithms are.

SEE	**SAY**	**THINK**	
$\log_b x$	"Log base b of x."	The power we raise b to in order to equal x.	$b^? = x$ $\log_b x$
$\log_3 9$	"Log base 3 of 9."	The power we raise 3 to in order to equal 9.	$3^? = 9$ $\log_3 9 = 2$
$\log_{25} 5$	"Log base 25 of 5."	The power we raise 25 to in order to equal 5.	$25^? = 5$ $\log_{25} 5 = 1/2$
$\log_2 1/8$	"Log base 2 of 1/8."	The power we raise 2 to in order to equal 1/8.	$2^? = 1/8$ $\log_2 1/8 = -3$
$\log_7 7$	"Log base 7 of 7."	The power we raise 7 to in order to equal 7.	$7^? = 7$ $\log_7 7 = 1$
$\log_5 1$	"Log base 5 of 1."	The power we raise 5 to in order to equal 1.	$5^? = 1$ $\log_5 1 = 0$

We list some basic rules (L1–L7) of logarithms in the margin. Rule (L6) allows us to compute any kind of logarithm on a scientific calculator, using the $\log x$ button, which means $\log_{10} x$. For example, if we come across an expression like $\log_3 8$ (which we do in studying fractal dimension), we can compute

$$\log_3 8 = \frac{\log_{10} 8}{\log_{10} 3} = \frac{\log 8}{\log 3} \approx \frac{0.903089987}{0.477121255} \approx 1.893.$$

Because we can always push a wrong button, it's good to partially check our rounded answer by recalling that "$\log_3 8$" means "the power we raise 3 to in order to equal 8." Does your calculator agree that $3^{1.893} \approx 8$? How would you guess ahead of time that $\log_3 8$ is between 1 and 2 and probably closer to 2?

Rules of Logarithms

Assume that x and y are positive real numbers, a and b are positive and not equal to 1, and p is any real number. Then

(L1) $\log_b b^x = x$

(L2) $b^{\log_b x} = x$

(L3) $\log_b xy = \log_b x + \log_b y$

(L4) $\log_b \dfrac{x}{y} = \log_b x - \log_b y$

(L5) $\log_b x^p = p \log_b x$

(L6) $\log_b x = \dfrac{\log_a x}{\log_a b}$

(L7) $\log_b x = \log_b y$ if and only if $x = y$.

Exercises for Chapter 9

s	N
971	1.0
490	2.0
200	5.9
100	15.4
30	69.1
10	293.1

Data from Richardson, L. F., The problem of contiguity: an appendix of deadly quarrels, *General Systems Yearbook*, **6** (1963), 139–187. Compare this data with Figure 9.4, which graphs $\log L$ as a function of $\log s$.

1. The table to the right contains L. F. Richardson's original divider data for the west coast of Britain. Here s is the step size in kilometers and $N = N(s)$ is the corresponding number of steps, with a fractional step estimated at the end of each walk.

 (a) Plot the points $(\log s, \log N)$ and fit a straight line to them, either visually or using a spreadsheet. The slope of your line should be about -1.25 and the y-intercept should be about 3.7. Thus the equation of the line is $y = -1.25x + 3.7$, or since $x = \log s$ and $y = \log N$,

 $$\log N = -1.25 \log s + 3.7.$$

 (b) For a chosen step size s and the corresponding number N of steps, the estimated length L of the coastline is given by $L = Ns$. By which of the logarithm rules (L1–L7) does this imply

 $$\log L = \log N + \log s\,?$$

 (c) Use the results of (a) and (b) to derive Equation (9.2) on page 165.

 (d) By what logarithm rule is it true that

 $$3.7 = \log 10^{3.7} \approx \log 5000\,?$$

 (e) By what logarithm rules do part (d) and Equation (9.2) imply

 $$\log L = \log(5000 s^{-0.25})\,?$$

 Equation (9.3) is therefore true by what rule of logarithms?

2. Figure 9.25 shows the data points from Figure 9.9, in which we computed the divider dimension of the southwest coast of Borneo. Notice that the x-coordinates x_n of the data points are equally spaced. Whenever we have the freedom to choose the step size s, it's possible to create equal horizontal spacing between the data points, rather than have some of them bunched up in one place. This is a fairly common procedure in many scientific applications. Part (d) below shows how to do this, and why it works.

(a) Apply the review of exponents and logarithms to fill in the blanks:

$$\log 10 = \log_{10} 10 = \underline{} \qquad \log 1 = \log_{10} 1 = \underline{}$$

(b) There is a point on the graph in Figure 9.25 that represents a single step ($N = 1$) from one endpoint of the southwest coast of Borneo (on an enlarged map) to the other. In view of (a), which point is it? (Name the x-coordinate and circle the point.) By measuring along the horizontal axis in Figure 9.25 and using a calculator, estimate how many inches long this step was.

(c) There is a point on the graph in Figure 9.25 that represents just a tiny bit more than ten steps along the coastline. In view of (a), which point is it?

(d) Let ℓ denote the straight-line distance from one end of the coastline to the other. The step sizes (the values of s) we used were ℓ, $\ell/2$, $\ell/4$, $\ell/8$, $\ell/16$, $\ell/32$. This is what caused the points on the graph in Figure 9.25 to have equal horizontal spacing. The proof goes as follows. Using the laws of exponents, we can write these step sizes as

$$\ell/2^0, \ \ell/2^1, \ \ell/2^2, \ \ell/2^3, \ \ell/2^4, \ \ell/2^5.$$

Thus the x-coordinates of the six points in Figure 9.25 are

$$x_0 = \log(\ell/2^0), \ x_1 = \log(\ell/2^1), \ x_2 = \log(\ell/2^2),$$

$$x_3 = \log(\ell/2^3), \ x_4 = \log(\ell/2^4), \ x_5 = \log(\ell/2^5).$$

Two adjacent neighboring points then have x-coordinates of the form x_n and x_{n+1} for $0 \le n \le 4$, and their horizontal separation is

$$x_n - x_{n+1} = \log(\ell/x^n) - \log(\ell/x^{n+1}).$$

Use the laws of logarithms and some algebra to simplify this expression and show that $x_n - x_{n+1}$ does not depend on n. What is this separation to three decimal places? Does that look about right on the graph? This shows that the horizontal separations between neighboring data points are the same.

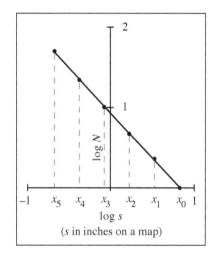

Figure 9.25 The divider data points from Figure 9.9. The x-coordinates x_n came out equally spaced by choosing step sizes of the form ℓ, $\ell/2$, $\ell/4$, $\ell/8$, $\ell/16$, $\ell/32$.

(e) What would happen if the step sizes were ℓ, $\ell/3$, $\ell/9$, $\ell/27$, and so on?

3. Using the ideas from Exercise 1 and the steps 1–4 we used in finding the divider dimension of the coast of Borneo, compute the divider dimensions of one rough section of coastline and one smooth section of coastline from somewhere around the world. A couple of examples in Figure 9.26 are the eastern shore of Chesapeake Bay (rough) and the outside coast of Cape Cod (smooth). Use the largest map(s) you can find for greater accuracy. You may also be able to find high-resolution satellite images on the internet.

4. Even though the Sierpiński triangle may not look like a fractal curve, it's possible to "take a walk" on it with dividers and compute its divider dimension. Figure 9.27 shows how to do it.

Figure 9.26. Top: NASA Landsat perspective image of Chesapeake Bay (NASA/Goddard Space Flight Center Scientific Visualization Studio). Bottom: Landsat image of Cape Cod.

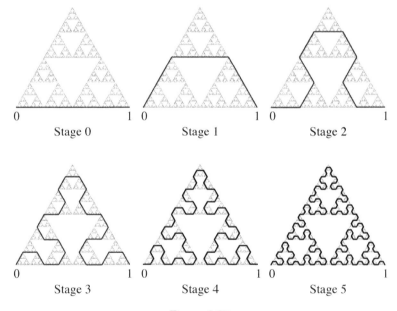

Figure 9.27.

This Sierpiński triangle is equilateral with sides of length 1. Its base extends from 0 to 1 on the x-axis, as shown. Starting at 0, it is not at all obvious which direction we should step in, but the following procedure leads to a sequence of nonintersecting "walks" along the fractal, each of which starts at 0 and ends

at 1. In Stage 0 we begin with a step of length $s = 1$ and take $N = 1$ step from 0 to 1. Notice that the black line segment representing this step is one side of the big triangle. In each subsequent step, we bend the black side of any Sierpiński triangle into that triangle, to form 3 new segments whose length is half of the previous base, with each new segment being a side of a smaller subtriangle. Thus in Stage 1, we bend the base upward into 3 segments ($N = 3$) of step length $s = 1/2$, so that each segment is a side of a smaller subtriangle. In Stage 2, each of these 3 three segments gets bent into its subtriangle, and so on.

What is the step length s and the number of steps N ...

(a) at stage 1?

(b) at stage 2?

(c) at stage 3?

(d) at stage m?

(e) In a manner analogous to the way we computed the dimension of the Koch curve using equation 9.5, compute the divider dimension of the Sierpiński triangle.

5. Recall that each of the Koch curves in Figure 9.12 had divider dimension $D = \log 4 / \log(1/s)$, where the corresponding fractal was the union of 4 smaller, similar copies of itself, and each copy was scaled by the same factor s. There is another definition of fractal dimension, called the *similarity dimension*, which is based on this idea and does not require dividers. If a self-similar set is the union of N smaller, similar copies of itself,[9] each scaled by the same factor r, then the similarity dimension D of the set is given by

$$D = \frac{\log N}{\log(1/r)}.$$

[9]The smaller copies should not overlap too much, but in a sense that's too technical for us to worry about here.

In particular, the similarity dimension and the divider dimension are the same for each of the Koch curves in Figure 9.12.

The Sierpiński carpet of Figure 8.13 on page 148 is the union of $N = 8$ smaller, similar copies of itself, each scaled by the same factor $r = 1/3$; its similarity dimension is therefore $\log 8 / \log 3 \approx 1.89$. What is the similarity dimension of the Sierpiński triangle in the previous exercise? Is it the same as the divider dimension you calculated? What are the similarity dimensions of the fractals in Figure 8.20 on page 156?

6. "But wait!" a student says, "I see the Sierpiński carpet of Figure 8.13 on page 148 as the union of $N = 64$ smaller, similar copies of itself, each scaled by the same factor $r = 1/9$. Its similarity dimension is therefore $\log 64 / \log 9$, not $\log 8 / \log 3$." How would you reply to the student?

7. Create a fractal with similarity dimension (a) $\log 3 / \log 2$; (b) $\log 5 / \log 3$; (c) $\log 7 / \log 4$. It is enough to show the first two or three iterations that generate the fractal.

8. What is the similarity dimension of the unit square in Figure 9.28? Use the laws of logarithms to simplify your answer. Does this dimension seem reasonable? What is the similarity dimension of a line segment? What is the similarity dimension of a cube? Draw a sketch to help justify your answer.

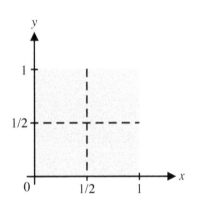

Figure 9.28

Artist Vignette: Kerry Mitchell

KERRY MITCHELL'S academic training is in Aerospace Engineering. He received his bachelor's degree from Purdue University, his master's from Stanford, and did his doctoral work at Purdue.

He performed aerospace research at NASA, served as Staff Scientist at the Arizona Science Center, and was a professor of Mathematics and Science at the University of Advancing Technology. He is currently a manager at the Maricopa Skill Center in Phoenix, Arizona.

In his spare time, Kerry is an algorithmic artist, having shown works in many galleries and museums. His images have been published on several book covers, album covers, and calendars.

I GREW UP in Iowa with an artist/art teacher father, but I didn't begin to pursue art for myself until later in life. Instead, I concentrated on the analytical side of my brain, which I got from my mother. I was always good in school, so I concentrated on academics (especially math), and dabbled a bit in art. Even then, I was fascinated by abstract geometric images; I would fill pages of graph paper with various square- and triangle-based doodles and lose afternoons with a Spirograph. One of my favorite types of images was the curves-from-straight-lines effect that would become the basis of many string-art sailboats in the seventies.

After I graduated from high school, I studied Aerospace Engineering at Purdue and Stanford universities. Then it was off to several years of aerospace research at NASA, investigating the aerodynamics of high-performance aircraft and the mechanisms through which jet engines produce noise. This engineering path is what gave me the technical chops needed for the art that I produce today: a good background in mathematics, some programming skill, and a working knowledge of computer graphics.

The analytical and artistic sides finally started coming together

"Even [growing up], I was fascinated by abstract geometric images; I would fill pages of graph paper with various square- and triangle-based doodles and lose afternoons with a Spirograph."

in 1985, when *Scientific American* published an article on the Mandelbrot set. Like many others, I was amazed at the beauty that arose from iterating such a simple formula. Unlike most, I had the means and inclination to investigate the process further, which fed both sides of me.

"I've always thought of myself as more of a technical person than an artistic person. Consequently, my art is about creating interesting images from technical ideas."

I've always thought of myself as more of a technical person than an artistic person. Consequently, my art is about creating interesting images from technical ideas. Other artists, perhaps most notably M.C. Escher, created art incorporating mathematical notions or themes. Now, some artists essentially paint with math—fractals and other shapes are their paintbrushes. In contrast, I see myself as a painter of math. If I may be so bold to compare myself with Ansel Adams, where he photographed trees and mountains, I capture images of fractals and other geometric shapes. As he did, I create the image which celebrates the underlying object. Fortunately, the objects in my images don't live in bear-infested areas and don't weigh millions of tons.

Initially, "typical" fractals (like the Mandelbrot set) comprised the bulk of my work. I was, and still am, drawn to their simultaneous simplicity and complexity. The prospect of a blank canvas is one that I find daunting, so I love the idea of a fractal formula giving me a structure from which to build, yet the structure is one that I can manipulate at will. Nowadays, my fractal efforts roll down two paths: (1) What else interesting is out there that I can find? How can new formulas be iterated and what shapes will they uncover? What other ideas can I implement and throw at a fractal to release a heretofore unseen facet? (2) How can I discover new ways to create images of familiar fractals? Artists have been creating landscapes and still lifes and portraits as long as there have been the means to create them. We'll never tire of seeing images of flowers or mountains, so long as there is a Georgia O'Keefe or Ansel Adams to provide us with new ways of looking at them. Likewise, even though "everyone" has seen the Mandelbrot set, how can I paint it or photograph it in a way that is new and different?

Kerry Mitchell
The In Crowd, 2001
digital

While I love fractals and hope to always return to them, I also feel a need to explore other areas of what is now being called "algorithmic art." The idea is that an overarching algorithm drives the creation of the work, but the resulting piece need not be a true fractal. This is a quite expansive and relatively untapped artistic field, as an algorithm can be algebraic, geometric, or even mechanical. The algorithms that I use often arise from number theory, plane geometry, and chaos and dynamical systems. For example, take a circle and draw several equal-spaced points around its edge. Connect every point with every other point by drawing lines between them. On top of this, overlay another image, with a different number of points.

Repeat many times. The type of final image depends on the relationships between the numbers of points. For example, prime numbers (2, 3, 5, 7, etc.; whole numbers larger than 1 that are only divisible by themselves and 1) give a much different image than using multiples of four (4, 8, 12, 16, etc.). Or, think about the minute hand of a clock. On its tip, place another hand that is half as long and rotates twice as fast. On its tip, place a smaller hand, half as long and rotating twice as fast. Add several more hands in the same way. Now, what is the path of the tip of the smallest hand? And, more importantly, how can that path be turned into a compelling piece of art? This is one way I think about my art.

While the math behind the art is a critical component, I often imbue my work with decidedly nonmathematical themes, which are equally as important. One such theme is jazz. I'm not a musician, but I am very enamored with the music. Many of my abstract images convey (to me, anyway) a sense of rhythm, harmony, and a mix of improvisation and tight structure that I associate with instrumental jazz. In fact, I created two series of images inspired by the music of Miles Davis (*Kind of Blue*)[1] and John Coltrane (*A Love Supreme*).

"While the math behind the art is a critical component, I often imbue my work with decidedly nonmathematical themes, which are equally as important."

[1]See *Kind of Blue: All Blues* in the Plates section.

Kerry Mitchell
Jazz ala Oscar, 2000
digital

In other cases, I combined fractal and jazz elements with a black-on-white coloring. The reasons were threefold: (1) Most fractals that make it to the public's eye are very colorful, and I found that a stark coloring focuses attention on the fractal shape; (2) It was reminiscent of the time of the heyday of jazz, when most of the photographs taken were in black and white; and (3) It spoke to me of the social order of the day, when the schism between Black people and White people was much larger and better defined than it is today. The Black experience

has been another theme of my work, from the brutality of lynching to the symbolism of Kwanzaa.

"Another theme that shows up regularly in my work is spirituality. It would be (and has been) all too easy to spend my life 'in my head,' thinking about math and analyzing things logically."

Another theme that shows up regularly in my work is spirituality. It would be (and has been) all too easy to spend my life "in my head," thinking about math and analyzing things logically. While I don't intend to espouse any particular religion in my work, I do believe in a transcendent power and I feel that art is a great way to explore and express that. In particular, I like the interplay between God and the relative lack of cultural bias in mathematics—math is available to everyone, as I feel God is. The study of fractals, like much of algorithmic art, has an aspect of infinity about it, which also connects it to the notion of the spirit.

Sometimes, I draw inspiration from other visual artists. My biggest source of inspiration was my father, and I probably get my interest in abstract geometric shapes from him. I enjoy seeing how I can interpret other works in my own way, such as Gustav Klimt's *The Kiss*, or Wassily Kandinsky's *Squares with Concentric Rings*.

Overall, I draw from the areas of mathematics, physics, computer science, music, and visual art, combining them with the mind of an engineer, the heart of a teacher, and the soul of an artist. My hope is that the resulting images powerfully reflect the beauty of mathematics that is often obscured by dry formulae and analyses. An overriding theme that encompasses all of my work is the wondrous beauty and complexity that flows from a few relatively simple rules. Inherent in this process are feedback and connectivity; these are the elements that generate the patterns. They also demonstrate to me that mathematics is, in many cases, a metaphor for the beauty and complexity in life. This is what I try to capture.

▣ For more of the artist's work, see the Plates section.

Kerry Mitchell
Funky Genes, 2003
digital

Answers to Selected Exercises

Chapter 1

The first two exercises appear in the margins.

Margin Exercise 1.1. $(1,2,7)$, $(1,2,3)$, $(1,3,3)$, $(4,2,7)$, $(4,3,7)$, $(4,3,3)$.

Margin Exercise 1.2. Higher: A (the y-coordinate is larger). Closer: A (the z-coordinate is smaller). More to the left: A (the x-coordinate is smaller).

1. (a) Answers will vary. Our own experience is that the ratio is often closer to 8.

 (b) Smaller. (Compared with adults, children have larger heads relative to their bodies or smaller bodies relative to their heads.)

2. (a) $H = (1,7,5)$.

 (b) $C = (1,2,4)$, $D = (2,3,3)$, $E = (1,3,3)$, $F = (2,2,3)$, $G = (1,3,4)$, $H = (2,2,4)$.

 (c) $C = (1,1,5)$, $D = (3,4,1)$, $E = (1,4,1)$, $F = (3,1,1)$, $G = (1,4,5)$, $H = (3,1,5)$.

 (d) The object in part (b) is a $1 \times 1 \times 1$ cube.

3. (a) The letter E.

 (b) There are many correct answers. One of these is $PRTRSQSU$.

 (c) There are many correct answers. One of these is $QTPRSQVUTQSWV$. You might verify that it is impossible to draw this figure without covering at least one edge twice.

 (d) There are many correct answers. Each answer requires covering many edges more than once.

Chapter 2

2. (a) This is close. It appears the dinosaur is running across the door to the people, so it is probably to the right of the door; the x-coordinate of Q is probably larger.

(b) Q (the dinosaur's claw is above the floor).

(c) P (the door is further away).

(d) Q and (e) P (by comparing directly on the photograph).

3. (a) $x' = 2 \cdot 5/(5+5) = 1$, $y' = 3 \cdot 5/(5+5) = 1.5$.

 (b) $x' = 2 \cdot 5/(95+5) = 0.1$, $y' = 3 \cdot 5/(95+5) = 0.15$.

 (c) $x' = 2 \cdot 5/(995+5) = 0.01$, $y' = 3 \cdot 5/(995+5) = 0.015$.

4. (a) width: 6, height: 4, depth: 12.

 (b) $(-10, -6, 12)$ $(x', y') = (-5.555555556, -3.333333333)$
 $(-10, -6, 24)$ $(x', y') = (-3.846153846, -2.307692308)$
 $(-10, -2, 12)$ $(x', y') = (-5.555555556, -1.111111111)$
 $(-10, -2, 24)$ $(x', y') = (-3.846153846, -0.769230769)$
 $(-4, -6, 12)$ $(x', y') = (-2.222222222, -3.333333333)$
 $(-4, -6, 24)$ $(x', y') = (-1.538461538, -2.307692308)$
 $(-4, -2, 12)$ $(x', y') = (-2.222222222, -1.111111111)$
 $(-4, -2, 24)$ $(x', y') = (-1.538461538, -0.769230769)$

5. (a) $F = (-12, -6, 105)$.

Chapter 2 Practice Quiz

1. $(-4, -2, 6)$ $(x', y') = (2, -1)$
 $(-4, -2, 3)$ $(x', y') = (8/3, -4/3)$
 $(-6, -4, 3)$ $(x', y') = (-4, -8/3)$
 $(-6, -4, 6)$ $(x', y') = (-3, -2)$
 $(-6, -2, 3)$ $(x', y') = (-4, -4/3)$
 $(-6, -2, 6)$ $(x', y') = (-3, -1)$
 $(-4, -4, 6)$ $(x', y') = (-2, -2)$
 $(-4, -4, 3)$ $(x', y') = (-8/3, -8/3)$

2. $(-4, -5, 6)$ $(x', y') = (-2, -5/2)$
 $(-4, -5, 3)$ $(x', y') = (-8/3, -4/3)$
 $(-6, -5, 3)$ $(x', y') = (-4, -8/3)$
 $(-6, -5, 6)$ $(x', y') = (-3, -5/2)$

Chapter 3

2. If the box is twice (or three times) as long as it is wide, the viewing distance is twice (or three times) the distance between the two trees.

Chapter 4

The first three exercises can be solved in straightforward ways by following the techniques introduced in this chapter. The remaining exercises require much more thought. We do not present solutions for most of these exercises for two reasons. The first reason is this: struggling to find a solution is difficult ... until you have seen the solution, at which point it becomes "obvious." Hence, we want to avoid tempting you to merely look at the answer and forego the pleasure of thinking hard. The second reason is that there are multiple correct solutions to each of these problems, and presenting a comprehensive catalog of correct solutions would take up too much space. We try to illustrate the variety of interesting and correct possibilities that exist by exploring one of these exercises (Exercise 8) in depth, but we leave the remainder to the reader.

Exercise 8, Solution 1. We begin with the first of two detailed solutions of Exercise 8. We close with an equally important concluding discussion to highlight what's in it for you. The answer section may seem like a strange place to put an essay on the value of perspective problems, but we stashed it here in the hope that you have first worked hard on the problem—successfully or not—before coming here. You'll get much more out of it that way. There are many possible correct solutions to this exercise. After reading the solutions here, we challenge you to find one of your own. It might be better in its own way than anything yet discovered!

Our first solution takes advantage of a convenient feature of the problem. Namely, if we look at the copy of the fence panel on the right side of Figure A-1, we see that images of the two fenceposts are parallel, and thus the actual fenceposts are parallel to the picture plane.

Now recall that Rule 5 of this chapter says that a shape (such as a single fencepost) that lies entirely in a plane parallel to the picture plane has a perspective image that is an undistorted miniature of the original. Thus if the actual fencepost had paint marks on it that divided it into thirds, the images of those marks would divide the image exactly into thirds, with no distortion. Consequently, we can correctly divide the image of the near fencepost into thirds by simply measuring on the image with a ruler and marking two points. For comparison, we have done this in Figure A-1 for both the straight-on view of the panel on the left and the perspective view on the right.

Figure A-1. Straight-on view of the fence panel (left) and perspective view (right).

The next step (Figure A-2) is to draw dashed horizontal lines through the two points in the straight-on view on the left, and then draw the images of these lines in the perspective view on the right by extending them to the vanishing point of the fence.

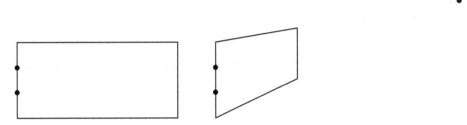

Figure A-2. Dashed horizontal lines (left) and their perspective images (right).

The final step (Figure A-3) is to draw a dashed diagonal of the panel on the left, and its image on the right. Through the intersection points of this diagonal with the horizontal lines we draw two vertical fenceposts that (as we will see) correctly divide the panel into thirds. Notice on the right of Figure A-3 that the *images* of the fence panels do *not* have equal widths, so we could not have located them by simply measuring along the top or bottom of the image of the fence. For later purposes we have labeled some lengths on the diagram.

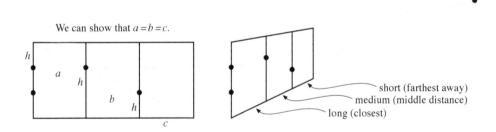

Figure A-3. Two additional posts divide the fence into thirds.

In order to be sure this method really works, we must verify that the three panels on the left side of Figure A-3 have equal widths. One way to check this approximately is to measure them with a ruler. To be sure it works precisely we need a proof.

On the left side of Figure A-3 we have labeled the sides of three similar right triangles. (How do we know they are similar?) Each has a vertical side h units in length, and the horizontal sides have lengths a, b, and c, which we hope are all equal. From the two similar triangles on the left we have $a/h = b/h$, and multiplying both sides of this equation by h gives $a = b$, which is exactly what we want. The fact that $b = c$ can be proved in the same way.

This drawing technique can be generalized to other problems. For instance, in the same situation it is just as easy to divide the fence into, say, five equal sections, as in Figure A-4. This method is often used by professional artists and illustrators.[2]

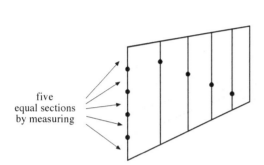

Figure A-4. Dividing the fence panel into fifths.

Nevertheless, this technique can't be generalized to all the cases in which we might like to use it. The reason is that if no side of a rectangle is parallel to the picture plane, then we can't measure along the image of a side to get started. For example, in the perspective view of the Italian flag on the right side of Figure A-5, the picture plane is tilted upward looking at the sky, and none of the edges of the actual flag is parallel to it. We can tell this because neither of the pairs of opposite edges have parallel images. To overcome this obstacle, we look at another solution. Although we use the flag as an example, this solution can also be applied to the fence. One piece of advice remains the same, however:

> Work on the undistorted rectangle *first*, then try to transfer your solution to the rectangle in perspective.

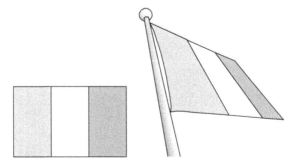

Figure A-5. The Italian flag straight on (left) and flying high in perspective (right).

[2]Including comic artists: see Stan Lee and John Buscema, *How to Draw Comics the Marvel Way*, Simon & Schuster, 1984, p. 37.

Exercise 8, Solution 2. Again let's work with a straight-on view and a perspective view. We have drawn these in Figure A-6; in the perspective view we have extended the nonparallel images of parallel lines to their vanishing points.

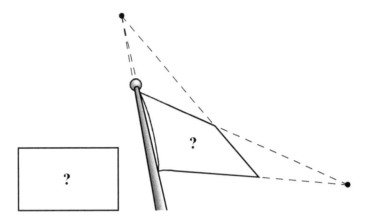

Figure A-6. Looking for a solution without measuring.

The Italian flag consists of three identical vertical rectangles of different colors (green, white, and red). Many national flags have this same three-rectangle design. This time we want to divide the larger rectangle (the flag) into thirds without measuring.

When mathematicians approach a tough problem, they will sometimes back up to an easier problem they know how to solve, and see if they can extend the easier solution to fit the new problem. Remember that we successfully subdivided a rectangle without measuring when we divided it in half by making an "X" with the diagonals and drawing a midline through the intersection point. Following the mathematicians' example, we do that on both sides of Figure A-7, and hope for inspiration!

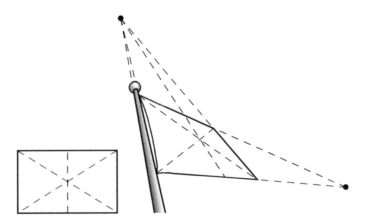

Figure A-7. Trying what we already know: dividing the flags in half.

Any ideas? If so, try them out before reading further!

It turns out that by simply drawing two more lines we can locate the "1/3" and "2/3" points we need to solve the problem. On each side of Figure A-8 we draw lines from the midpoint of the bottom edge of the flag to the upper corners. The "1/3" and "2/3" points are the intersections of these lines with the diagonals. Through these points we draw vertical lines that correctly divide the flags into thirds.

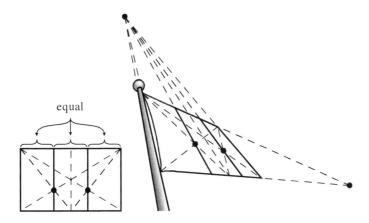

Figure A-8. A solution without measuring.

Of course we must prove that we are correct. To simplify the proof, let us assume that the rectangle is 1 unit long and h units high, and let it be the rectangle in the Cartesian plane with corners $(0,0)$, $(1,0)$, $(1,h)$, and $(0,h)$ (see Figure A-9). The rectangle has been divided in half using the diagonals, and the diagonal of the rectangle from $(0,0)$ to $(1,h)$ has the equation $y = hx$.

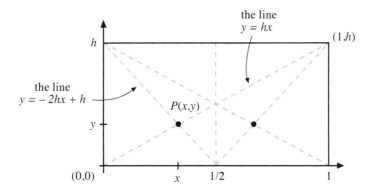

Figure A-9. Proof that the method works.

Following our drawing technique, we draw a dashed line from $(0,h)$ to the midpoint $(1/2, 0)$ of the bottom edge of the rectangle. This line has slope $-h/(1/2) = -2h$ and

y-intercept h, so its equation is $y = -2hx + h$. Let $P(x, y)$ be the intersection of this line with the diagonal; if our drawing method works, then we should have $x = 1/3$. Since P lies on the two lines $y = hx$ and $y = -2hx + h$ all we need to do is solve the system of equations

$$\begin{cases} y &=& hx \\ y &=& -2hx &+& h. \end{cases}$$

The solution is $x = 1/3, \quad y = h/3$.

This proves what we wanted to prove, and gives us something extra: the point $P = (1/3, h/3)$ not only locates the left-hand third of the rectangle, whose boundary is the vertical line $x = 1/3$, it also locates the bottom third of the rectangle, whose boundary is the horizontal line $y = h/3$. Thus, without any extra effort, we have already made progress toward dividing the rectangle into thirds both horizontally *and* vertically. That's one reason we chose coordinates to do the proof—sometimes mathematics gives you more useful information than you asked for!

Finally, let's see if we can generalize this drawing technique the same way we did Solution 1. Can we extend the method to divide a rectangle into fourths, fifths, etc.? First let us observe that if we want to divide a rectangle into fifths, say, and we already know how to divide a rectangle into fourths, then all we need to do is locate the first fifth. We can finish by dividing the remaining part into fourths. Thus our problem simplifies to one of locating the first fourth, the first fifth, etc., of a rectangle.

Here's what we know so far. On the left of Figure A-10 we have divided a rectangle in half without measuring. In the center of Figure A-10, we locate the first third by drawing a line from the upper left of the rectangle to the "foot" of our previous solution (1/2). So what happens if we draw a line from the upper left corner of the rectangle to the foot of our latest solution (1/3)?

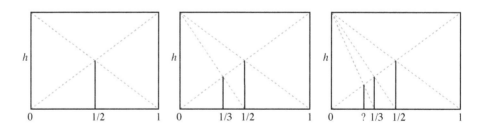

Figure A-10. Trying to extend the technique.

What if we keep going? That is, suppose (Figure A-11) that we have found the first nth (third, fourth, etc.) of the rectangle, and we draw a line from the upper left corner of the rectangle to the foot of the previous solution $(1/n)$ to get a new "solution" (the question mark). If you had your wish, what would you want it to be? Is it?

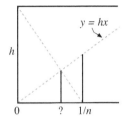

Figure A-11. What is the next "solution"?

We have presented two solutions to Exercise 8 in some detail in order to illustrate characteristics of it common to other perspective problems:

I. The problem is natural and easily understood. The goal of the problem and its value are immediately clear. Without its solution we can't even do a competent job of drawing a flag!

II. The problem has multiple solutions of varying difficulty and applicability. We deliberately present the problem in one-point perspective to admit a wide range of solutions. There are many more solutions than the two shown here. For instance, several solutions require drawing constructions outside the fence panel, such as the so-called "measuring line" technique sketched in Figure A-12.[3]

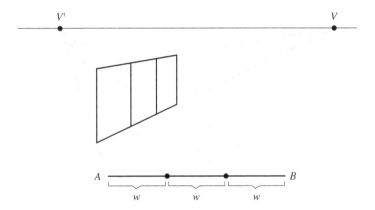

Figure A-12. Solution by a measuring line AB.

The existence of many solutions allows a maximum number of students to tackle the problem with a good chance of at least partial success. Comparing the many solutions is an important follow-up exercise, involving several interesting and practical questions. For example, which solutions

[3] Briefly, we locate an arbitrary second vanishing point V' on the horizon as the apex of a triangle ABV', with a horizontal base AB and sides passing through the feet of the original fenceposts. We then trisect the "measuring line" AB by direct measuring, and the lines from the trisection points to V' locate the feet of the inner fenceposts. Why does this work?

- use the least number of construction lines?

- are easiest to remember?

- generalize to divisions other than thirds?

- do not require drawing outside the rectangle (allowing for aligning a ruler with vanishing points)?

- generalize to two-point perspective?

Note that Solution 2 solves what is perhaps the most difficult form of the problem: How can we take a rectangle in two-point perspective and correctly divide it into thirds without drawing outside the rectangle? Even art majors and professors are not generally aware of this form of the solution, even though it is easy to use and remember.

III. The problem admits multiple proofs, both geometric and algebraic. Most people would not suspect that the ability to set up and solve systems of linear equations would help us to draw better, but that is exactly what we have shown. Moreover, as implied at the end of Solution 2, the ability to do proofs by mathematical induction can help us to draw better still! Strictly geometric proofs are of course possible, too.

IV. Once arrived at, the solutions are easy to remember and rewarding to use. Using the solutions in drawing is an important part of the payoff. A toolbox of solutions to various problems allows anyone to show off their newfound skills and create drawings that hold their own even with the work of art majors on the same assignment. The drawing on the left of Figure A-13 by Tim Nelson, a math education major, solves several interesting problems and pays homage to a clever solution by two other students.

The geometric design that appears on two faces of the building is a correctly rotated version of the embellished square on the right of Figure A-13. This design was created by Jenna, an art major, to correctly divide a square into fifths in both directions. She developed the design in the process of seeking beauty and symmetry as well as accuracy in her solution. When Jenna needed help proving her solution at the blackboard, Tia, a biology major, leapt to her aid, having independently discovered the same solution. Tim's homage to Jenna and Tia is a visual acknowledgment that real mathematics is an art form requiring both sides of the brain!

V. The solutions capture the essence of mathematical research. It is not surprising that Jenna found a superior solution by seeking beauty and symmetry for their own sake—rather, it is a common success story in mathematics. It's the job of mathematicians to seek beautiful patterns, secure them with logic, and exploit them for further investigations. This work also includes: groping; fumbling; experimenting; seeking alternate solutions, generalizations, and applications; collaborating with colleagues whose skills complement one's own; and in the end, savoring and sharing the

results for the sheer joy of creation and discovery. In an authentic and uncontrived way, problems in perspective embody each of these characteristics, and do so at a level that is accessible to every student.

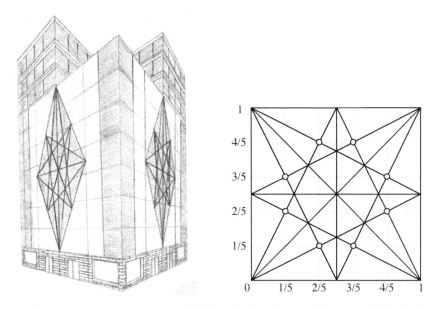

Figure A-13. Homage to a solution (left), and the solution of Jenna and Tia (right).

Chapter 5

Example 1. The hint for this example applies to the other Chapter 5 examples as well. The dashed semicircle V_1EV_2 in Figure A-14 is the same as the horizontal "viewing circle" (actually a semicircle) in Figure 5.4. The viewpoint E in Figure A-14 lies on the viewing circle, and it must also be directly opposite the viewing target T, which lies at the center of the uncropped photograph. That is, the line \overleftrightarrow{ET} must be perpendicular to the picture plane.

Unfortunately, photographs and drawings do not come with attached, transparent, horizontal shelves on which we can draw horizontal viewing circles and locate viewpoints. Instead, we imagine rotating the dashed viewing circle about the horizon line $\overleftrightarrow{V_1V_2}$ until it becomes the solid semicircle V_1UV_2 in the picture plane. The point E rotates into the point U, which we *can* locate. To do this, we draw the semicircle V_1UV_2, locate T as the intersection of the diagonals of the photograph, and then draw \overleftrightarrow{TU} perpendicular to $\overleftrightarrow{V_1V_2}$. Finally, we imagine rotating the entire construction about $\overleftrightarrow{V_1V_2}$, back up into a horizontal position so that U becomes E. That's why TU is the viewing distance.

NOW HEAR THIS: It is *absolutely essential* that you use this kind of reasoning in the rest of the examples. In particular, think of every circle in the examples

as having *two* incarnations: a version in the picture plane (which is practical to draw), and a version rotated 90° about $\overleftrightarrow{V_1 V_2}$, so that it lies in the horizon plane and sticks out horizontally from the picture plane. This second version can't be drawn, but your eye must lie on it in order to view the picture correctly. Obviously you will need to draw lots of top and side views of the viewer, the picture plane, the object being drawn or photographed, the vanishing points, the circles, etc. Draw, draw, draw!

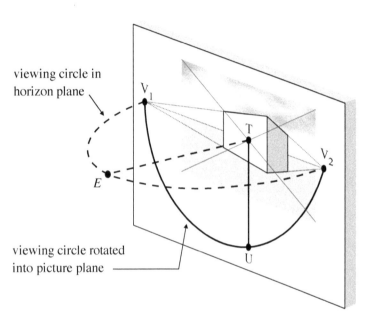

Figure A-14. A circle with two incarnations: the dashed, horizontal viewing circle (actually a semicircle) in the horizon plane, and a solid version of it that has been rotated 90° about $\overleftrightarrow{V_1 V_2}$ to lie in the picture plane. The viewpoint E rotates into the point U.

Example 4. This hint is also helpful for Example 5. The point V_3 in Figure 5.14 (also shown in Figure A-15) is directly above V_2, and it is the vanishing point of a diagonal of the dark face of the building. Now refer to Figure A-15. From any point on the dashed horizontal circle centered at V_2, the line of sight to V_3 has angle of elevation α. These lines of sight generate a cone whose apex is V_3. From the correct viewpoint, a viewer's line of sight to V_3 must be parallel to the diagonal on the actual building, hence this line of sight must have angle of elevation α. The viewpoint must therefore lie somewhere on the dashed horizontal circle, because these are the points in the horizon plane from which one looks up to V_3 with angle of elevation α.

The solid circle in the picture plane centered at V_2 is obtained by rotating the dashed circle about $\overleftrightarrow{V_1 V_2}$. Now assume we know the angle α for the actual

building. In practice, we draw α as indicated to locate the point S on the horizon line $\overleftrightarrow{V_1V_2}$, and then draw the solid circle in the picture plane with radius SV_2 centered at V_2. Now see if you can explain the rest of the construction in Figure 5.14.

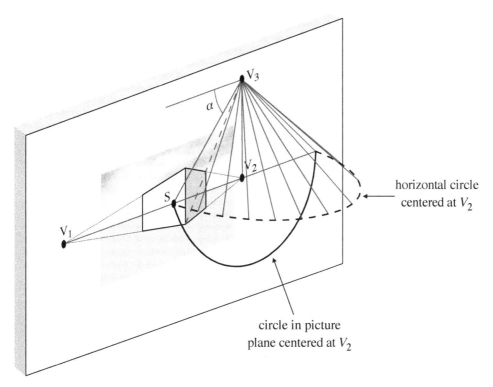

horizontal circle
centered at V_2

circle in picture
plane centered at V_2

Figure A-15. The point V_3, which is directly above V_2, is the vanishing point of the dashed diagonal of the dark face of the building. From any point on the dashed horizontal circle centered at V_2, the line of sight to V_3 has angle of elevation α. The solid circle in the picture plane centered at V_2 is obtained by rotating the dashed circle about $\overleftrightarrow{V_1V_2}$.

1. (a) 90 deg (b) 45 deg (c) 45 deg (d) 90 deg (e) 45 deg (f) 45 deg

3. Compare this to Exercise 2 in Chapter 3. The dimensions of the building fall approximately into the triple ratio

$$\text{height : white length : gray length} = 1 : 1.3 : 0.82,$$

so the white face is about 65 feet wide and the gray face is about 41 feet wide.

4. Compare this to Exercises 6 and 7 in Chapter 4.

5. Compare this to Exercise 4 in Chapter 4.

7. Compare this to Exercise 8 in Chapter 4.

10. Compare this to Exercise 8 in Chapter 4.

Chapter 6

7. Here is one possible solution. If the three main vanishing points form an equilateral triangle whose sides are all 22 inches long, then standard (but careful) geometry, together with the formula for viewing distance in Theorem 6.2, shows that

$$d = \sqrt{(22/\sqrt{3}) \cdot (11/\sqrt{3})} \approx 9.$$

So perform these steps in order. Draw the principal vanishing points V_i on this large equilateral triangle. Create the feet of the altitudes F_i by measuring 11 inches on each side of the triangle, and then draw the altitudes themselves. Mark off each of the W_i on an altitude exactly 11 inches from the corresponding V_i. From each of these W_i, draw a small 1×2, 1×3, or 2×3 rectangle and extend the diagonals out to the edge of the equilateral. It is tricky at this stage to keep track of which orientation each rectangle should have (should it be 1×2 or 2×1?). Choose an arbitrary line segment that (if it were to be extended) would pass through some vanishing point V_i. From this point on, everything is determined.

Another possibility arises after we have marked off each of the W_i points. Doing this step creates a cube in the center of the picture; we could use the fence dividing (or fence expanding) techniques of Chapter 4 to divide (or add onto) this object to create a $1 \times 2 \times 3$ rectangle.

Chapter 7

3. There are several ways to do this; here we describe one way. First locate the viewing target T at (or even off) one edge of the paper, draw a horizontal line L though T, and add the point U one inch below T. Now draw any semicircle passing through U whose diameter lies along the horizontal line L. The diameter should be large enough that C (one intersection point of the semicircle and the line L) lies in the piece of paper where you will draw your grid. Label the other intersection point V. Using V as the center, draw a second semicircle with radius \overline{UV}, and use this circle to identify the point V_1 directly above or directly below V. Now you can draw the grid using lines that pass through V (images of horizontal lines), a diagonal construction line to V_1, and vertical lines.

Chapter 8

Caption of Figure 8.16.

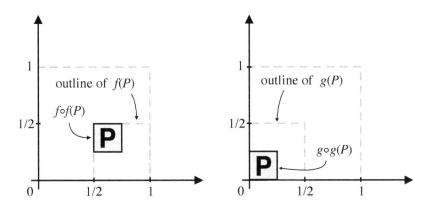

Figure A-16. Answers to questions in the caption of Figure 8.16. Note that $f \circ f(P)$ shrinks and flips the picture of $f(P)$ through the diagonal and places that flipped picture in the bottom right corner. Similarly, $g \circ g(P)$ shrinks the picture of $g(P)$ and moves it without flipping to the bottom left corner.

Caption of Figure 8.19.

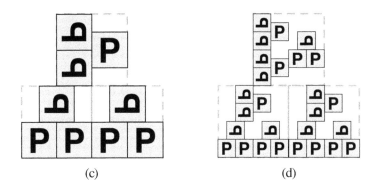

(c) (d)

Figure A-17. Answers to questions in the caption of Figure 8.19.

Exercise for Figure 8.20.

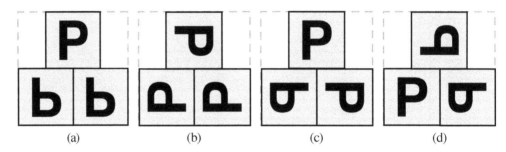

(a) (b) (c) (d)

Figure A-18. Solutions to the first four exercises of Figure 8.20. For the fractals in (a) and (c), the symmetry means there are 8 correct solutions because we are allowed to reflect each "P" through its stem.

Remark. For problems galore of a similar type, see the website called Dave Ryan's Fractal World. An intro to "Regular Square Fractals" is at

www.angelpage.co.uk/fractalworld/week3.htm

and all 232 "Regular Square Fractals" are displayed at

www.angelpage.co.uk/fractalworld/square.htm

Chapter 9

1. (b) Rule (L3).

 (d) Rule (L1).

 (e) Rules (L3) and (L5). Rule (L7).

2. (a) $\log 10 = 1$; $\log 1 = 0$.

 (b) $\log s = x_0$, because $\log N = \log 1 = 0$. By measuring we get $x_0 \approx 0.85$, so $s \approx 10^{0.85} = 7.2$.

 (c) $\log s = x_3$, because $\log N \approx 1$.

 (e) The horizontal separation between the points is $\log 2 \approx 0.301$.

 (f) The horizontal separation would change from $\log 2$ to $\log 3 \approx 0.477$.

3. There are many possible correct answers.

4. (a) $s = 1/2$ and $N = 3$.

 (b) $s = 1/4$ and $N = 9$.

 (c) $s = 1/8$ and $N = 27$.

 (d) $s = (1/2)^m$ and $N = 3^m$.

 (e) $D = \log_2 3 = \log(3)/\log(2)$.

5. The similarity dimension of the Sierpiński triangle is again $D = \log_2 3 = \log(3)/\log(2)$. Indeed, the similarity dimension of each of the fractals in Figure 8.20 is $D = \log_2 3 = \log(3)/\log(2)$.

6. Both fractions are the same number: $\log(64)/\log(9) = \log(8^2)/\log(3^2)$. (We can use logarithm rule (L5) to get the desired equality.)

7. There are many correct answers. For part (b), for example, you could draw a fractal such that the first iteration has 5 nonoverlapping boxes, each one-third the size of the original box.

8. The similarity dimensions of a square, line segment, and cube are 2, 1, and 3—as you would expect.

Appendix: Information for Instructors

This section contains three parts: advice on window taping, a sample timetable for a first-year seminar course based on *Viewpoints*, and a list of additional writing assignments. The timetable and writing assignments describe what Annalisa Crannell does in her class, which fulfills a writing requirement at Franklin & Marshall College.

Tips for Window Taping

The best way to gain a true understanding of perspective is to do the real thing. The window-taping exercise discussed in Chapter 1 is an enjoyable activity that forms an important basis for understanding everything that comes later. In order for the activity to be successful, instructors should follow a few simple tips, the most important of which is:

1. Never have your students tape a window that you haven't already taped yourself. In fact, following this tip makes the other tips almost superfluous, because most will become obvious in the process. You will need to find windows to accommodate teams of 2–3 students for each tape drawing. You (with the aid of a helper or two) should tape from each viewpoint beforehand to see where the best viewpoints are, whether the views and resulting images are appropriate, and how long it takes to get a reasonably nice and instructive image. Lacking good windows, you can use large sheets of 1/4-inch Plexiglas propped on tables as shown in Chapter 1. In this case each team should have 4 students: one to direct, one to tape, and two to hold the Plexiglas.

2. Use half-inch drafting tape. Masking tape will do, but drafting tape from an office supply store is easier to find in a skinny width, and it's less sticky, which makes for fast and easy cleanup when you're done.

3. Encourage students to tape the most important and instructive features first. You'll know these for each drawing by following tip #1. In just a single class period you won't get masterpieces, but by gently encouraging students to tape the most important and instructive features first, they will see enough to realize Observations 1 and 2 of Chapter 1. Indeed, that's the point—for the students' own work to reveal these observations. A single wall with windows can be enough, but in

this case the wall must not be parallel to the plane of the window. Also note that it's important to get at least *three* lines converging to a vanishing point, because it's trivial that two coplanar, nonparallel lines will intersect somewhere.

4. Continually remind art directors to keep one eye closed, and to check the position of their viewing eye. The existing tape should always appear to align with the real-world objects it represents, before instructing tape artists to lay down new tape. Otherwise the students will wind up with an inconsistent drawing done from several viewpoints.

5. Keep a pair of shish kebab skewers handy so you can surreptitiously check the convergence to vanishing points. That way you can redirect students if their drawing is out of kilter at an early stage. Simply have them assume the viewpoint and see that not all the tape simultaneously aligns with the objects outside the window.

6. Never have your students tape a window that you haven't already taped yourself. Redundant, yes, but it can't be overemphasized!

Timetable

Because of the time Crannell spends on writing, her class spends most of its time at the beginning and at the end of this book: she skims quickly through the chapters on two-point and three-point perspective (largely omitting questions of viewing distance), and touches hardly at all on the chapter on anamorphic art (although, as we noted above, the students have a semester-long research assignment which appears in that chapter). If Crannell had less writing in the course, those chapters would get significantly more time and attention during the semester.

Crannell supplements the *Viewpoints* book with several additional pieces:

Edwin A. Abbott, *Flatland: A Romance of Many Dimensions*, Dover Publications, Inc., New York (1992).

Robert Devaney, *The Chaos Game*, from http:// math.bu.edu/DYSYS/applets/chaos-game.html.

David Hockney, *David Hockney's secret knowledge* (videorecording produced and directed by Randall Wright), a BBC Production, Princteon, N.J. (2004).

Plato, "The Allegory of the Cave," from *The Republic, Book VII*, available, for example, at http://www.historyguide.org/intellect/allegory.html.

Henry M. Sayre, *Writing About Art*, Prentice Hall, New York (1995).

Before the semester begins:
Read: "The Allegory of the Cave," from Plato's *Republic*, Book VII.
Draw (or create): Diagram that explains what was happening in the cave.
Write: One-page paper. (See Socrates assignment.)

Week 1: Window-taping exercise as an experiential introduction to perspective, discuss summer assignments, share and discuss papers and artwork.

Math/Art Homework: Buy supplies.

Write: Rewrite Socrates assignment.

Week 2: Introduction to the Plan View for perspective; coordinate systems. Visit the Writing Center. Read selected essays from previous week and discuss use of detail to support a thesis. Interview professors for next week's paper.

Read: Chapters 1 and 2 of the textbook.

Math/Art Homework: From Chapters 1 & 2 of book.

Write: Taping Exercise.

Week 3: Introduction to the library. Visit computer workroom and create Excel spreadsheet for drawing a house. Three-dimensional coordinates. Algebraic formulas for projecting these points on a picture plane. Misplaced modifiers.

Read: Finish Chapter 2.

Math/Art Exercises: Draft of Excel House.

Write: How to succeed in your classes.

Week 4: What is a vanishing point? How to draw a cube in one-point perspective. First encounter with viewing distances. How to quote and paraphrase. Using other sources to support your thesis.

Read: "Using Outside Sources" handout from the Writing Center; also an artist vignette from the textbook.

Math/Art Exercises: Finish Excel House.

Write: Either first multipage paper, or else choice of one-page paper—"Blind Copying Paper" or "Vignette Summary."

Week 5: Read, mark up, and discuss 5 student papers. Visit art gallery; viewing distance exercises. Poster gallery; more viewing distance with 1- and 2-point perspective. Start 1-point perspective sketch of hallway.

Read: Student essays.

Write: Same as last week.

Week 6: Read, mark up, and discuss 5 student papers. Computing viewing distances when there is no image of a square, from 1×2 and other rectangles. Begin to sketch images of 3-D letters, with an emphasis on correct width and depth.

Read: Student essays.

Math/Art Assignment: Sketch your hallway in 1-point perspective.

Write: Same as last week.

Week 7: Read, mark up, and discuss 6 student papers. Begin "fence" problems from Chapter 4. Active and passive voice.

Read: Textbook, Chapter 3.

Math/Art Assignment: Write a word that is at least 4 letters long in 1-point perspective.

Write: Active/Passive paper.

Week 8: Fall Break. Revisit passive/active voice. More fence problems: can you double the fence? divide it into 3 pieces?

Read: Chapter 4.

Write: Rewrite your least favorite paper.

Week 9: Perspective with irregular objects. Art field trip to a coffee shop; add a "poster" to the wall in your hallway sketch. Drawing square floor tiles in 1- and 2-point perspective (and how do you know they're "squares" and not rectangles?).

Read: Anamorphic Art chapter.

Math/Art Assignment: Finish "poster on a wall" sketch.

Write: What kinds of math are in your piece of art?

Week 10: Drawing in 2-point and 3-point perspective. "What's my line?" game.

Read: Chapter 5.

Math/Art Assignment: Draw a 4-letter word in 2-point perspective.

Write: "Viewing distance paper."

Week 11: Introduction to Fractals. Fractal dimension. Iterations and the "Chaos Game."

Read: Chapter 8.

Math/Art Assignment: Hausdorff dimension of self-similar objects.

Write: Second multipage paper.

Week 12: Using fractal software; connection between an iterated function system to the generated fractal. Sketching fractal "cauliflower."

Math/Art Assignment: Finish fractal cauliflower.

Read: Student papers.

Write: "Course summary paper."

Week 13: Thanksgiving Break. Iterations with rotation and reflection.

Math/Art Assignment: Draw a fractal tree.

Read: Chapter 9.

Week 14: Iterations with rotation and reflection. Recovering the original function system from an existing fractal. Dimension of the Chesapeake Bay. Introduction to the fourth dimension. The Hypercube.

Read: *Flatland*, pages 1–52.

Math/Art Assignment: Given several fractals, uncover original transformation, check by plugging these into fractal software; print it out.

Week 15: *Flatland* and art. Hockney's video on optical devices in Renaissance art.

Read: *Flatland*, pages 53–83.

Math/Art Assignment: Sketch person & cube passing through *Flatland*.

Write: *Flatland*/"Allegory" Paper.

Mathematics of Art Writing Assignments

These short (one page) writing assignments complement and intermingle with longer papers that form the basis for a semester-long research project—see the last exercise in Chapter 7.

Socrates Paper: Socrates, in "The Allegory of the Cave," claims,

> Some persons fancy that instruction is like giving eyes to the blind, but we say that the faculty of sight was always there, and that the soul only requires to be turned round towards the light.

Do you agree? Give me an example of a time you learned something important to you. Was it more like "getting eyes" where you had been blind, or more like discovering something you already somehow knew? You will turn in this essay on the first day of class, and your preceptor and I will both get a chance to read it over. We are hoping to use this as a chance to get to know you and how you learn— so it's better to be honest than to say what you think some stuffy old college professor might like to read. (Of course, we're also trying to get a feel for your writing style.)

Taping Exercise: In a one-page paper, describe what we did in the taping exercise on the first day of class. Include not only the details of what we did, but some of the lessons that you learned from the exercise. If there are confusions or questions that you have, feel free to include those, too.

I am interested in this paper partly for feedback reasons (that is, I want to see if what you learned is what I thought you learned). I also want you to practice using correct, descriptive terminology (distinguishing between objects and their images).

How to Succeed in Your Classes: Over the course of [the first week of class], I want you to interview your professors; ask each of them what is the best way to study for their class. You will write an essay based on what they tell you, so take good notes as you interview them. For your paper, describe something worth noting that you learned from talking to your professors. Perhaps you discovered that they all emphasized the same idea; perhaps they were wildly different in their approach. Perhaps you heard just what you expected to hear (and that surprised you), or perhaps you learned something new by talking to them.

As I read this paper, I will pay attention to your ability to develop a thesis and to support that thesis with specific details.

Blind Copying Paper: In class, we'll do a "blind copying" exercise, in which you will get to tell one of your classmates how to draw a picture that only you can see. In this paper, you will try to describe a picture in much the same way. That is, you will choose a picture (perhaps the one you used in class, perhaps the piece you're using for your long papers) and describe it in detail as though explaining it to somebody who hasn't seen it.

The point of this assignment is to turn a picture into words: to use clear, concise language in a way that evokes an image (perhaps even the mood of that image). Organization and coherence will be important parts of presenting your piece clearly. You may find it helpful to read *Writing About Art*.

Vignette Summary: Choose one of the artist vignettes from this textbook. What is the main point the artist is trying to make in his or her essay? Summarize the parts of the essay that support this point (or if you think the artist did not support that point well, say so).

The point of this paper is this: I want you to commit to a thesis, and then use judicious and accurate evidence from a text to support your argument. Do you understand what your author is actually saying? Can you paraphrase accurately? Do you include relevant quotations correctly? Can you construct an argument in support of your own thesis, even though other people could reasonable argue a different thesis?

Active/Passive Paper: Write one page with two paragraphs about your art project. (The two paragraphs can be two different topics, or the second paragraph might continue the topic that the first paragraph starts.)

You should write one of these paragraphs entirely in the active voice.

The other paragraph should be written (by you) entirely in the passive voice.

There should be no neutral verbs anywhere on the page.

Math in Your Piece of Art: I have put you into groups based on mathematical similarities in your artwork. You should meet with your groups and figure out what it is about your pieces that are mathematically similar. Since each of your artworks are different, your analyses will be different, too, and so I can't tell you in general terms what you ought to include. But I have strong opinions about each of your pieces individually! To help you think about your paper, I want you to meet in these groups and work together before your 1-page paper is due.

You should jointly think out loud about good approaches to take. In this paper, you will tell me what kinds of mathematical aspects you intend to explore in your next 4-page paper. Being specific about how this relates to your piece of art will help. For example, saying "I will draw a plan view" isn't specific. Saying, "I will probably have to draw 3 different plan views, so that my readers can see the top of the building, the side of the building that they think they see, and the side of the building that they actually see," is much better.

What am I looking for as I grade this?

• Content: I am looking to see that you've thought seriously about several things: your piece, what we've learned in this class, and how those two things do (or even cooler, don't) fit together.

• Honesty. If you have questions about what you're going to say in your 4-page paper, bring those up! If you're uncertain about which of two approaches you might take, say so. I want to use this paper to guide you. I don't want Serious Baloney (BS).

• Good exposition. As always.

Viewing Distance Paper: In this one-page paper, you will choose a painting that uses correct perspective, and you will describe, step-by-step, how to determine the viewing position. This means that you will need to find a fairly decent image of the painting and also to know its original size, so you will need to include the citation for the book/website/museum where you found your figure you use as well as for the information about its size. It also means that I expect you to give me an actual number for the viewing distance (with units and everything)!

I expect you to use the mathematicians' "we" together with vigorous, active voice, as in,

> To locate the primary vanishing point, we can extend the red lines along the left and right sides of the desk. We see that these points meet at the saint's right eyebrow.

Some possible paintings you might use include these:

Jacques-Louis David, *Oath of the Horatii* (1784)

Raphael, *Marriage of the Virgin* (1504)
Piero della Francesca, *The Flagellation* (probably 1455–1460)
Perugino, *Giving of the Keys to St. Peter* (1581–1582)
Beccafumi, *Stigmatization of St. Catherine* (1518)
Tintoretto, *Transport of the Body of St. Mark* (1562)
Fra Filippo Lippi, *Feast of Herod* (1452–1466)
Botticelli, *Annunciation* (1489–1490)
Leonardo da Vinci, *The Last Supper* (1495–1498)

Course Summary Paper: This paper has varied over the years. One version I use runs along the lines of, "We have done very little with numbers or equations this semester, and it would be easy to argue that this is not a math course. Have we really been doing math? Decide for yourself and defend your answer with specific examples." Another version asks students to write a 150-word catalog description for the course.

***Flatland*/"Allegory" Paper:** Both Abbott (in *Flatland*) and Plato (in "The Allegory of the Cave") describe a character who sees only two dimensions for the greater part of his life, then suddenly encounters a 3-dimensional world, and who returns to his original 2-D world with a knowledge that none of his compatriots can share. Each story ends with questions about the obligation of a person who has knowledge and the effect that new knowledge can have for a society that is comfortable in the lack of that knowledge.

In this essay, I want you to focus not on knowing the world in a new way, but in seeing the world in a new way. Compare (or contrast) the kind of sight that Plato's returned cave dweller gains with the sight that Abbott's Mr. Square gains.

Annotated References

History of Linear Perspective

1. Andersen, K. 2006. *The Geometry of an Art: The History of the Mathematical Theory of Perspective from Alberti to Monge.* New York: Springer.

 This is probably the most comprehensive history of the mathematics of artistic perspective.

2. Andersen, K. 1992. *Brook Taylor's Work on Linear Perspective: A Study of Taylor's Role in the History of Perspective Geometry. Including Facsimiles of Taylor's Two Books on Perspective.* New York: Springer-Verlag.

3. Dürer, Albrecht. 1977. *The painter's manual : A manual of measurement of lines, areas, and solids by means of compass and ruler assembled by Albrecht Dürer for the use of all lovers of art with appropriate illustrations arranged to be printed in the year MDXXV.* New York: Abaris Books.

 This work, like Euclid's *Elements*, is a classic that is still worth reading today.

4. Hockney, D. 2006. *Secret Knowledge: Rediscovering the Lost Techniques of the Old Masters.* New York: Viking Studio.

 In this book, the prominent artist David Hockney presents his convincing and widely known—but controversial—theory that many Renaissance artists used optical devices to create their highly realistic portraits and still life paintings. The paintings Hockney discusses are largely of people rather than of linear objects, and therefore not directly related to the material in this *Viewpoints* book, but it is a beautiful book and well worth reading.

5. Leonardo da Vinci [Trans. McMahon, A. P.]. 1956. *Treatise on Painting [Codex urbinas latinus 1270]*. Princeton: Princeton University Press.

> Leonardo da Vinci wrote copious notes for a book on perspective – mathematical and optical – that he never published. This work contains a reproduction of the Italian text which is a compilation by Francesco Melzi of notes from the original manuscripts of Leonardo, together with English translations.

6. Taylor, B. 1715. *Linear Perspective*. London.

7. Taylor, B. 1719. *New Principles of Linear Perspective*. London.

> Brook Taylor, a mathematician who gave his name to the famous "Taylor's Series," wrote several influential books on the mathematics of perspective.

Modern Articles on the Viewpoint

8. Adams, K. R. 1972. Perspective and the viewpoint, *Leonardo,* **5**, No. 3, 209–217.

9. Byers, K. McL., and J. M. Henle. 2004. Where the camera was, *Mathematics Magazine,* **77**, No. 4, 251–259.

> This article analyzes a historic 2-point perspective photograph of a building and finds an algebraic method for computing the location of the camera; the article is aimed at a level that first-year college students can read. (Byers was an undergraduate student when she cowrote this paper.)

10. Crankshaw, N. M. 1990. CARPA: Computer aided reverse perspective analysis, *APT Bulletin,* **22**, No. 1/2, Cultural Resource Recording, 117–129.

> This paper demonstrates the value of a perspective analysis of architectural photographs in two-point perspective in the field of architectural preservation.

11. Crannell, A. 2006. Where the camera was, take two, *Mathematics Magazine,* **79**, No. 4, 306–308.

> A follow-up to the Byers/Henle article, with a slightly more geometric flavor.

12. Duffin, R. J. 1993. On seeing progressions of constant cross ratio, *American Mathematical Monthly,* **100**, No. 1, 38–47.

> The perspective image of an infinite row of equally spaced objects forms an infinite series whose terms are the apparent gap widths. This article analyzes these series in terms of the concept of cross ratio.

13. Frantz, M. 1998. The telescoping series in perspective, *Mathematics Magazine,* **71**, No. 4, 313–314.

> This note illustrates the convergence of the famous telescoping series from calculus using the perspective image of a row of telephone poles. See also the more general paper by Duffin above.

14. Frantz, M., and A. Crannell. 2007. Three-point perspective and plane geometry, *Journal of Mathematics and the Arts,* **1**, No. 4, 213–223.

> A proof from plane geometry uses a diagram of a triangle, its altitudes, and three circles to prove the concurrency of the altitudes at the orthocenter. The proof characterizes the orthocenter as the radical center of the three circles. We show that this diagram is also a self-sufficient device for drawing and analyzing images in three-point perspective.

15. Greene, R. 1983. Determining the preferred viewpoint in linear perspective, *Leonardo,* **16**, No. 2, 97–102.

16. Macmillan, R. 1996. Getting the right perspective. *The Mathematical Gazette,* **80**, 258–261.

17. Mauldin, J. H. 1985. *Perspective Design: Advanced Graphic and Mathematical Approaches.* New York: Van Nostrand Reinhold Co.

> This book presents a method for drawing a box of a specified shape in three-point perspective by a method different from ours. Mauldin also used the vanishing point triangle and the outer halves of the altitude circles to determine the viewpoint, although again by a different method than our book uses.

18. Robin, A. C. 1978. Photomeasurement. *The Mathematical Gazette,* **62**, 77–85.

19. Taylor, P. 2007. Mathematical Lens. *Mathematics Teacher,* **101**, No. 3, 179–182.

Describes an in-class exercise trying to find the viewing distance of a picture that has arches receding into the distance. Students had several instructive false starts in solving this problem.

20. Tripp, C. 1987. Where Is the camera? The use of a theorem in projective geometry to find from a photograph the location of the camera, *The Mathematical Gazette,* **71**, 8–14.

Geometry

21. Coolidge, J. L. 1971. *A Treatise On the Circle and the Sphere.* Bronx, New York: AMS-Chelsea Publishing.

22. Coxeter, H. S. M. 1974. *Projective Geometry.* Toronto: University of Toronto Press.

23. Coxeter, H. S. M., and S. L. Greitzer. 1967. The power of a point with respect to a circle. In *Geometry Revisited.* Washington, DC: Mathematical Association of America, 27–31.

24. Henderson, A., and J. W. Lasley Jr. 1938. On harmonic separation, *National Mathematics Magazine,* **13**, No. 1, 3–21.

Among other things, this paper describes the construction by Philippe de La Hire (c. 1650) of the *harmonic conjugate.* This construction is useful in creating a box in three-point perspective.

25. Pedoe, D. 1970. *Geometry: A Comprehensive Course.* New York: Dover.

26. Steiner, J. 1826. Einige geometrische Betrachtungen, *J. Reine Angew. Math.,* **1**, 161–184.

Anamorphosis and Other Perspective Illusions

27. Brigham, J. 1984. *The Graphic Work of M. C. Escher.* New York: Crown Publishers Inc.

The "impossible figures" in this book make able use of 2-point perspective, and many students enjoy exploring the use of correct perspective to make incorrect objects.

28. Seckel, A. (editor). 2004. *Masters of Deception.* New York: Sterling Publishing.

> This book contains the work of 20 modern artists (including Dick Termes) whose work contains illusion or deliberate distortion. Some of these effects rely on the clever use of perspective.

Fractal Geometry

29. Barnsley, M. 1988. *Fractals Everywhere.* San Diego: Academic Press.

> Although this book teaches some metric space topology for upper level undergraduates, its expository style is enthusiastic, friendly, and very visual. It gives a good coverage of iterated function systems, with lots of examples.

30. Eglash, R. 1999. *African Fractals: Modern Computing and Indigenous Design.* New Brunswick, N.J.: Rutgers University Press.

> This book combines mathematics (iterated function systems) and anthropology (local stories) to describe the shapes of architecture and design motifs in various African cultures.

31. Frantz, Marc. 2009. A fractal made of golden sets, *Mathematics Magazine,* **82**, No. 4, 243–254.

> A recursive fractal-drawing scheme avoids erasing if every stage of the drawing is a subset of the fractal. This article, which relates golden rectangles to fractals, gives sufficient conditions for a set to be a subset of a given fractal.

32. Kappraff, Jay. 1986. The geometry of coastlines: A study in fractals, *Computers and Mathematics with Applications,* **12B**, 655–671.

> An analysis of Mandelbrot's famous 1967 article (see below).

33. Mandelbrot, Benoit. 1967. How long is the Coast of Britain?, *Science,* **156**, 636–638.

> The classic article relating natural phenomena to fractal dimensions.

34. Mandelbrot, B. 1982. *The Fractal Geometry of Nature.* New York: W. H. Freeman and Company.

> This was one of the earliest popular books on fractal geometry. Although it does contain substantial mathematics, the book has enough of an expository flavor and enough beautiful pictures that it remains popular today.

35. Prusinkiewicz, P. and A. Lindenmayer. 1990. *The Algorithmic Beauty of Plants.* New York: Springer-Verlag.

> This beautiful book describes an iterative, fractal model for describing the growth of plants. Lindenmayer was a biologist and botanist.

36. Richardson, Lewis Fry. 1963. The problem of contiguity: an appendix of deadly quarrels, *General Systems Yearbook,* **6**, 139–187.

> In this study Richardson measured various coastlines and suggested that a model of a coastline should have infinite length. It was the inspiration for Mandelbrot's famous 1967 article (see above).

Index

Milton Keynes UK
Ingram Content Group UK Ltd.
UKHW030411271023
431403UK00003B/21